Published in the United States by The New Press, New York, 2001
Distributed by W. W. Norton & Company, Inc., New York

LIBRARY OF CONGRESS CATALOGING-IN-PUBLICATION DATA

Brenson, Michael.
 Visionaries and outcasts : the NEA, Congress, and the place of the visual
artist in America / Michael Brenson
 p. cm.
 Includes bibliographical references.
 ISBN 1-56584-624-9 (hc.)
 1. Federal aid to the arts—United States—History—
20th century. 2. Art, Modern—20th century—United States—
Political aspects. 3. National Endowment for the Arts. I. Title.
 N8837.B74 2001
 707'.9'73—dc21 00–042360

The New Press was established in 1990 as a not-for-profit alternative to the large,
commercial publishing houses currently dominating the book publishing industry.
The New Press operates in the public interest rather than for private gain, and is
committed to publishing, in innovative ways, works of educational, cultural, and
community value that are often deemed insufficiently profitable.

The New Press, 450 West 41st Street, 6th floor, New York, NY 10036

www.thenewpress.com

Printed in the United States of America

2 4 6 8 9 7 5 3 1

VISIONARIES AND OUTCASTS

The NEA, Congress, and the
Place of the Visual Artist in America

MICHAEL BRENSON

The New Press
New York

For Theodore Brenson
(1893–1959)

VISIONARIES AND OUTCASTS

CONTENTS

PREFACE AND
ACKNOWLEDGMENTS

This book began as an essay on the National Endowment for the Arts' visual artists' fellowship program. It was commissioned by Jennifer Dowley, the Endowment's head of museums and visual arts, who had been hired in 1994 by Jane Alexander and who had lived through Congress's elimination of its funding for individuals, except for writers, at the end of 1995. She knew how much the visual artists' fellowship program had meant to hundreds, if not thousands, of artists. She was fully aware of the extraordinary distortions of it by people who had no idea what it had accomplished or how it worked but were hungry for anything that would allow them to mock artists and the agency. She imagined a book that would list all 4,000 visual artists' fellowship recipients, as well as all the panelists. It would be illustrated by work by the best 100 or 150 artists who received fellowships as selected by critics and curators. She asked me to write an overview that would place the program in a historical context and consider its development and achievements. She wanted my essay to be able to have some effect on policy in case Congress allowed the Endowment to fund individual artists again.

I was thrilled to take on the project. As the son of an abstract painter

who had fled Europe in 1941 and never felt at home in the United States, I had grown up with America's aversion to artists in the fifteen years after World War II and then seen the country's attitude toward them soften, becoming more tolerant, sometimes even welcoming, after the NEA was founded in 1965. Then came 1989, the controversy over the Andres Serrano and Robert Mapplethorpe photographs, and an onslaught of the distrust, even hatred, of living artists that I had assumed would never be as sanctioned as it was before the NEA began. For as far back as I can remember, I had been concerned with the place of the artist in America. After 1989, I was convinced that it was impossible to understand what art and artists mean in this country without thinking about the NEA in depth. Here was my chance.

It was clear to me almost immediately that I would have to answer two questions: Why, in 1965, did the United States government decide to trust and believe in artists more than ever before? And why, in 1995, had this trust and belief become little more than traces, or reminders, of a distant history?

It was also clear to me that with all the generalizations about the visual artists' fellowship program, no one had ever tried to explain how it—and the peer panel system that guided it—actually worked. And while pretty much everyone who ever heard of the agency had an opinion about what it did or did not do, no scholar or commentator on it had bothered to ask artists who had some connection with the agency what they thought of it. Of the fifty-five people I interviewed, roughly two thirds were artists. They span all the generations of artists funded by the NEA and represent a broad range of aesthetic positions.

My deadline was early 1999. Two months after I sent in a one-hundred-page essay that was between an essay and a book, Dowley left the agency to become president of the Berkshire Taconic Community Foundation in Great Barrington, Massachusetts. The essay's fate was in the hands of chairman William J. Ivey. He decided it was not appropriate for the book he envisaged and asked me to write a different essay, based on the art the book would reproduce, that could communicate to

the general public why the art supported by the Endowment had made an important contribution to American culture. I declined.

I sent the essay to Archibald L. Gillies, president of the Andy Warhol Foundation for the Visual Arts, who had published two papers of mine in which the NEA had been prominently featured, and asked him to read it. His response was enthusiastic. He asked if he could send it on to the New Press. I said I would be delighted. The Warhol Foundation, which initiated and houses the Creative Capital Foundation, the first major effort to award money to individual artists after the visual artists' fellowship program ended, helped underwrite the publication and provided support for the expansion of the essay into a book.

During the rewriting in early 2000, the essay changed radically. Living and working among historians at the Getty Research Institute for the History of Art and the Humanities in the fall of 1999 made it easier for me to think more historically. The information I gathered about the fellowship program, its peer panel system, and the attitudes about art, artists, and the United States that shaped it, continued to inform my writing, but I saw the program from more of a distance. The NEA became a lens onto larger issues of the changing identity of the American artist and the enduring problem of the place of the visual artist in a country that, no matter how much the notion of the artist is expanded and redefined, is still only comfortable with the artist as a maker of high-priced commodities controlled by galleries and museums.

My book is one piece of a gigantic puzzle. The NEA is an agency of immense complexity. Each program was different; each has its own history. Each of the many programs within an umbrella program—for example, the Art in Public Places, Visual Artists' Organizations, and fellowship programs within the visual arts program—was different. No generalizations about all the fellowship programs within the agency should be drawn from the visual artists' or any other fellowship program.

I am profoundly grateful to Jennifer Dowley for her faith in me and her continuing support. I did not interview her for the essay, thinking that including the words of the person who had commissioned me

would be a conflict of interest. One of the pleasures of seeing the essay become a book is that her voice could become part of it.

I am also grateful to Michael Faubion of the Endowment, who bore the brunt of my endless questions and answered all of them with exemplary professionalism; to Arch Gillies; to André Schiffrin and his staff at the New Press; to Martha Wilson, who helped edit the original essay; and Terry Ann Neff, who worked with me on its expansion into a book; to Tracey Shiffman, who designed the jacket; and to Michael S. Roth, Deborah Marrow, and the Getty Research Institute. Special thanks go to the many artists and former Endowment officials who were generous with their time and thoughts, most of whom are cited in this book.

My deepest thanks go to Sharon O'Connell, who has given me joy and hope for twenty-four years, and who already knew in the sixties, as a dancer, how much the NEA would mean to generations of creative people.

They really were trying essentially to underwrite a kind of creative process, and that's a very rare thing in the world.

> —Robert W. Irwin, artist, visual artists' fellowship recipient 1973, peer panel member 1975, 1976, and 1978

We were building, we were looking for how to enable, how to establish ways of seeing quality, how to acknowledge where our own eyes were limited and who would have less limited eyes, how to evoke creativity in different kinds of groups. How to give courage.

> —Newton Harrison, visual artists' fellowship recipient 1975, chair of the visual arts policy panel 1978

The peer panels really defined what we would support and what we would not support. They were the shapers of the culture in a way. They defined our investments. They defined and redefined every year what quality was. It wasn't us, the bureaucrats, doing that; it was them. They were our voice, the Endowment's voice. We were the vessel through which they spoke.

> —Jennifer Dowley, president of the Berkshire Taconic Community Foundation, director of the NEA's visual arts program 1994–1999

I know for a fact that people who got those grants felt truly honored by having them. It wasn't just the money. It gave them a sense of empowerment, a kind of slingshot to pull their work forward, because they felt someone really cared. It was because this country cared.

> —Roger Mandle, former director of the Toledo Museum of Art and deputy director of the National Gallery of Art, currently president of the Rhode Island School of Design, member of the National Council on the Arts 1989–1996

How can we set up artists' spaces, places where artists can go that support them against all the things they don't have, that they've given up. That give them faith and spirit to go on and to keep pushing. These are the things that make the difference between a society that succeeds and one that fails. To grow and to be imaginative, that's what I felt we were really about—to make a world that would support that kind of thinking, whatever form it took.

> —Leonard Hunter, artist, professor of art at San Francisco State University, assistant director of the visual arts program 1980 and 1983, acting director 1981 and 1982.

Epigraphs taken from interviews conducted between October 1998 and January 2000.

VISIONARIES AND OUTCASTS

THE ARTIST IN AMERICA, 1965

On September 29, 1965, President Lyndon B. Johnson signed into law the National Foundation on the Arts and the Humanities Act that brought into existence the National Endowment for the Arts and the National Endowment for the Humanities. Johnson had never felt at ease with the arts, but he had good reasons for supporting this act. He knew of the culture boom in the United States. He knew that culture had become an American Cold War weapon soon after World War II ended.[1] He was fully aware of how much good press John F. Kennedy had received for his administration's support of the arts and how much goodwill this support had generated at home and abroad. He hoped that by creating a federal art agency, he could gain some support from the East Coast liberal establishment that was opposed to his Vietnam policy. And he believed, like Kennedy and Dwight D. Eisenhower before him, that without a reputation for supporting the arts, America would never be recognized as a great society, or a great civilization.

In an often-cited statement at the ceremony at which the Arts and Humanities Act was signed into law, Johnson let the rhetoric flow. "In the long history of man," he said, "countless empires and nations have come and gone. Those which created no lasting works of art are reduced today to short footnotes in history's catalogue.

"Art is a nation's most precious heritage, for it is in our works of art

that we reveal to ourselves, and to others, the inner vision which guides us as a nation. And where there is no vision, the people perish.

"We in America have not always been kind to the artists and scholars who are the creators and the keepers of our vision. Somehow, the scientists always seem to get the penthouse, while the arts and the humanities get the basement."

Johnson declared that artists mattered. The Arts and Humanities Act told the country that it could no longer afford to treat artists as second-class citizens. In order for America to achieve self-knowledge and greatness, art had to be supported and artists had to be welcomed into the privileged spaces of the nation.[2]

A few days later, the Center for the Study of Democratic Institutions in Santa Barbara held a two-day meeting to debate the "purpose, function, and methods of this venture of the federal government into an area it had never before entered (except for relief purposes in the Depression years of the WPA)."[3] The distinguished arts professionals invited to the meetings were excited and hopeful about the new agencies and eager to understand what the new federal support would mean for the arts and how it would work. Roger L. Stevens, the first chairman of the NEA (1965–1969), was there. So were Walter Hopps and Thomas W. Leavitt, California museum directors; Kirk Douglas, the actor; John Houseman, a theatre and film producer and director; Lawrence Lipton, a critic and writer; Abbott Kaplan, a professor of theatre arts and an associate dean at UCLA; and Henri Temianka, founder and director of the California Chamber Symphony.

In the opening paper, Gifford Phillips, a trustee of the Phillips Collection in Washington and of the Pasadena Art Museum, and a director of the International Council of the Museum of Modern Art in New York City, cited a 1965 report by the Rockefeller Brothers Fund on the state of the performing arts that "emphasized the art boom in this country."[4] In explaining this boom, Phillips referred to another influential report, one that had been presented to President John Fitzgerald Kennedy in 1963 by August Heckscher, the president's special consultant on the arts and a former chairman of the Museum of Modern Art's

International Program. Heckscher, Phillips said, "attributed the new interest in the arts to three factors: an increasing amount of free time, not only in the working week but in the life cycle as a whole; a new sense of the importance of cities, and a recognition that life is more than the acquisition of material goods."[5]

In Phillips's paper, and then during the ensuing discussion, a number of remarks were made that reveal some of the assumptions about artists that were informing decisions then being made about the arts by many culture professionals and politicians, including decisions shaping the NEA. To Phillips and others at the conference, artists were committed to a search for meanings deeper and more enduring than any provided by the standardization and commodification of culture that were alarming many Americans at the time. Phillips believed the artist offered "an aesthetic alternative to the utilitarian pursuits in which most of us are busily engaged."[6] Because artists were inner-directed, they were not seduced and corrupted by money, the obsession with which was threatening to undermine the moral and spiritual purpose that cultural and political leaders believed America had to maintain if it was going to be equal to the challenges it faced at home and abroad.

The estrangement of artists from mainstream America noted by participants at the conference—"It has become commonplace to point out that never before has" the artist "been so alienated from society," Phillips said—was therefore not a result of their maladjustment but rather to a justified unease with the deceptions and distortions of American society.[7] Phillips stated that the artist was part of a "generalized estrangement from society" but felt it "more keenly because of his heightened sensibilities."[8] Because America was being weakened by its emphasis on conformity and money, maintaining a distance from society was a condition of the artist's integrity and insight. For the first time, respectable people in high places were coming to believe that the country needed artists *because* they were outsiders. It was as outsiders that they had to be welcomed in. To Phillips, "the artist has a special need to live outside of society. . . . Whenever there is an official attempt to destroy this detachment, as there as been in the Soviet Union, for ex-

ample, art is likely to suffer . . . But alienation is too extreme a feeling for what should be the desirable relationship between the artist and his work; rather, detachment, separation, divorcement, independence. I prefer the last because independence from some, if not all, social constraints is what the artist most needs and should have."[9]

In order for artists to give the country what it needed, they needed a sophisticated system of support. They needed money. According to the Rockefeller Brothers Fund report, many artists were near starvation. "The truth of the matter," Phillips said, "is that most artists in this country exist slightly above the poverty line, as any number of recent studies have found."[10] Since their ability to expose the temptations and disequilibrium of postwar America depended upon their independence, their ability to function both inside and outside society had to be preserved. They needed to be integrated into society in order to survive and influence. Phillips cited Richard Hofstadter, who in his book *Anti-Intellectualism in American Life* concluded, in Phillips's words, that "the separation of culture and the arts from vital economic and political forces in American life was not . . . healthy for the arts themselves."[11] But they also needed to be left alone so that they would remain uncorrupted. Artists had the ability to prevent people from feeling like "victims of a highly organized, technically automated society, no longer able to relate to their environment in a normal way," but they could not "provide this alternative if they allow themselves to be taken over and perhaps consumed by the world."[12] Supporting artists and making them feel part of American society while protecting their distance from it would be one of the NEA's goals.

While the October 1965 conference suggests both why the United States government began supporting artists as it never had before and what idea of the artist it supported, it does not adequately explain the degree of alienation from their government and from mainstream America many visual artists felt after World War II, and it only begins to suggest why many artists who came of age in the forties, fifties and sixties found their government's sudden concern for them in 1965 so welcome. In the affluent and dangerous years after the war, the distrust

of conformity and suspicion of materialism that Phillips and others at the conference valued in artists could inspire vicious attacks. Some of the staunchest Cold War warriors identified everything critical of mainstream America with Communism. For Congressman George A. Dondero of Michigan, all of modern art was "depraved" and "destructive." Because Cubism, Futurism, Dadaism, Expressionism, Abstraction, and Surrealism, which had shaped generations of American modernists, originated in Europe, modern art was un-American. In New York's *World Telegram*, Dondero said: "Modern art is communistic because it is distorted and ugly, because it does not glorify our beautiful country, our cheerful and smiling people, and our material progress. Art which does not glorify our beautiful country in plain, simple terms that everyone can understand breeds dissatisfaction. It is therefore opposed to our government, and those who create and promote it are our enemies." Dondero described artists who opposed his beliefs as "human termites" and "germ-carrying vermin."[13]

This hostility toward artists and toward the most vital new art was apparent in the press as well as in government. "Like Dondero," William Hauptman wrote in a 1973 article, "The Suppression of Art in the McCarthy Decade," newspaper magnate William Randolph Hearst "equated any form of artistic radicalism with communism, and assumed that all of the work produced in a nontraditional manner was a disguised means of communist propaganda."[14] During the next ten years, a number of well-known artists were targeted by the right, and several Government-sponsored exhibitions organized to show the rest of the world the best of American art were ridiculed and canceled.[15]

During the McCarthy years of 1950 to 1954, questioning the free enterprise system, or the belief that America's material prosperity was proof that we were a good and indeed chosen nation, or acting and thinking in ways that did not conform to the ethos of frontier male individualism, or just looking or acting different in some way could be seen as aiding and abetting the enemy. "Throughout the 1950s and early 1960s," the cultural critic Maurice Berger has written, "Cold War America was fraught with paranoia: fear of communist aggression,

fear of protest and public unrest, fear of racial and sexual difference. In the world of everyday politics and popular culture, this paranoia focused on the threat of communism, subjecting celebrities and ordinary citizens alike to congressional witch-hunts, loyalty oaths, and blacklists."[16] The persecution of people who did not conform to a fundamentalist vision of America at once reinforced the marginalization of artists and undermined the country's democratic image. "Seemingly unstoppable, the McCarthy-inspired cultural cleansing bankrupted America's claims to be the harbinger of freedom of expression," the film producer and writer Frances Stonor Saunders wrote.[17]

There were periodic expressions of official support for artists. On several occasions, President Dwight D. Eisenhower stated that the arts, and the free expression he said was essential to their flourishing, were crucial to America's greatness. In 1954, on the occasion of the twenty-fifth anniversary of the Museum of Modern Art, a museum with a number of influential curators and board members eager to put art in the service of America's Cold War struggle,[18] Eisenhower sent a recorded message in which he said: "Freedom of the arts is a basic freedom, one of the pillars of liberty in our land. For our Republic to stay free, those among us with the rare gift of artistry must be able freely to use their talent. Likewise, our people must have unimpaired opportunity to see, to understand, to profit from our artists' work. . . . As long as artists are at liberty to feel with high personal intensity, as long as our artists are free to create with sincerity and conviction, there will be healthy controversy and progress in art. Only thus can there be opportunity for a genius to conceive and to produce a masterpiece for all mankind."[19] Six years later, Eisenhower's 1960 Commission on National Goals, setting the stage for statements by Kennedy and Johnson, declared, "In the eyes of posterity, the success of the United States as a civilized society will be largely judged by the creative activities of its citizens in art, architecture, literature, music, and the sciences."[20]

In addition, thoughout the fifties, the government saw the propaganda value of circulating throughout the world the kind of brash and inventive American art that was drawing the attention of Europe. "At

decade's end," curator Lisa Phillips wrote, "the same art once lambasted by conservative forces as anti-American was being held up as a symbol of capitalist liberty, freedom, and the American way of life."[21]

But Eisenhower's words were not backed up by government actions in support of artists, free expression, and creative risk, so his statements were little more than rhetoric. In addition, the primary creative activity supported by the government during the fifties and sixties was writing; the government had limited use for the visual arts and almost no use for artists, who, as opposed to writers and other members of what was then seen as the intellectual elite, were almost never included in the international conferences intended to celebrate American cultural achievement.[22] Furthermore, the shift toward greater appreciation for the arts within the country remained far less pronounced than the campaign against difference and free expression that had preceded it and that in many circles continued. So despite the changing climate, visual artists continued to be seen by many Americans as emblems of otherness. Even as an increasing number of politicians were beginning to believe that the arts could serve the larger interests of the country, artists continued to be widely seen as aliens. Thirty years before Patrick J. Buchanan, the right wing commentator and politician, denounced the NEA for funding art that was unclean and un-American and declared a culture war intended to "help depollute and detoxify the culture so that Middle America can again drink freely from it, and be nurtured and enriched, not nauseated or poisoned," artists—in particular, visual artists—remained embodiments of what guardians of mainstream America feared and hated.[23]

Far more even than now, the visual artist was then widely perceived as irrational, undisciplined, and parasitic, as someone who was getting away with something, immersed in a selfish, rebellious, even sinful, activity that normal, hardworking Americans would indulge in only as a hobby or recreation. This anti-American image of the artist was so pervasive that Gifford Phillips could not begin his 1965 keynote in support of the arts and artists without referring to it. "A favorite subject for public debate has now emerged in the United States—the proper place of

the arts in a democratic society. It is argued so frequently and so vehe-
mently that one wonders what shirt-sleeve democrats of the frontier era
would have thought of the concern being given to matters they always
regarded as frivolous, if not un-American."[24] Look at the crack made at
that conference by theater and film producer-director John Houseman:
"One would prefer not to have them starve, but the nature of their art is
in large measure a protest against the artistic Establishment of their time
and it is always hard and invidious to subsidize revolutionaries or sub-
versives or radicals. If their passion is sufficient they will continue to
create, living the while through the support of their wives or mis-
tresses."[25]

Remembering the distrust of artists in the early sixties, Livingston
Biddle—the third chairman of the Endowment (1977–1981), the
deputy chairman under Roger Stevens, and a framer of the original
legislation—said that when the NEA began, "the arts were considered
possibly dangerous ground for the Congress to get into. It was close
enough to the McCarthy period so that artists were equated on occasion
with Communism. So to give grants to individual artists was considered
by some a hazard. . . . There was always this suspicion that an artist
could get the protagonists for this program in some sort of
trouble. . . . The individual artist was the focal point of some criti-
cism about how this program would evolve."[26]

The sculptor George Segal could hardly believe the NEA's interest in
artists and support of artistic freedom. "The McCarthy era was ten
years or so earlier," he said. "I had been schoolteaching. If you believed
in being a liberal democrat, the Republicans began to accuse you of be-
ing a Communist. . . . In the face of this political history, it was
shockingly unexpected for the National Endowment even to attempt to
practice this freedom."[27]

The repressiveness of the McCarthy years, combined with an aware-
ness of the repressiveness of state sponsorship of art in the Soviet
Union, made Segal say no when he was asked in 1966 to serve on one of
the first NEA panels to award direct, unrestricted grants to individual
artists. "I didn't want a Soviet-type system" that would lead to undue

pressure on artists, he told the art historian John Pultz in 1985.[28] After Stevens took the trouble to speak with him personally, Segal changed his mind. "Here Roger Stevens had come along and proposed helping artists with no strings attached, no dictates as to how the money should be spent, and that was remarkable and contradictory to government practice," he said.[29]

Gary Kuehn, a painter who was awarded one of the grants recommended by Segal's panel, remembers how stunned he and his father were by government's recognition of artists. His father, a machinist, "was very political," Kuehn said. "We had direct experience of surveillance and pressure in the McCarthy time. . . . I have horror stories of surveillance and FBI harassment from my childhood." The grant "confused him and me . . . Overall—he died fifteen years ago—I think he was proud."[30]

Many artists who were awarded fellowships by the Endowment have vivid memories of the contempt for artists in the fifties and sixties. For the sculptor Joel Shapiro, who received a visual artists' fellowship in 1975, whatever America feared, "artists personified."[31] The painter Ellen Phelan, who received a visual artists' fellowship in 1978 and who is currently the director of Harvard University's Carpenter Center of the Visual Arts, has not forgotten her mother's curt reaction when, as an adolescent in Detroit, Ellen expressed her desire to be an artist. "She was a nurse, and became a public health administrator," Phelan said. "A lot of her criticism of me being an artist was that I wanted to play, and work was service to others."[32]

The Philadelphia-born sculptor Judith Shea, who received visual artists' fellowships in 1984 and 1986, said that "in the family I grew up in, art was seen as somehow in the realm of the female, like making drapes—nice, but not important." Receiving the fellowships meant "being able to say to my father, I got this money from the federal government. That's how good I am. That's how real this is. That's how much it means."[33]

For the video and performance artist Carolee Schneemann, who received visual artists' fellowships in 1974, 1977, and 1983 and grew up in

a farm community near Lancaster, Pennsylvania, wanting to be an artist elicited a similar response: "I was wasting my time," she said. "When will you get a job? For them, it was a path to dereliction, playing at life."[34]

This suspicion of visual artists had been a feature of American culture since World War II. Henry Hopkins, former director of the Los Angeles County Museum of Art and the San Francisco Museum of Modern Art, currently professor in the department of art at UCLA, and three-time visual artists' fellowship peer panelist (1969, 1974, 1989), remembers how a career in the arts was thought of in the forties in Idaho, where he grew up. "If you had some talent, or you were interested in the arts" in other ways, he said, "you were thought of in your own family as being a little loony."

Hopkins attended college just after the war, when the GI Bill provided money for thousands of soldiers to go to school. "I remember during those days a lot of people being upset that the GI Bill was allowing people to go to art schools," Hopkins said. "They thought it was wasting money. People thought those yo-yos should be engineers or should be something else. Why would you pay for somebody to go to art school?" For Hopkins, this resistance reflected "the impracticality and the fear on the part of parents that somebody wouldn't make a living, because America was very strongly into the work ethic, much more so than now."

Hopkins traces this resistance to artists "back to the Puritan fathers and the fact that they left decadent Europe to find this wonderful country that was going to be busy building buildings and machines and not concerned about these things that corrupted you and made you think strange thoughts. I think that was the general premise of the westward movement, that it was all physical labor, it was all hard work, it was all toil, toil, toil, and what a different thing to be sitting in your studio painting."[35]

In the course of living on the West and East coasts, as well as in the South, Peter Plagens, the art critic for *Newsweek* since 1989, who received visual artists' fellowships as a painter in 1977 and 1985 and who

sat on a fellowship panel in 1984, has encountered many of the attitudes that have led Americans to demean artists as peculiar creatures who can never, even if they become millionaires, be considered fully American. "We suspect artists of basically being goldbricks in terms of the work of the world," he said. "We also regard making art as a pleasurable thing that most people don't deserve to do until they're finished doing the work of the world. When you're finished being Eisenhower or Churchill, then you can paint, like they did. It's something somebody does when they quit working." Like Shea and Hopkins, Plagens pointed out that for a long time art was identified with women's work and, as a result, stigmatized. "I still think we think of it as a sissy thing," he added. "It's a feminine thing. It's finishing school for wealthy women that includes poetry, religion, music and learning to play the lyre or mandolin, or something like that, and the fine arts."[36]

Given the history of resistance to visual artists in the United States, the decision of the United States government to welcome them into the main body of American society is astonishing. So was its attempt to support them in a way that welcomed them into that body even while making it possible for them to examine it from a distance. What explains this commitment? What was the machinery that enabled the government to carry it out? What changed in 1989, when the political and media heirs to Dondero and Hearst proudly emerged, and visual artists were once again targeted as enemies of the real America? And in 1995, when Congress brought to an end all fellowship programs, except the one to writers? How and why is the situation of the artist different than it was in 1965, and how and why is it the same?

Notes

1. See Frances Stonor Saunders, *The Cultural Cold War: The CIA and the World of Arts and Letters* (New York: New Press, 1999).

2. These remarks were made at a Rose Garden ceremony on September 29, 1965, at which the National Foundation on the Arts and the Humanities was signed as Public Law 89-209. See Fannie Tyler and Anthony L. Barresi, *The Arts at a*

New Frontier: The National Endowment for the Arts (New York: Plenum Press, 1984), 49.

3. See *The Arts in a Democratic Society*, An Occasional Paper *Published by the Center for the Study of Democratic Institutions* (Santa Barbara: the Fund for the Republic, 1966), 1.

4. Ibid., 3.

5. Ibid., 2, 3.

6. Ibid., 8.

7. Ibid., 8.

8. Ibid., 8.

9. Ibid., 8.

10. Ibid., 8.

11. Ibid., 6.

12. Ibid., 8.

13. See William Hauptman, "The Suppression of Art in the McCarthy Decade," *Artforum* (October 1973), 48–52.

14. Hauptman, op. cit., 48.

15. Ibid., 49.

16. See Maurice Berger, "Artistic Censorship in Cold War America," in *The American Century: Art & Culture 1950–2000*, ed. Lisa Phillips (New York: Whitney Museum of American Art, with W. W. Norton & Company, 1999), 36.

17. Stonor Saunders, op. cit., 194.

18. Ibid., chapter 16.

19. The full text of Eisenhower's three-paragraph message, on October 19, 1954, is available in a press release in the Museum of Modern Art's archives.

20. This statement from Eisenhower's Commission on National Goals was cited several times in the September 15, 1965, *Congressional Record*; for example, on page 23944.

21. See Phillips, "The American Century: Art & Culture 1950–2000," op. cit., p. 37.

22. It is clear from Stonor Saunders's book that the cultural war was to be fought primarily with writers, and that the CIA leaders who conceived and supported it believed in the paramount importance of the written word.

23. See Patrick J. Buchanan, "The Cultural War Goes On," *New York Post*, 19 May, 1993, 21.

24. "The Arts in a Democratic Society," op. cit., 2.

25. Ibid., 16.

26. Interview with Livingston Biddle, 4 September 1998.

27. Interview with George Segal, 13 October 1998.

28. See John Pultz, "An 'Electric' Alliance? The Visual Arts Program of the National Endowment for the Arts, 1966–1973," an unpublished 1985 paper written when Pultz was a graduate student at New York University's Institute of Fine Arts. The paper is in the Henry Geldzahler archives in Manhattan, box 1, document 31.

29. Interview with George Segal, op. cit.

30. Interview with Gary Kuehn, 4 November 1998.

31. Interview with Joel Shapiro, 21 December 1998.

32. Interview with Ellen Phelan, 22 December 1998.

33. Interview with Judith Shea, 26 July 1998.

34. Interview with Carolee Schneemann, 6 August 1999.

35. Interview with Henry Hopkins, 21 November 1999.

36. Interview with Peter Plagens, 21 September 1998.

II

IDEOLOGY AND IDEALISM

The president who asserted the national importance of artists and free expression and also welcomed into the privileged spaces of America artists of all kinds, including those whose work revealed the creative potential of free expression, was John F. Kennedy. One hundred sixty-eight artists, scientists, scholars, and writers were invited to his 1960 inauguration at which the poet Robert Frost prophesied "a golden age of poetry and power, of which this noonday's the beginning hour." Many were thrilled to have been invited. The Abstract Expressionist painters Mark Rothko and Franz Kline were among those who attended.[1]

The enthusiastic response of artists and the promise of a mutually respectful relationship between artists and government received a good deal of coverage in the American and European press. So did Kennedy state dinners to which visual artists, writers, actors, and musicians were invited, most famously the one in the fall of 1961 in which the great and aging cellist Pablo Casals gave a concert at the White House. The Kennedy administration received clear and repeated evidence of the political benefits, at home and abroad, of honoring artists. Clearly the government could profit from openly identifying itself with artists. Clearly many artists wanted to feel their creative contributions mattered to their country.

A few days after Casal's concert, Arthur Schlesinger, Jr., special as-
sistant to the president, sent Kennedy a memorandum called "Moving
Ahead on the Cultural Front." In it, he wrote: "The Casals evening has
had an extraordinary effect in the artistic world. On the next day, when
the advisory council for the National Cultural Center met, a number
people [sic] said to me in the most heartfelt way how much the adminis-
tration's evident desire to recognize artistic and intellectual distinction
meant to the whole intellectual community." Schlesinger, who was
comfortable around artists and other intellectuals and who had been a
devoted participant in America's cultural Cold War efforts, added: "All
this is of obvious importance, not only in attaching a potent opinion
making group to the Administration, but in transforming the world's
impression of the United States as a nation of money-grubbing materi-
alists." Schlesinger proposed hiring a consultant to help the White
House define the "government's cultural responsibilities."[2]

 In his May 1963 report, that consultant, August Heckscher, remarked
that "recent years have witnessed in the United States a rapidly devel-
oping interest in the arts" and noted that "the artist, the writer, and the
performer hold new positions of respect in our society." He wrote that
"there has been a growing awareness that the United States will be
judged—and its place in history ultimately assessed—not alone by its
military and economic power, but by the quality of its civilization." He
called for the establishment of "administrative means for dealing with
issues of the arts" and proposed a series of steps that would formalize "a
constant concern with the enhancing and development of the arts
through normal activities of the Federal Government. They [the steps]
look forward to a more direct involvement of government through a
new institutional body with operating funds. They do not envisage any
effort to direct or influence the work of artists; their purpose is to keep
the arts free, not to organize or regiment them."[3]

 A few days after receiving the report, Kennedy wrote Heckscher: "I
have long believed, as you know, that the quality of America's cultural
life is an element of immense importance in the scales by which our
worth will ultimately be weighed." Kennedy suggested the catalytic

value and also the limits of government patronage: "Government can never take over the role of patronage and support filled by private individuals and groups in our society. But Government surely has a significant part to play in helping establish the conditions under which art can flourish—in encouraging the arts as it encourages science and learning."[4]

In an address at the dedication of the Robert Frost Library at Amherst College on October 26, 1963, a month before his assassination, Kennedy made his fullest statement on art and culture. Even as the work of a speechwriter, it is a shrewd, influential, and, given the animosity toward artists in this country, even a moving document marked by that vexing Kennedy blend of elevated oratory and cold-blooded realism. Because this address clarifies the framework for almost all congressional debates about the NEA, the arts, and the artist, and contextualizes the NEA within the history of the Cold War, as well as coordinating many of the buzzwords that had been punctuating government statements about culture since the end of World War II, it deserves close attention.[5]

The speech presented the artist as an American hero. It identified him (Kennedy's generic artist is always a "he") with "self-comprehension," resistance to "self-deception and easy consolation," and "diversity and freedom." In a land of rampant conformity, the artist was independent and incorruptible. "As Mr. [Archibald] MacLeish once remarked of poets," Kennedy said admiringly, " 'There is nothing worse for our trade than to be in style.' " By being "faithful to his personal vision of reality," the artist was the "last champion of the individual mind and sensibility against an intrusive society and an officious state." Artists were fearless truth-tellers. "The men who create power make an indispensable contribution to the nation's greatness. But the men who question power make a contribution just as indispensable, especially when that questioning is disinterested." Artists were spiritual guides. "The spirit which informs and controls our strength matters just as much" as "our national strength." For America to maintain its values and win the hearts and minds of men and women around the world during a Cold

War that, because of the incalculable destructiveness of nuclear weapons, had to be won culturally, artists were now essential.[6] Without the artist, Kennedy said, it would be difficult for the United States to meet the challenge of being the "leader of the free world."

In order to be able to fulfill their creative missions and make art that served the core needs of the nation, artists had to be able to make what they needed to make. "If art is to nourish the roots of our culture, society must set the artist free to follow his vision wherever it takes him." If artists attacked the state, if they bit the hand that fed them, so be it. If they were not truly independent, and if the government did not demonstrate it was confident enough to allow them to criticize, even attack, American institutions, artists could not help ground the country during this win-at-all-cost moment that required the government to adopt an ends-justify-the-means mentality in order to survive, and they could not be effective ideological weapons. In a divided, uncertain country and in a divided, dangerous world, the speech suggested that America now needed artists, badly. Kennedy made a point of declaring that artists were Americans. Robert Frost "was supremely two things—an artist and an American." It was time for America to allow them to feel they belong here. "I see little of more importance to the future of our country and our civilization than full recognition of the place of the artist," Kennedy said.

The romantic image of the artist promoted by Kennedy's speech is very much one of a heroic outsider who maintained his moral and spiritual footing in an unruly and treacherous time. Because the artist was an independent and incorruptible outsider, he could not be led astray by the seductions of money, technology, and mass culture, and by the expediency required to win the Cold War against an implacable and immoral foe. Outsiderness was a strength. "The great artist" was "a solitary figure," Kennedy said. "In pursuing his perceptions of reality he must often sail against the currents of his time." Because of his outsiderness, the artist could also be an insider, in touch with the truth of his time and the soul of his country, as well as with a timeless human essence. By being allowed to thrive in his outsiderness, the artist could

remind or reveal to the nation the best of itself. "In serving his vision of the truth the artist best serves the nation," Kennedy said.

In this ideologically saturated moment, Kennedy's artist was uninfected by ideology. "Art is not a form of propaganda, it is a form of truth," Kennedy said. "In free society art is not a weapon and it does not belong to the sphere of polemics and ideology. Artists are not engineers of the soul.

"It may be different elsewhere. But democratic society—in it—the highest duty of the writer, the composer, the artist, is to remain true to himself and let the chips fall where they may."

One of the key assumptions here is that America, however much it might be momentarily compromised by Cold War methods it was forced to adopt by the policies of the Soviet Union, is a country whose destiny is to exist in a state outside or beyond ideology. Another is that what guarantees Americans' access to this state is art. In Kennedy's speech, art allows Americans to remember and reenter that Edenic state that is their natural condition. Nothing may be more central to American ideology, and to the United States' belief in its own righteousness and privilege, than this conviction that it is, at its core, a nonideological nation. Supporting artists in their outsiderness and encouraging them to sail against the currents of their time could enable the country to benefit from the gift of truth artists provided, while the Soviet Union, which made artists tools of the state, remained mired in ideological muck.

Kennedy's speech, and the subsequent government willingness to create a national arts organization that would respect the independence and outsiderness of artists and support a broad range of American artistic creativity, must be seen not just in the context of the Cold War but of a particular cultural cold war moment. In the fifteen years prior to Kennedy's speech, the CIA, largely surreptitiously but with the actual or tacit approval of many of the principals involved, had sponsored influential cultural publications, like *Encounter* and *Preuves*, as well as cultural conferences and festivals, in which some of the most important American and European writers, musicians, and other intellectuals wrote or performed. These highly visible publications and events were

intended by the CIA to flaunt the freedom in the West, but the freedom permitted by the CIA was limited. Writers in these publications were not free to examine "the free world." The freedom the CIA was flaunting was, Frances Stoner Saunders suggested, "a kind of ur-freedom, where people think they are acting freely, when in fact they are bound to forces over which they have no control."[7]

When Kennedy gave his 1963 Amherst speech, the CIA involvement in the cultural cold war was about to be exposed. The propaganda intent of these seemingly independent arts magazines and conferences was beginning to be known. The ways in which the American government had used writers, and writers had allowed themselves to be used, was becoming clear. If the government was going to remain involved with the arts and use them effectively in its Cold War struggle, it was imperative that any subsequent government cultural endeavor not be controlled. If the government and the country was really going to be able to profit from artistic independence and creativity, they needed a federal agency that actually did support "self-comprehension," resistance to "self-deception and easy consolation," and "diversity and freedom."

Free expression was a cornerstone of the NEA. In the early debates about the agency, a number of congressmen saw the agency as proof that free expression was a fundamental American principle. In 1968, Representative Robert O. Tiernan of Rhode Island, arguing for reauthorizing the agency, said: "In the name of sensible economy, let us preserve, not only for ourselves, but for all generations to come, that which is worthiest—the free, creative expression of a free people."[8]

Just as important to the formation of the NEA was the assumption that art had the potential to transcend ideology, and the confusion and unhappiness that were seen as inseparable from it. Arguing in the House on behalf of the Arts and Humanities Endowments in September 1965, shortly before the National Foundation on the Arts and the Humanities Act became law, Representative Claude Pepper of Florida said that the Endowments promised "relief for our whole society, relief to meet the fundamental needs of our people." The act bringing the Endowments into existence was "designed to *purify*, to beautify, and to strengthen the

soul of America; to stimulate the intellectual, the cultural, and the spiritual interests of our people and to make this a nobler, a more beautiful and happier nation. What America stands for in the world today is a nation which has spiritual significance and high and noble spiritual purpose as its national objective. I am therefore glad to support this monumental bill" [my emphasis].[9]

This elevated, even holy, view of art shaped the response to the Endowment by supporters and detractors alike. Throughout its history, conservative critics have assumed that if art is overtly political—i.e., ideological—it cannot be good; it probably cannot even be art. In 1968, the one concession made by the Senate when it rejected a House amendment to eliminate grants to individual artists was to add four words to the law: "The Chairperson, with the advice of the National Council on the Arts, is authorized to establish and carry out a program of contracts with, or grants-in-aid or loans to, groups, or, in appropriate cases, *individuals of exceptional talent* engaged in or concerned with the arts." "For some reason," Livingston Biddle said, "members of Congress were thinking that if an artist were really excellent, he wouldn't express any untoward viewpoint."[10] An excellent artist, an artist of quality, a true artist, cannot, by definition, make art that takes an ideological position. The true artist, which America, as opposed to the Soviet Union, appreciated, is above the geopolitical struggle, which was endangering the world, and social divisions, which in the sixties were endangering the country.

The conflict between the belief in true art as inherently nonideological, beyond politics, and a commitment to free expression, which allows artists to be critical of institutional power, and therefore, in theory, to make art that takes strong political positions, was as unresolved in the sixties as it is now. It is built into the Kennedy speech, with its overriding belief that art was ennobling and transcendent and yet its recognition that if art was going to be a spokesman for American values, artists had to have the right to resist "an intrusive society and an officious state" and "let the chips fall where they may." Although the Cold War climate in America demanded tolerance for radical challenges to con-

vention, whatever form they took, the Kennedy oratory, and congressional arguments for the Endowment, were more comfortable with the belief that art was ennobling and transcendent. As the Cold War wound down, and President Ronald Reagan's America, chest-thumpingly proud of its God-fearing economic and military empire, assumed, correctly, that it no longer needed to prove its tolerance for free expression to win the hearts and minds of the rest of the world, the Kennedy and NEA balance between an ennobling view of art, which in the eighties came to be identified with museum art, and a commitment to artistic free expression, identified with contemporary art, became increasingly unstable. After the Cold War ended in 1989, the willingness of Congress to tolerate NEA support for free expression, and with it for contemporary art values, disappeared.

If the arts could reveal America's spiritual and moral substance and demonstrate the American commitment to free expression, they could help America become a civilization. In his 1963 address, Kennedy maintained that if the United States was to become a legitimate empire, it had to be recognized as a civilization. "I look forward to an America which commands respect throughout the world not only for its strength but for its civilization as well," he said. "The Communists were barbarians," was a common American refrain during this period.[11] "Russia was considered by many in those days as a part of the uncivilized world," Biddle said.

In the early political debates about the Endowment, establishing the United States as a great civilization that could expose the barbarism of the Soviet Union and also compete with Europe, which still seemed to many Americans the pinnacle of artistic and cultural achievement, was widely seen as a national imperative.[12] In 1965, Representative Frank Thompson, Jr., of New Jersey, the chief sponsor of the National Foundation on the Arts and Humanities Act, said: "We are the last civilized nation on the earth to recognize that the arts and the humanities have a place in our national life."[13] Representative Fernand J. St. Germain of Rhode Island said: "The time is long past when we as a nation can assume our inherited role of world leadership without giving leadership

in every area of human endeavor; that is to say, in those matters of the intellect and of the spirit as well as those matters of the physical world about us."[14] Congressman Walter H. Moeller of Ohio said that "in the area of the arts and the humanities we are not distinguished for our excellence but for our neglect. We have lived too long as a nation to continue to tolerate a laissez-faire attitude toward such an essential element in our national life. Our neglect in the arts and humanities borders on the scandalous, and our indifference is an indictment of our sense of values."[15]

The anxiety evident in comments like these, as well as in words permeating the Kennedy speech such as *responsibility, understanding, compassion, moral restraint, wisdom*, and *purpose* and its warning about the amount of poverty in America's land of plenty, reflects the concern in the sixties about international challenges posed by the Soviet Union but also, just as important, about a crisis at home. The Soviet Union accused the United States of being a hollow country, intoxicated by money, and there was a widespread sense, even within the country, that it might be right. One of the great themes of early-twentieth-century American literature—F. Scott Fitzgerald's 1922 novel *The Great Gatsby* and Arthur Miller's 1949 play, *Death of a Salesman*, are two of the most celebrated examples—is the human and national cost of the American lust for material success, and the tendency of a great many citizens of a country that promoted itself as a beacon of democracy to judge others not by the content of their character but by their position and possessions, and by their class and race. Throughout the sixties, James Baldwin used prophetic and occasionally apocalyptic language in his scathing exposés of racism. In 1968, *Slouching Towards Bethlehem*, Joan Didion's generation-defining collection of essays, revealed pervasive "evidence of atomization, the proof that things fall apart" and called attention to an immense absence, or void, at America's center.[16]

Supporters of the Endowment saw art as a force of moral guidance and leadership that could inspire "progress in human relations"[17] and lead to the "cultivation of the best spirit in our country."[18] "The arts

and the humanities are as essential to a nation as a conscience is to an individual," Representative William D. Ford of Michigan said.[19]

Even some House members who had reservations about the Endowment believed that the agency was a response to a society that was easily led astray by money and might. "What is to happen to the arts, the humanities, and culture in this materialistic society we are building?" Representative John M. Ashbrook of Ohio asked. "In this day when everywhere around us we see alarming signs of the vast buildup of the military-industrial complex, it is imperative that our Nation keep alive the esthetic values which alone separate civilized society from primitive life."[20]

At a time when institutions were not providing convincing answers to the nation's problems, the same resistance and outsiderness that continued to make many Americans see artists as outcasts could now also make them seem like visionaries and prophets—even saviors—who by following the beat of their own drummer and through their attentiveness to their materials, traditions, and aspirations could produce a poetic reality that told the truth of the human heart and gave form to insights that society as a whole either had not grasped or was not yet willing to face. Like Robert Frost, writing his inexhaustible, yet earthy, poems in the solitude of the New Hampshire woods, the solitary, independent, incorruptible artist could provide access to levels of understanding that would help the country define a bedrock identity that would not be deflected by Cold War practices or tainted by the seductions of technology and wealth.

It is easy to see where this image of the artist came from. Some of the nineteenth- and twentieth-century modernist masters had been dirt-poor, and their art was born of necessity and struggle and the need to cut through the deceptions and codes that had been defining social and political conventions and creating the conditions for World War I, the Holocaust, colonialism, and other horrors of modernity. Most of the giants of the modernist avant-garde, like Édouard Manet, Paul Cézanne, and Pablo Picasso, had made art that questioned and invented while communicating feelings and experiences that exposed the con-

flicts and challenges of the time and gave many people access to the intensity and fullness of their inner lives. Much of the early-twentieth-century avant-garde connected advanced artistic thinking with social progress. Russian Constructivism and the Bauhaus were convinced that reimagining the language of art, expanding the experiences of time and space, and integrating art in everyday thinking and behavior could contribute to a more integrated personality and a more just world.

In the 1950s, Abstract Expressionists like Jackson Pollock let the United States and Europe know that even as abstract art was still being trashed as un-American by politicians and the press, the modern artistic tradition was at home here. In fact, that tradition, which had seemed to belong to Europe, now needed the United States in order to keep going. The Abstract Expressionists, who had assimilated many of the lessons of Manet, Cézanne, and Picasso, showed the world the kind of impact American art could have when it was stoked by the American principle of free expression, the American obsession with the new, and the American faith that it was possible for individuals to create themselves from scratch. For the Abstract Expressionists, no rule was inviolable. Any material could be used. A painting could be the evidence of an existential drama in which artist and viewer met existence in its raw state and were transformed by the encounter. At the Museum of Modern Art's twenty-fifth-anniversary ceremony in 1954, Heckscher, then the chief editorial writer at the *New York Herald Tribune*, captured something of the spirit of the time and in the process suggested the impact of Abstract Expressionism: "Our generation has seen the external world lose its absolute significance," he said, citing physics and psychology. "More than anyone, the artist has experienced a progressive meaninglessness in the universe." But, he added, the modern artist "had the dignity to affirm that what is, is; he has possessed what Paul Tillich calls 'the courage to be.' To chaos he has given a form and a shape, so that it is not quite chaos anymore; and his art, that began as a Revelation ends as a prophecy."[21]

Just as important, the artists whose encounters with this existential predicament released an expansive, lyrical beauty were being mytholo-

gized as the kind of real men the American pioneers would have been proud of. The Abstract Expressionists wore jeans, drank whisky and gave a masculine, frontier legitimacy to their often-exhilirating aesthetic arguments by regularly performing them in bars. As in the fiction of Mark Twain and Ernest Hemingway, their refined subtlety and sophistication were not immediately apparent in their work, which seemed driven to proclaim its first allegiance to energy, assertiveness, and bigness. The Abstract Expressionists' aims and languages connected American principles and rituals to other cultures—to European mural traditions, to indigenous American sand paintings, and to the signs and symbols in prehistoric caves. Not only were these artists not rich, but recognition came late to most of them and this lateness did not deflect them from their chosen paths. Their success seemed to depend on inner-directedness, perseverance, will, and talent, not on careerism or the promise of material success.

The American government was aware of Abstract Expressionism. Already in the early fifties the CIA had understood its propaganda value, and, with the help of the Museum of Modern Art, whose long-time president, Nelson Rockefeller, had referred to Abstract Expressionism as "free enterprise painting,"[22] worked to initiate or arrange for exhibitions of this brash and gutsy American art to travel around Europe. Because of the Abstract Expressionists, the American avant-garde, particularly abstract artists, had become useful to the state. "The view that abstract art was synonymous with democracy," Stonor Saunders wrote, "that it was 'on our side,' was also stressed by Alfred Barr [the founding director of the Museum of Modern Art], who borrowed from Cold War rhetoric when he maintained that 'The modern artists' nonconformity and love of freedom cannot be tolerated within a monolithic tyranny and modern art is useless for the dictator's propaganda.'"[23] Abstract Expressionism, which had a confidence, intelligence, and courage many artists abroad did need and which many younger artists throughout the world continue to admire, really could show the world what America in these Cold War years could do. By the time Kennedy was elected in 1960, many people in government who

had little or no interest in art but who knew America and the world were in crisis had been convinced by the rhetoric of heroic individualism and uninhibited creativity surrounding Abstract Expressionism. They were ready to believe radical American creativity could help the country find its center and were convinced it could be an invaluable Cold War tool.

Politicians had good reason to think of artists as uncontaminated by wordly success. When the NEA was founded, being an artist was still widely considered a calling. Few painters and sculptors believed they could make a living through their work. The reason George Segal describes the moment when he served on the first peer panel as "the golden years" is that "it was impossible to make a mistake since there was such a long list of first-rate artists who were not earning a living. . . . In those years, there was no history of anybody making a living at art."[24]

The abstract painter Pat Adams, who received three visual artists' fellowships (1969, 1976, and 1987), echoed Segal's words. "When I came to New York in 1950," she said, "nobody made any money. I have never believed in anything to do with the market. I have never counted on it. I have been independent of it."[25]

Another painter of their generation, Alfred Leslie, one of the first grant recipients in 1967, who began as an Abstract Expressionist before embarking on monumental figurative paintings, said artists then didn't "expect to make a living." That was "never factored into it . . . Making art was not a career."[26]

Until the 1980s, few artists believed they would make money through their work. Asked if she thought she would ever earn a living making art, Barbara Kruger, a mixed-media and video artist who received a visual artists fellowship in 1983, said: "Absolutely not! Of course not! . . . The 70's were very depressed, economically depressed. . . . Nobody was making work directed toward the market sector because even in the late 70's and early 80's, nobody thought they were going to sell their work."[27]

Dorothea Rockburne, a painter who received a visual artists' fellowship in 1974 and whose early work, at once rigorously systematic and

unpredictable in its investigation of activities like soaking, pressing, and rolling and of materials like paper, crude oil, and nails, was an example of the vigorous, free-wheeling artistic experimentation of the late sixties and early seventies, agrees that for artists economic expectations were different then. "Inherent in my attitude was that not earning a living came with the territory, and I would figure it out," she said. "The main attitude was, you had to do it."[28]

Artists made work and found ways to get by. Many taught; many important artists still teach. Some worked as craftsmen, for example, as carpenters; many artists work as craftsmen now. Some married someone with a regular job or money. Others were fortunate enough to have ambitious projects financed by enlightened patrons like Virgina Dwan, whose support made possible some of the Minimalist artworks and Earthworks that help define the art of the late 1960s and 70s. Rockburne emphasized that in the 1970s, few artists were interested in luxurious lifestyles, and some of the most admired, like the sculptors Ronald Bladen and Tony Smith, both of whom received visual artists' fellowships in 1967, died without gaining the money that would have enabled them to see their ambitions realized.

One of the overriding concerns in the Kennedy speech is a national disequilibrium. Although Kennedy did not specifically refer to the national preoccupation with science and technology, many political leaders were alarmed by it. The need to balance this preoccupation was another essential factor in the NEA's formation and development. The United States had dropped the first atomic bomb, and it was living with an awareness of the destructive potential of science even as the country was roaring forward, foot to the pedal, in an arms race with the Soviet Union that poured billions of dollars into scientific research while intensifying the threat of human extinction. On the other scientific and technological front, the United States was involved in a space race with the Soviet Union that seemed to have no chance of being slowed down either, even though it was devouring money at a time when the scope of the poverty in this richest of countries had become a national scandal.

In 1965, Representative Ken W. Dyal of California supported the

arts and humanities act because it would "act as a catalyst to start cul-
tural and artistic development in our Nation to equal the tremendous
growth of the new aerospace technology."[29] In 1968, a year for which
Congress appropriated $16 billion for the sciences and $7.8 million for
the arts endowment, Representative Frank J. Horton of New York was
one of many congressmen to express concern about the preoccupation
with science and technology: "Just a few months after the launching of
the first Sputnik ten years ago," he said, "the people of this country be-
came alarmed that we might be behind the Soviets in the fields of sci-
ence and engineering. The result was that we greatly expanded the role
of the Federal Government in the sponsorship of research and graduate
study in the physical sciences. . . . By the middle of this decade these
programs had grown so large and so visible on the campuses of partici-
pating universities that many felt the deemphasis on the arts and hu-
manities and the overemphasis on the physical sciences would result in a
serious imbalance in our society."[30]

That the NEA was brought into existence in part to respond to an
overemphasis on science and technology, as well as on money, is clear
in the Declaration of Findings and Purposes that begins the National
Foundation on the Arts and the Humanities Act of 1965. One of them
states: "The world leadership which has come to the United States can-
not rest solely upon superior power, wealth, and technology, but must
be solidly founded upon worldwide respect and admiration for the Na-
tion's high qualities as a leader in the realm of ideas and of the spirit."

Another declaration asserts: "An advanced civilization must not limit
its efforts to science and technology alone but must give full value and
support to the other great branches of scholarly and cultural activity in
order to achieve a better understanding of the past, a better analysis of
the present, and a better view of the future."

Giving artists the respect and the opportunities that were taken for
granted by scientists was a priority of the NEA. At the 1965 meeting at
the Center for the Study of Democratic Institutions in Santa Barbara,
Roger Stevens, the first chairman of the NEA, said that convincing the
country that the creative experimentation of the artist was as necessary

as that of the scientist was an Endowment goal. "People think science is exact but it isn't. It is failure after failure. And so with the arts. The arts should be approached more tolerantly by the public and the critics. The artist should be allowed to fail, and he won't do any great work unless he stops being afraid to fail. In this country there is too much of a premium on success."[31]

At the 1973 appropriations hearings, Nancy Hanks, the best known and most beloved NEA chairman (1969–1977), noted that one reason for the NEA's support for individual artists was that "fellowships are not available" for them "except for one or two foundations. In other words, you cannot get fellowships if you are an artist as you could if you were a professor or in the sciences or most other fields."[32]

As the agency worked to put artists on an equal footing with scientists, words identified with the scientific method, such as *research* and *investigation*, were incorporated into its vocabulary. "Without continuous creative individual expression," the agency stated in 1968, "a society does not grow culturally and, though the vast majority of the people may not appreciate or understand the work of the most perceptive writers, composers, and visual artists, it is their work which inspires and influences other artists and our daily lives. In this regard, support for the individual artists is much like support for basic research in the sciences."[33] A decade later, James Melchert, the third visual arts program director, wrote: "What a great many artists do is investigate. For that matter, art can be thought of as esthetic investigation. Where would science be without research? The same question can be said about art."[34]

Another key Endowment word, one that had been part of the languages of both science and art since the beginning of the century, is *progress*. Kennedy identified artistic creativity with progress in his 1963 speech when he said that the dedication of the Robert Frost Library was important to "the progress of the United States." The value of artistic progress was written into the first Declaration of Findings and Purposes in the National Foundation on the Arts and the Humanities Act: "The encouragement and support of national progress and scholarship in the humanities and in the arts, while primarily a matter for private

and local initiative, are also appropriate matters of concern to the Federal Government."

The word *progress* was frequently used in the early congressional debates about the Endowment but hardly ever defined. The ways in which the word was used connected artistic progress to political progressiveness and suggested that the arts, like the sciences, were important to the ethos of a progressive nation. After Representative Seymour Halpern of New York used the word *progress*, he expressed his "earnest hope that the Council will encourage experimentation and innovation in the arts, and not reserve its help for those projects which are common and innocuous." Progress in the arts, which was assured by a commitment to experimentation and innovation, would, Halpern said, "help solve the problems which confront our country" and contribute to the "enrichment of our country."[35]

Representative Silvio O. Conte of Massachusetts believed that "progress in the Arts and Humanities" had to be supported because they alone, "in spite of our tremendous strides in the physical sciences, provide the record of our journey as a society and Nation through history." Conte went on to say that the Cold War was a "war of ideas" in which a vital culture would help the country "win men's minds." He made the crucial point that the commitment to progress in the arts and humanities would ensure the kind of openness and readiness necessary to be successful "in the unpredictable and completely unscientific area of human affairs."[36] In this Cold War climate, the creative process of the artist was seen by political supporters of the Endowment as a developer of readiness, inquiry, and vision equal to, although different from, the creative process of the scientist, and as important to national survival.

Respect for progress and the creative process were defining principles of the visual artists' fellowship program, and of the NEA. Because the fellowships were unrestricted, they were forward-looking. They rewarded risk taking. They encouraged artists to accept whatever challenge their art presented to them and push themselves into areas they had glimpsed but not entered. Because they respected process as much as product, they rewarded an awareness of each detail, each part,

each decision. For an artist who values process in itself, everything is in play at all times. This means that each line, color, or edge of a canvas, each bump or joint of a sculpture, or each conversation with a community member or city official participating in a project is not just a means to an end but an end in itself. As a result, each challenge can be so compelling that it may oblige an artist to change a work, or even his or her art. Attention to the creative process fosters a readiness for the moment. The fellowships to artists were investments in openness and the unknown. They were investments in the potential of the individual and the nation to welcome and respond to unforeseen challenges, and to welcome and respond confidently to a future no one could define or predict but for which the country had to be prepared.

While the Endowment saw as one of its responsibilities nourishing the entire field of the visual arts, its first responsibility was to encourage experimentation and innovation. Since 1965, many of the agency's critics have attacked it for not funding more artists, in particular realists, who were immediately accessible to the nonart public. In fact, the visual artists' fellowship program funded many prominent figurative painters and sculptors—including Peter Agostini, John Ahearn, Lennart Anderson, Jack Beal, Robert Birmelin, Richard Estes,[37] Jane Freilicher, Chuck Forsman, Luis Jimenez, Catherine Murphy, Alice Neel, Tom Otterness, Philip Pearlstein, Mel Ramos, and Helen Miranda Wilson. The Endowment remained attentive to artists working in almost every medium and style. But it could fund only the most adventurous figurative artists. An agency that believed that the art most necessary to the country was art that questioned, did not conform, and resisted "self-deception and easy consolation" had to be mainly concerned with encouraging artists and projects whose work was driven by the need to push, risk, test, and transform.

Although the NEA continued to include curators on its peer panels, it assumed, not surprisingly, given its belief in the independence and incorruptibility of artists and in their attentiveness to the insight and information embedded in the creative process, that artists were the people most capable of recognizing the pressures and understanding the imagi-

nations driving the art under consideration. "The preponderance of votes was in the hands of artists themselves," Richard Andrews, the visual arts program director from 1985 to 1987, said. This "reinforced the notion that" the fellowship program "was really meant to fund artists who were at a point where the grant could be catalytic, and that the artist would be in many ways the most generous. The artist would recognize the genuineness of an artist's endeavor, even if what the artist was creating was out of step, or out of fashion, or out of style, and that could be on the emerging level or on the mature artist level."[38]

During the twenty-eight years of the visual artists' fellowship program, the majority of panel members were attentive to the unfamiliar and the partially formed. "We wanted to fund projects that were fresh and original," said Suzanne Delehanty, the director of the Miami Art Museum and a visual arts fellowship panelist in 1993, as well as a member of many other NEA panels. "There was an openness to funding works that were not particularly fashionable."[39] One of the reasons Ursula von Rydingsvard, who received sculpture fellowships in 1979 and 1986, valued the 1984 sculpture panel on which she served was that it made "a very earnest effort to give to the work that had the greatest amount of potential. . . . We would especially be good to people who did some odd numbers in the backwoods, that seemed to talk about the kind of idiosyncratic energy that we wanted supported, that didn't feel quite there yet."[40]

"The charge to the panels, sometimes unspoken, sometimes spoken, was to choose the best work but be careful how you define best," said artist Newton Harrison, who sat in on numerous peer panels as chair of the visual arts policy panel in 1978. "Look for the greatest creativity. Don't be afraid to fund something that's crude, that feels very creative, against something that's very refined. So creativity is never defined but you're asked to look for it and to reward it. Playfulness, originality, gee-I-never-saw-anything-like-this-before, opening up something that hadn't been opened before, taking a risk where taboo was concerned— all those things were rewarded, and discussed in some measure because

most of the people on the peer panel were artists, peers. So they were honest with each other. I mean: oh, look, this guy really has balls. What do you think that is?"[41]

Because the majority of the panelists were responsive to the force of searching and need within the images projected on the screen before them, and therefore to the particularities of the artist's own creative process, the fellowships were often experienced by the recipients as recognition of the most meaningful kind. So many of the fellowships were awarded at moments of hunger for encouragement that they made artists feel that the program was especially attuned to where they were in their careers and lives. Because the government placed such value on experimentation and risk and brought in people who were likely to recognize and appreciate them, the government, through the NEA, made a personal connection with the lives of artists. They felt that the government cared about them.

The respect for risk and experimentation helps explain one of the greatest strengths of the visual artists' fellowship program—its timing. It not only gave fellowships to many of the most influential postwar American artists, but it gave them at a moment when it was particularly beneficial to their work. Look at the list of visual artists who received MacArthur Fellowships, the so-called "genius grants," of which one of the main criteria through the mid-nineties was need. There are nineteen: Janine Antoni, Ida Applebroog, Vija Celmins, Ann Hamilton, David Hammons, Gary Hill, Robert W. Irwin, Alfredo Jaar, Kerry James Marshall, Amalia Mesa-Bains, Elizabeth Murray, Pepon Osorio, Martin Puryear, John T. Scott, Cindy Sherman, James Turrell, Bill Viola, Kara Walker, and Fred Wilson. Only Antoni, Mesa-Bains, Murray, Scott, and Walker did not receive an NEA grant and Antoni and Walker came of age after the NEA stopped giving individual grants in 1995. Many received an NEA fellowship years before the MacArthur Foundation still defined them as needy, and it was essential to their development. Applebroog's MacArthur was in 1998; her first of three NEA fellowships was in 1980. Celmins's MacArthur was in 1996; her first of two NEA's in 1971. Hill's MacArthur was in 1998; his first of four NEA fellowships

in 1979. Jaar's MacArthur was in 2000, his first of two NEA fellowships in 1987. Osorio's MacArthur was in 1999; his NEA in 1988. Puryear's MacArthur was in 1989; his NEA in 1977. Sherman's MacArthur was in 1995; her first of two NEAs in 1977. Viola's MacArthur was in 1989; his first of four NEA's in 1976.

Testimony about the impact of the timing of the fellowships is plentiful and dramatic. For example: "I have only applied twice in my life, when I was desperate," said the sculptor Luis Jimenez, who received fellowships in 1977 and 1988. "I received my first grant at a time when I thought I would have to return to the east coast to survive. The fellowship enabled me to stay out west. I used this grant to [do] research for public work, and the next year I got my first public commission for 'Vaquero,' a cast of which is at the National Museum of American Artists [sic] in Washington, D.C."[42]

For the sculptor Petah Coyne, her fellowship was "like a gift from heaven. . . . Without the grant in 1990, I would have been in real hot water. It was not just the award itself that was important—although it was—but the money was desperately needed to be able to keep my studio, as humble as it is. . . . Since my grant year, my work has been purchased by over ten museums in the U.S., including the Modern Museum of Art and the Whitney."[43]

The Endowment was right to reward courage, inquiry, improvisation, and intuition. The language of creativity is the only viable first language for a federal agency concerned with the purpose and progress of American art. Because the Endowment's commitment to quality and excellence was shaped by attention to the particular process of making and thinking, it could continue to reward quality of perception, quality of understanding, quality of mind, quality of desire, quality of spirit, which together make artistic quality possible. Attention to the intensity of questioning, perception, and nerve in a body of work makes it possible to go beyond look and style, personal taste and market value and locate the necessity of the art—its reason for being. The concern with process leads to the fullest understanding of contemporary art. Since it can also lead to a greater understanding of artistic creativity in general,

whether the product is a statue, a sand drawing, or a masquerade, whether it was made in Greece, Tibet, or Nigeria, in prehistory or the nineteenth century, the concern with process can also make possible a fuller appreciation of the art of the near or distant past.

Seen within the context of the Cold War, it is possible to understand why the United States government, in 1965, turned to artists for the first time in American history. Kennedy was dead, his murder a dramatization of the disorder and disequilibrium his speech said art could help to illuminate and overcome; the war in Vietnam was escalating; outrage over racial and economic inequities at home was leading inexorably to riots in the streets; weapons were proliferating; the Cold War was putting the entire planet in danger. Despite its unimaginable resources, muscle, and expertise, the United States was a confused and conflicted country that was not sure what it really was, or how to find a moral and spiritual center. Since the end of World War II, the government had believed it could use the arts to help the country win the cultural cold war by demonstrating capitalism's creative energy and freedom. The NEA was created because the government, increasingly drawn to the romantic modernist image of the artist as truth-telling visionary outsider, decided artists could also serve the country by helping it to get beyond the deceptions, uncertainties, and injustices of the moment and experience a poetic lucidity and mission that could help inspire and deliver its people. The NEA was an ideological instrument. But it was also profoundly idealistic. It was only by being exemplary in its idealism that it could be an effective ideological instrument. It would not have been exemplary in its idealism if it had not been willing to support artists who were intent on developing forms and languages that questioned prevailing systems of power. Idealism and national self-interest were intertwined in it. Their seamless partnership at a time of crisis when this partnership was needed by the country gave the Endowment legitimacy, purpose, and vision. It enabled the agency to serve artists, the field, and the country, and to provide a model of what an artists' fellowship program in the second half of the twentieth century could be.

Notes

1. See Milton C. Cummings, Jr., "To Change a Nation's Cultural Policy: The Kennedy Administration and the Arts in the Unites States, 1961–1963," in *America's Commitment to Culture: Government and the Arts*, ed. Kevin V. Mulcahy and Margaret June Wyszomirski (Boulder, San Francisco, Oxford: Westview Press, 1995), 98. Almost all the information in the first three paragraphs of this chapter is taken from Cummings's essay.

2. Ibid., 104–5. Schlesinger is a recurrent character in Frances Stonor Saunders's *Cultural Cold War*. She cites Schlesinger's statement that the CIA's influence was not "always, or often, reactionary and sinister" (op. cit. 3) and gives a full picture of his involvement in CIA-supported cultural projects.

3. See August Heckscher, "The Arts and the National Government," report to the president (Washington: U. S. Government Printing Office, 28 May 1963), 1, 27.

4. John F. Kennedy, letter to August Heckscher, 10 June 1963.

5. The text of Kennedy's speech at Amherst is printed in its entirety in the *New York Times*, 27 October 1963, 87.

6. Stonor Saunders (op. cit., 17) cites an American intelligence officer who, in 1945, reported to General Donovan, the chief of the Office of Strategic Services: "The invention of the atomic bomb will cause a shift in the balance between 'peaceful' and 'warlike' methods of exerting internal pressure."

7. Ibid., 5.

8. See *Congressional Record*, 27 February 1968, 4316.

9. See *Congressional Record*, 15 September 1965, 23957.

10. Biddle, op. cit.

11. Stonor Saunders, op. cit., 280.

12. For Suzanne Delehanty, the director of the Miami Art Museum, the NEA allowed many people to consider the United States as culturally equal to Europe. She spoke about growing up in Massachusetts and "looking to Europe as the model for great moments in art . . . In Europe, the different nations had ministers of culture, and finally in the United States we were going to have something that was the equivalent of the ministry of culture." For her, this was one reason why the NEA helped to "legitimize art." Interview with Suzanne Delehanty, 23 October 1999.

13. See *Congressional Record*, 15 September 1965, 23940.

14. Ibid., 23944.

15. Ibid., 23948.

16. See Joan Didion, *Slouching Towards Bethlehem* (New York: Farrar, Straus & Giroux, 1993, first published 1968), xiii.

17. See *Congressional Record*, 15 September 1965, 23944.

18. Ibid., 23945.

19. See *Congressional Record*, 27 February 1968, 4322.

20. Ibid., 4326 and 4327.

21. Museum of Modern Art 1954 press release, October 19, 1954, in the museum's archives.

22. Stonor Saunders, op. cit., 258.

23. Ibid., 268.

24. Segal, op. cit.

25. Interview with Pat Adams, 1 December 1998.

26. Interview with Alfred Leslie, 11 November 1998.

27. Interview with Barbara Kruger, 10 February 1999.

28. Interview with Dorothea Rockburne, 23 February 1999.

29. See *Congressional Record*, 15 September 1965, 23948.

30. See *Congressional Record*, 27 February 1968, 4330–31.

31. *The Arts in a Democratic Society*, op. cit., 15.

32. See Department of the Interior and Related Agencies Appropriations for Fiscal Year 1973, *Hearings before a Subcommittee of the Committee on Appropriations*, United States Senate, 99th Cong., part 3, p. 2647.

33. See Department of the Interior Appropriations for Fiscal year 1969, 14 March 1968, p. 2305.

34. See National Council for the Arts notes, November 1980, p. 69. Published in the *Washington International Arts Letter*, March 1981, p. 2350.

35. See *Congressional Record*, 15 September 1965, 23952.

36. Ibid., 23952 and 23953.

37. The historian and journalist Alice Goldfarb Marquis reported that "Richard Estes, an immensely successful photorealist artist, received a grant even though he had not applied for one. He suggested that the endowment give the money to a young artist in need, but was told that the grant would be canceled unless he took it. Estes suspected that he was chosen in order to dispel rumors of discrimination against realist artists." Estes received the award in 1971, when artists were still being nominated for fellowships. See Alice Goldfarb Marquis, *Art Lessons: Learning from the Rise and Fall of Public Arts Funding* (New York: Basic Books, 1995), 224.

For an example of the kinds of attacks the Endowment regularly had to deal with from politicians and art professionals who felt that representational artists visibly comfortable working within existing traditions were being dis-

criminated against in favor of "avant-garbage," see Taylor and Barresi, op. cit., pp. 97 and 98, and Livingston Biddle, *Our Government and the Arts: A Perspective from the Inside* (New York: American Council for the Arts, 1988), chapter 39.

38. Interview with Richard Andrews, 2 October 1998.
39. Interview with Suzanne Delehanty, op. cit.
40. Interview with Ursula von Rydingsvard, 28 August 1998.
41. Interview with Newton Harrison, op. cit.
42. See Huong Vu, *Impacts of NEA Visual Artists Fellowships: A Case Study*, report commissioned by Visual Arts Office, National Endowment for the Arts, 1995, 22.
43. Ibid., 14.

III

THE PEER PANEL PROCESS I: WHO, WHAT, WHERE, WHEN, AND WHY

The visual artists' fellowship program was one of the crown jewels of the National Endowment for the Arts. It funded many of the artists who helped define American art during the last third of the century, and it awarded most of them money at the right moment, when it could have the maximum catalytic effect on their artistic development. Unlike other Endowment grants, which were based on the principle of matching, the fellowships were direct and unrestricted. Because the money was given with complete confidence, with no strings attached— "To enable artists to set aside time and/or purchase materials, and generally to enable them to advance their careers as they see fit," according to the first guidelines, in 1973—the fellowships underlined the Endowment's, and the government's, unconditional commitment to artists. Here! Take this money, the NEA said to artists, in effect. We trust you. We are investing in you because we believe you are essential to the identity, well-being, and progress of the United States. Your veracity and vision will help America remain on course. Your creativity will help us become a great civilization in which risk, experimentation, openness, and diversity will be so essential to the robustness and purpose of

American society that they will be valued in themselves. We consider you invaluable moral and spiritual resources and we will help you become a community that from this time forth will be integral to the larger community that is America.

The visual arts program, like the Endowment as a whole, was constructed around the individual artist. "All things centered on money for artists," said Michael Faubion, who has held many titles in his twenty-four years with the Endowment, including acting visual-arts program director. "In the visual arts program, it was the most important thing. It was the top priority always."[1] Roughly half the budget went to fellowships. In 1967, the first year of grants to individual artists, for example, the budget for the visual arts program was $736,000 (out of an Endowment budget of $8.4 million), of which $300,000 went for fellowships. In 1982, the visual arts program budget was $6.5 million (out of an Endowment budget of $143.4 million), and the amount awarded for fellowships was $3.4 million. In 1995, the last year of visual artists' fellowships, the visual arts program budget was $4.4 million (out of an overall budget of $162 million) and the money awarded for fellowships, national and regional, was $2.1 million. In no year did the visual arts program allow as much money to be allocated for its second priority, visual artists' organizations (VAOs).

Artists were the focus of the arts infrastructure the Endowment was trying to build throughout America. The visual arts program funded VAOs, which included alternative spaces, defined in part in the guidelines as spaces where artists "can experiment and create new work"; in order to be funded, VAOs had to be run by artists. For a number of years, the visual arts program made money available for residencies, thereby making it "possible for art schools, university art departments, and other institutions to invite artists, critics, photographers, and craftsmen of national reputation for short-term stays to instruct, influence, and stimulate students and faculty while practicing their professions."[2] The visual arts program developed an ambitious Art in Public Places program that installed existing sculptures in, or, more importantly, commissioned new sculptures for spaces outside museums, thereby

helping to expose the general population to art and, in theory, helping to integrate art in the fabric of urban life. For all but three years from 1972 through 1984 (1974, 1982, and 1983), the visual arts program provided fellowships for art critics, essential mediators between art and many of its publics.[3] Knowing how little money museums had for acquiring contemporary art, the Endowment put the visual arts program in charge of a museum purchase plan that gave many museums $10,000 to buy work by living artists. At various times, the program provided money so that artists could engage students and teachers in high schools, patients in hospitals, or inmates in prisons. It supported artistic activities in poor urban neighborhoods and in small towns. Supporting artists in almost every possible way, making art available to everyone who wanted access to it, and raising the level of audience understanding and appreciation were part of the mandate of the NEA.

Trust and belief in artists were built into the agency at its inception. "When the Endowment got started, it was not at all about major institutions," said Ana Steele Clark, who was hired by Roger Stevens in December 1965 and held a number of positions, including acting chairman, during her thirty-two years at the agency. "The individual artist was important right away. We didn't get to museums or orchestras until the 70's." Stevens, who produced or coproduced over 125 plays and put both Shakespearean tragedies and *West Side Story* (a musical, street version of Shakespeare's *Romeo and Juliet*) on Broadway, set the tone. "One of my favorite statements of his was: 'This is the place where the artist's voice will be heard,'" Clark said. Stevens, who died in 1998, "loved being with artists," she said. "He would tell anyone who asked him that he found it boring to be around managerial and financial and real estate people compared with people whose lives were about art, and that was totally genuine."[4]

Again and again, the Endowment affirmed the value, indeed the primacy, of the individual artist. Two weeks after the 1968 House hearings in which an amendment was passed that threatened to eliminate fellowships to individuals, the agency declared that "the individual artist" was "the heart of all artistic enterprises and of paramount importance to all

progress. He is responsible for the standards by which the arts are judged. He produces the work which is the foundation of all institutions of the arts and which in turn preserves his tradition after him."[5] In 1979, the visual arts program's five-year plan stated: "Support to the individual artist has been central in the thinking and planning of the program from the beginning. Opportunities for individuals to pursue their creative work will continue to be the highest priority over the next five years." All of the plan's "general objectives" demonstrate a commitment to giving artists a secure place in the United States. "To support the fulfillment of artistic vision in a society that has made little commitment to it" was the first objective. "To support esthetic inquiry and investigation" was the second. Then: "to establish opportunities for younger and emerging artists at the outset of their careers." And: "to assist mature artists particularly in transitional phases of their work and in other investigative pursuits." The final objective was "to provide advocacy for artists . . . through exhibition possibilities."[6]

Every aspect of the visual arts program was shaped by sensitivity to the individual artist's needs—including the fellowship application, which one program director after another worked to simplify. "They asked for exactly what artists are capable of doing," said Daniel J. Martinez, who received visual artists' fellowships in the category of new genres (which included conceptual, performance, and video art) in 1989 and 1995. "Ten slides, slide description, artist's statement, end of story. That's it. You can make the application in one afternoon. It's none of this spending three weeks or a month and begging everybody to do this or to do that; and you pay all this money on your application, and time and everything else. And then nothing. . . . Not every visual artist can write, not every visual artist has friends or people they can ask for recommendations. Not every visual artist can even deal with the process of application. The fact they made it so easy to apply was absolutely liberating."[7]

Nothing about the NEA did more to convince artists of its trust and belief in them than its peer panel system. It was because the fellowships awarded by the United States government to roughly 4 percent of the

applicants each year were, in effect, chosen by accomplished and re-
spected artists that they were taken as certifications of talent by many
galleries, museums, and universities. It was because of the artists on the
panels that the fellowships were experienced by most of the recipients
as irreplaceable confirmations. "The fact that a peer panel signified a
certain level of interest in my work was critical in terms of my sense of
self and development," Joel Shapiro said.[8] For the sculptor Ronald
Jones, former chair of the Columbia University School of the Arts' vi-
sual arts division, receiving the fellowship in 1983 "provided a confir-
mation that you were going down the right track" because "there were
people on the panel whom I deeply respected. That effect was very
strong on a young artist, that these people had, out of all the people who
had applied, picked me."[9]

For as long as the fellowship program existed, this recognition from
other artists had an almost incalculable importance. For Diane Burko,
who received painting fellowships in 1985 and 1991, that "stamp of ap-
proval from the NEA . . . tells you that your peers—and the profes-
sionals you respect—are confirming your choice of the life as an artist.
It validates the monetary risk and sacrifices you have made to pursue a
career which provides little financial security."[10] For Linda Bills, the
crafts fellowships she received in 1988, 1990, and 1992 were meaningful
"because of the directness of the process, a process based on the
strength of one's work, and the fact that it is undertaken by a panel of
professionals from within the field, not encumbered by marketplace is-
sues."[11] For Ann Hamilton, the installation artist who represented the
United States at the 1999 Venice Biennale, "winning" a fellowship in
1993 "gave me a very important sense of support from my peers, which
is and was very important in maintaining the trust and faith necessary to
make new work, to change, to make a leap of imagination toward what
can't be easily knowable or containable in language."[12]

Why Peer Panels?

In a 1963 report to Senator Claiborne Pell—a cosponsor of the Na-
tional Foundation on the Arts and the Humanities Act of 1965—on his

first legislative attempt to bring into existence a National Arts Foundation, Livingston Biddle emphasized the value of peer panels. "It is intended that the advisory panels which shall be composed of highly qualified professionals will give added assurance that government aid does not lead to government interference in the practice or performance of the arts."[13]

The idea of peer panels had been planted in Roger Stevens's mind when he met with the National Council on the Arts for the first time at the White House in April 1965. President Johnson swore in the council members, an extraordinary group of twenty-four arts professionals and administrators that included Leonard Bernstein, Agnes de Mille, Ralph Ellison, Gregory Peck, Richard Rodgers, and Isaac Stern. The visual arts were represented by a visual artist, the New York School sculptor David Smith, who was killed in a road accident a month later, and two museum directors, René d'Harnoncourt and James Johnson Sweeney, both of them connected to the Museum of Modern Art and its international exhibition program in the fifties—d'Harnoncourt had been the museum's director since 1949; Sweeney had been a curator there from 1945 to 1952 before becoming director of New York's Solomon R. Guggenheim Museum and then the Museum of Fine Arts in Houston. The council, appointed by the president, was conceived as a group of arts professionals "distinguished by their knowledge and experience of the arts," in the words of the agency's 1967 annual report. Its responsibilities primarily consisted of advising the chairman "on agency policy and programs" and reviewing and making "recommendations to the Chairman on applications for grants." At this first council meeting, "Stevens suggested that if future funding became available the Council might also want to utilize panels of experts to offer 'advice and recommendations' as well as providing 'a means of engaging increased numbers of private citizens in this fledgling partnership between the Federal Government and the arts world.'"[14] The following September, the National Foundation on the Arts and the Humanities Act of 1965 gave the chairman of the NEA authority "to utilize experts and consultants, including panels of experts." Shortly afterward, at the 1965 conference in

Santa Barbara, after an intense debate about the most appropriate way to locate and support artistic excellence in a democracy, Roger Stevens left no doubt about his belief in peer panels: "The bill says that panels of experts should advise the Council in all of the various categories of the arts. This is the only satisfactory way to make these judgments."[15]

The peer panel system was created not only to make the best possible judgments but also to give the agency and the fellowship programs sufficient independence and protection. It involved private citizens at two stages: The artists who made the recommendations were private citizens brought in to recognize promise and achievement. If the panels were made up of respected and accomplished artists, and if they were consistently rotated and represented a diversity of approaches and regions, it would be hard to accuse the government of dictating taste. The members of the National Council who had the final say on peer panel recommendations were also private citizens. In his 1985 study, the art historian John Pultz underlined the importance of these two levels of private citizen involvement. He wrote that "the distance achieved between the government and grant recipients offers freedom from political interference to the individuals and institutions receiving grants, while making the government less vulnerable to criticism for the activities of grant recipients."[16]

From the mid-to-late seventies on, the majority of panelists were artists. Quite apart from the aesthetic and political usefulness of allowing artists to shape panels, it is hard to imagine how, given the conditions that brought the NEA into being, they could have been excluded from a major role in the selection process. The government had decided that it needed artists to help the country find its spiritual and moral center. It would not have needed them if it did not have questions about the judgment of a society that seemed to demand conformity and worship money and trashy television and that was only beginning to be willing to acknowledge and take a collective stand against ingrained injustices like racism. The government established the National Endowment for the Arts in part because it was convinced that the country needed a thriving artistic culture in order to know itself and find its center and

show the world America was more creative and confident than the Soviet Union and committed to becoming a great civilization. It believed that the American people were not yet capable of making the kinds of informed decisions that would allow artists to realize their potential and the arts to flourish.

These reservations about the general public must also be understood against the background of the Soviet Union, which had created deep suspicion within American political and cultural institutions of any state program that obliged artists to appeal to the masses. "In the tyrannical societies of today, in the societies of Stalin and Hitler, the artist was not only encouraged but coerced into creating art for the masses, and invariably he failed," Henri Temianka, the director of the California Chamber Symphony, said at the 1965 Santa Barbara conference.[17] If the NEA was to fulfill its Cold War mission, artists had to be given decision-making power and full artistic freedom so they could follow their inner voices. "One of the things that art is is a new vision, whatever the particular form the vision may take," the philosopher Richard Lichtman said at the Santa Barbara conference on "the arts in a democratic society." Lichtman added that "art will flourish only when one cannot foretell the limits of the vision—that is, when the state cannot control the character of the vision . . . For all of the arts to flourish, there cannot be the imposition of a general restraint on the artist."[18] Artists were leaders and they had to be allowed to lead. Given the need for artists and the anxieties, assumptions, and beliefs that inspired this need, it is hard to imagine how the NEA could have developed a visual artists' fellowship system that did not depend on peers.

Henry Geldzahler (1966–1969)

Another indication of the visual arts program's belief that artists were its first priority is that of all its directors from 1966 to 1987, only one was not or had not been an artist. The exception was the first director, Henry Geldzahler. At age thirty-one when Stevens brought him to the Endowment, this cherubic, cigar-smoking New Yorker was youthful, ener-

getic, urbane, and ambitious. As the child of affluent European Jews who immigrated to New York in 1940, he could understand the kind of outsiderness many artists felt and he was able to approach it without insecurity or defensiveness, as a potentially valuable, even privileged condition. In addition, he was comfortable around artists and he knew how to gain their trust. Particularly in the fifteen years before his death in 1994, he was as sympathetic to the forgotten and the marginalized as he was to the stars.[19]

Geldzahler's curatorial reputation was and remains mixed. While known in 1965 as a knowledgable arts professional who cared about art and artists, he was at least as well known as a friend of Andy Warhol and a social butterfly who reveled in the company of a newly fashionable artistic elite—"an enchanting pop-society celebrity" whose "professional contributions have been, to put it politely, undistinguished" is the way Thomas B. Hess, the respected art critic and editor of *Artnews*, described Geldzahler in 1967 in an editorial praising the Endowment's sixty $5,000 awards to painters and sculptors as the "best list of grants (or prizes, or honors, call them what you will) that we have ever seen in the field."[20]

Stevens's decision to hire Geldzahler suggests both the chairman's belief that big New York arts institutions were America's cultural elite and his awareness of the potential dangers of funding individual painters and sculptors. At the time, Geldzahler was a curator of American art at the Metropolitan Museum of Art, where he had been working since 1960. "He had come to the Endowment through a friendship Roger had developed with James Rorimer, who was then head of the Metropolitan Museum," Biddle said. "Henry primarily operated out of New York. . . . Roger felt that it was a good idea to have him at the center, at what we could still consider the center of the arts." Stevens clearly believed that the first visual arts program director, who was involved almost exclusively with contemporary art and living artists, would have a better chance of establishing the credibility of the program among politicians and other leaders if he was identified with a prestigious New York institution known for its scholarly devotion to the art of the past.

The program "had to begin with some insulation from things that might go wrong," Biddle said.

When he became visual arts program director, Geldzahler took a year's leave from the museum. Then, according to Calvin Tomkins in a 1971 *New Yorker* profile, "Geldzahler soon discovered that being program director for visual arts did not require a great deal of his time, and so, when he was reappointed for a second year with the National Endowment, he came back to the museum and continued to handle the visual arts job on the side. Some of Stevens's other program directors were a bit put out that Geldzahler spent so little time in Washington, but somehow he could manage to get his work done in half the time it took them, and Stevens was thoroughly pleased with his efforts. 'Henry makes up his mind very fast, and he has plenty of self-confidence,' Stevens has said. 'So many people in the arts want to call up four or five experts and get their opinion before making a decision, but Henry doesn't do that. Besides which, he was a lot less emotional than some of my other program directors.' "[21]

Geldzahler devised a peer panel system that divided the country into five regions—East, Midwest, West, Southeast, Southwest. He chose three panelists to make both the nominations and recommendations for each region: the East, Midwest, and West panels met in 1966; the Southeast and Southwest panels, in 1967. Of the fifteen panelists these first two years, three were artists, seven curators, three teachers, one a critic, and one a collector. Fourteen of the fifteen were men. Each panel met in its region, an imaginative decision that helped Geldzahler meet his responsibilities both at the Endowment and at the Met, where his job required an awareness of contemporary art throughout the United States. "It may have been that he was very conscious of the dangers of everybody seeing everything as being all about New York or the East Coast," Steele Clark said. "He was also interested in seeing things from all over the country, which he may have had less of an opportunity to do."[22] The dependence upon nomination reflected Geldzahler's belief that the best way for the new agency to support art was to get people in the know to fund the artists they knew to be the best. "Ideally the state of

the arts is furthered, and the foundation looks better in retrospect," he said in 1969, "if you can manage to land heavily on the best men available and truly help them rather than attempt to cover the waterfront. Fairness in art is not nearly so interesting as quality."[23]

Geldzahler's approach to the panels reflects the relative smallness of the art world in the sixties and the common belief among its movers and shakers in New York that there really was essentially one standard of artistic quality and that the number of artists who met it was limited. Despite the regional panels, Geldzahler, like Stevens, took for granted that New York was the center of American art and culture. That is where he lived. That is where his heart was. There is no question that he was proud to work at the Endowment. Although Geldzahler did not spend a lot of time there, Steele Clark remembers that he "was absolutely a presence there. He was a commuting program director but he was there in the offices; every staff meeting I went to he was there."[24] But in his 1994 book, *Making It New: Essays, Interviews, and Talks*, which looks back over Geldzahler's whole career, there is not a single mention of his Endowment years.[25] The peer panel process he developed reflected the personality and the professional life of a knowledgeable and flamboyant New York museum curator who moved fast, avoided conflict and labor, and believed decisions about quality were immediately apparent to anyone in the know.

The first East Coast panel consisted of the narrative sculptor George Segal, the Abstract Expressionist painter Robert Motherwell, and the art critic Barbara Rose, all from the New York metropolitan area. Segal remembers the first meeting, "somewhere downtown," where "we chipped in names. I think it was just as casual and informal as that. We were asked whom we regarded as a high-level artist who needed some encouragement to keep working in the face of seemingly endless poverty." For the second meeting, at Geldzahler's Manhattan apartment on September 11, 1966, slides had been gathered for those artists' works. "Generally there was a consensus," Segal said. "There was not too much of a discussion because it was assumed that all of us knew them . . . We were told that there was a limit on the number of art-

ists. That was the big discussion. We were in agony because we had a long list of highly regarded artists." The minutes for this meeting noted that "the panel also suggested names for the consideration of the Midwest and West Coast panels."

"In those years," Segal said, "the art world was incredibly smaller than it is now. Everybody in the art world tended to know everybody else, mostly because the entire art world in the city of New York was roughly three hundred people. It's incredibly larger now."[26]

The October 5 Midwest panel took place in Chicago and consisted of Martin Friedman, director of the Walker Art Center in Minneapolis and later a member of the National Council on the Arts (1979–1984); Richard Hunt, a Chicago-based sculptor who not long after this panel was appointed to the National Council (1968–1974); and Edward Henning, a curator at the Cleveland Museum of Art. Hunt's recollection of his peer panel is similar to Segal's. "We got together and talked about artists in our area," he said, "an informal kind of thing compared with the application process and the slides and all. On the other hand, since this was the first time something like this had been done, there were all the artists out there to choose from . . . Members of the panel brought names or information about artists. We spent probably a day. No slides but some materials. Most of these were artists who were known regionally . . . Henry wanted individual panel members to bring up artists that they felt were talented people . . . obviously not someone who didn't need it, where it would be seen as an extravagance, throwing money at somebody. There ended up being a consensus about the group of names that we proposed, but during the day there was debate about one person or another to bring that consensus around."[27]

On the West Coast, in Los Angeles, at a particularly vibrant moment in the art life of southern California, when radically inquisitive, strong-willed artists like Robert W. Irwin and Edward Kienholz were beginning to come into their own, Geldzahler ran the panel in a way that would have been unthinkable to him in New York. His panel was made up of Walter Hopps, director of the Pasadena Art Museum; John Humphrey, curator at the San Francisco Museum of Modern Art; and John

Denman, a collector in Seattle. They met in Geldzahler's suite at the Chateau Marmont. "It's a famous old hotel, all the way back to [F. Scott] Fitzgerald. That's where John Belushi overdosed," Hopps, the founding director of the Menil Collection in Houston, where he is currently the consulting curator, explained. Slides and dossiers had been shipped to the hotel. "We had either nominated artists or contacted them and had them send things in," Hopps said. "When we met, Henry said, ok, whom do we want to get these awards? And he'd go around the room . . . I just want names, he said. Who are your main choices? So we gave him that and one of us said, But aren't you going to look at the applications and the slides? There was this long blank look from Henry. And he said, oh, ok." He had somebody bring in the boxes. "The boxes were pushed into the room. Henry stood up and went over and thumped each box with his hand and said, ok, now we've seen the applications and we've seen all this." The boxes were then removed from the room. "Nobody looked at any slides," Hopps said. "Nobody read any applications. We just talked about who we wanted . . . It was all over in a morning.

"Henry was a friend," Hopps added. "I don't want to just trash him, but we certainly saw the world from two very different vantage points. I was interested and grateful that I got to serve on his panels. You see how things are going on. In his terms, yeah, if we're going to decide what artists we think are good and deserve some help . . . Yes, I got my shots in, I don't begrudge that, but I don't think the process was right."[28]

Geldzahler initiated the fellowship program and gave it visibility and flair. Because of his museum affiliation and his reputation as a devotee of the new, he helped give the NEA a reputation for adventurousness. Under him, the Endowment gave money to many first-rate artists in need. Early in 1969, he left. "Henry had this impression of himself as an important government official," Hunt said, "so when the new administration came in, he thought that, like cabinet officials, you hand in your resignation, which he did and that was the end of it."[29]

Brian O'Doherty (1969–1976)

It was not until the Endowment had made it through its first reauthorization in 1968 that it was secure enough to hire as visual arts program director someone who was not identified with museum standards, although Brian O'Doherty, the second director (1969–1976), did bring with him the cachet of another bastion of the establishment, the *New York Times*, for which he had written art criticism from 1961 to 1964. O'Doherty, thirty-five, tall, long-limbed, with a natural elegance and a preference for turtlenecks over suits and ties, was Geldzahler's choice.[30] He was hired in May 1969 by acting chairman Douglas MacAgy—after Stevens had left, in March, and before Nancy Hanks was hired, in October. Hunt, a valiant and effective spokesman for the visual arts on the National Council, compared Geldzahler and O'Doherty: "Henry was a good person to be the first director because he was able to get along in his way with the variety of people one would have to deal with. He had enough patience with political people that he had to deal with . . . At that time, he had a real passion for what he was doing. He had an exaggerated sense of his importance, which served him well in the beginning and maybe made what he was doing more important . . . Brian is very articulate, with a sense of humor and an intellect that made him able to be listened to and liked by a variety of people within the Endowment and in Congress, so he was a good spokesperson for the programs."[31]

An Irish immigrant whose rage at the British occupation of Northern Ireland led him to choose Patrick Ireland as his artist's name, O'Doherty was more attuned than Geldzahler to the complex relationship between art and politics, and between artists and society, and he had a heightened sense of the artist's second-class citizenship in the United States. He was also commited to the agency. His two names reflect his cultivation of a double life and dual, if not multiple, identities. Artist, writer, doctor (he has an M.D.), and adminstrator, he was able to slide effortlessly from one identity to another. Like Geldzahler, he was a New York insider: through his years at the *Times* and at *Art in America*,

he knew most of the players in the New York art world. He, too, was very New York–centric. But he actually lived in Washington from Monday to Friday. During his twenty-eight years as an adminstrator at the agency, he continued to develop a career as a conceptual artist whose rope installations, like his theoretical writings, encouraged an awareness of the perceptual and ideological conditions in which art is experienced.[32] He wrote eloquently about popular realist painters like Edward Hopper and Andrew Wyeth[33] while knowing, partly through his friendships with Robert Smithson, Sol LeWitt, Eva Hesse, and other leaders of his artistic generation that many of the most significant artists who came of age in the late sixties were poet-thinkers whose rigorous minds and unpredictable imaginations enabled them to see art and the world with fresh eyes. Because he was astutely aware of institutional machinery and congressional process and so charismatic and silver-tongued that he could charm almost anybody, he could make politicans, as well as artists and intellectuals, feel he was one of them.

O'Doherty worked under Hanks, who wanted to get away from Stevens's improvisational style and codify the agency, and he gave the visual artists' fellowship program structure and dynamism. He grasped the full significance of fellowships both to the Endowment and to artists. Hanks, a brilliant politician and leader who had worked closely for many years with Nelson Rockefeller, was no more a student of the visual arts than Stevens. As one of her two "pets," according to her other pet, Bill N. Lacy, the Endowment's design program director, O'Doherty was able to build the fellowship program and keep the agency behind it.[34] "Brian felt very, very strongly in favor of the fellowship program," said Fred Lazarus, the NEA's special assistant to the chairman from 1975 to 1978, when he left to become president of the Maryland Institute, College of Art, in Baltimore. "I think the support of the Endowment in that was as much a tribute to his involvement as anybody's."[35]

O'Doherty saw the Endowment, and the peer panel system that was its heart and soul, as a way not only of supporting artists but also of engaging them in their government and of giving them respect. He

wanted to change the way artists were perceived. He knew how hard
most artists worked, how thoughtful they were, and how much they
had to offer. "The artist's opportunities to exercise responsibility are
limited in a society that does not allow him any," O'Doherty wrote in
1976 in an essay on the visual arts program. "The artist is viewed as
irrelevant to serious social discourse, and easily managed within the
support structure—universities, museums, collectors, galleries—of
which, of course, the Endowment is also a part. But for seven years
now, I have watched artists scrupulously exercise responsibility when
given the opportunity to do so through the advisory panel systems. For
many it has been the first time they have been asked to perform a social
task of dignity and responsibility—a comment again, in my view, not
on the artist, but on the society that so excludes him. . . . By charging
artists with responsibilities of which they are generally deprived, the
Endowment, in my view, contributes to the reeducation of the public,
which has gotten into the habit of seeing the artist as an underprivileged
producer of privileged goods."[36]

But O'Doherty is also one of the most controversial figures in the
agency's history. Everyone who worked with him admired his talents,
but he left many people with a sense of unease. More often than not, the
tone of the interview changed when he was being discussed; one former
Endowment official pointed toward the tape recorder and gestured to
me to turn it off so he could get off his chest his distaste for O'Doherty's
capacity for disdain. While the negative word that emerged in inter-
views about Geldzahler's tenure at the Endowment is *autocratic*, the
negative words that recurred in interviews discussing O'Doherty's
leadership are *dictatorial* and *dismissive*. O'Doherty wanted to keep
power in his hands. He could be arrogant with people who did not agree
with him, and he made people feel either like insiders or outsiders.
Acutely aware of the history of the decades of public hostility to first-
rate modern art and artists, he believed the essential decisions about art
should be made by arts professionals he and other knowledgeable arts
professionals judged to be the best. Panel members and other Endow-
ment officials said that as head of the Art in Public Places program, he

did not believe communities were informed enough about art to deserve a say in the art they would have to live with. He knew how to gracefully interject into a peer panel discussion his own opinion about an artist, something subsequent visual arts program directors vigorously resisted, and he brought experts onto his staff who were so sure of their judgments that they would occasionally try to act over the heads of a panel when they believed it had not made a just decision. O'Doherty's self-confidence, intellect, and sophistication made the visual arts program a force in American art, but he did not trust people and process enough to allow the peer panel system to develop fully.

Many decisions made under O'Doherty's directorship were decisive. It was under O'Doherty that the awards changed from grants to artists in recognition of past achievement to fellowships for future development, a crucial shift that reflected Hanks's belief that the fellowships were investments in the nation's future as well as the Endowment's desire to make it hard for Congress to pinpoint the way government money was used.

In 1974, the fellowship program initiated different funding tiers. While the importance of the large grant, which in 1976 rose to $10,000, is obvious, the smaller grants are more revealing about O'Doherty's, and the agency's, commitment to promise as well as achievement. Robert W. Irwin, who was awarded a fellowship in 1973 and who served on three peer panels (1975, 1976, and 1978), as well as 1981 and 1982 policy panels, believed the smaller amounts encouraged panelists and artists alike to trust creative instinct and risk. "With the small, $2,000 or $3,000 grant, the panels felt they could roll the dice and you could give it to people who were really out there," he said. "I saw the positive effect of that grant. On my travels, I kept meeting young students and that grant had major effects on their lives. In my mind, it alone justified the existence of the NEA."[37]

Many of O'Doherty's decisions suggest the complex intersection of aesthetics and politics that may be unavoidable in the formation of a government fellowship program. Look at his decision to end regional panels and invite all panelists to Washington. "O'Doherty opposed the

de facto quotas implied under Geldzahler's system," Pultz noted. "No
particular area—geographic or esthetic—has a quota, nor in my mind
should it," O'Doherty wrote. "Quotas politicize quality and ultimately
destroy it."[38] Holding the panels in Washington facilitated and central-
ized the panel process and ensured that each award would be given the
same national stamp, but it also ensured that the artists under consider-
ation could not be evaluated in their cultural and environmental condi-
tions, which meant that regional character and significance could be
harder to appreciate. And in Washington, there was more pressure on
panelists from other regions to act as regional spokespersons rather than
as experts who wanted to be as open about the art in their backyards as
they were about the rest of the art under consideration. Van Deren
Coke, a curator at the University of New Mexico and a panelist in 1968,
1971, 1973, and 1978, "saw his role on national panels for 1971 and 1973
as a representative of regionalism," Pultz wrote, "not just of his own
region." Coke said: "I wanted to make the New York establishment
aware it's not just the boonies out there."[39]

 During O'Doherty's directorship, the fellowship categories began to
be discipline-based. From 1967 to 1969, the only category was "artists."
By the time O'Doherty left the visual arts program in 1976 to begin the
Endowment's media arts program, fellowships were given in the cat-
egories of artists (which increasingly meant painting and sculpture),
photography, video, conceptual/performance, and prints. "Originally
there was one category of artists' fellowships and then there were cat-
egories," Lazarus said. "Theoretically the reason for this was there
were too many aplications to handle and it was unmanageable, but the
fact of the matter is there was another side to it, and that was to make
sure that there was a distribution among mediums and that you didn't
always fund painters and sculptors."[40]

 Fellowships were now also given in the category of crafts, a decision
O'Doherty and others at the agency resisted, finding it as difficult as
many other arts professionals to accept that craftsmen and -women
were indeed artists. "Nancy felt that was an important move in terms of
being more democratic and more open," Lazarus said. The expanding

number of categories reflected the program's commitment to an unending process of democratization that was built into the agency, and a responsibility to the totality of the field that would ensure that this process would continue, but a clear hierarchy remained. The category "artists" included painters and sculptors but not photographers, video-makers, performance artists, and craftsmen and -women. In 1976, O'Doherty's last year as visual arts program director, the top fellowship amount for painters and sculptors was $10,000; they could also be given $2,000 or $5,000 fellowships. There was only one amount for photographers ($7,500), craftsmen and -women ($5,000), and printmakers ($3,000).

In 1971, O'Doherty began the momentous shift from nomination to application. The evolution reflects the tension within the agency between a commitment to the authority of arts professionals and a commitment to broad cultural engagement and representation. Since the initial number of applications was expected to be light, nominations were still solicited, Pultz wrote, "from over one hundred experts in the art world as well as from scouts employed part-time"; the aim, in O'Doherty's words, was "to identify new and hidden talents that do not easily come to light."[41] The 1971 letter signed by O'Doherty, asking for nominations, announced that the Endowment would "grant Fellowships of $7,500 each for forty artists. The aim of the Fellowships is to allow artists of exceptional talent to pursue their work free of the debilitating economic pressures that hamper the full realization of their gifts and plans. The grants will enable them to buy time and/or materials and to advance their careers as they see fit.

"We would be most grateful if you would assist us in maintaining the high standard of excellence in these awards by nominating not more than five artists who are, in your estimation, of national significance. If the artist is little known, we would appreciate some supporting information."

Panelists were sent the list of nominees months in advance of the panel meetings and expected to familiarize themselves with the artists' work and speak with other experts about it. This was intended, in Pultz's view, to counter criticism that the process was inbred, but this

method could easily subject panelists to pressure from artists who found out they were being considered, as well as from dealers, collectors, or other supporters of the artists, and, in fact, strengthen an insider network.[42] Although there are numerous examples of panelists who took this responsibility seriously, preparatory work is a problem for panelists, of any kind, and some of them waited until the meetings began in Washington before committing themselves to the process of study and recommendation.[43]

The changing role of slides also suggests the tension in O'Doherty's visual arts program between inside and outside, control and openness. In the early seventies, slides had a growing but still minimal importance. In some panels, they were set up on slide boxes. Panelists were expected to parade by and look at them. Often they played little role in the decision making. When the ceramic artist James Melchert served on peer panels, in 1971 and 1973, "the amounts were decided not on the basis of slides presented to a panel" but rather still through discussion of nominations. "We all came with lists of artists we wanted everyone to consider," Melchert said. "I don't know that we even looked at slides because everybody seemed to know everybody who was mentioned. I know that not everybody knew all the people I was talking about in California but there was enough support for everyone who ended up" getting a grant.[44]

The first year in which the recipients were chosen exclusively from applications was 1974. With the shift from nominations to applications, the peer panel process changed dramatically. Artists who were totally unknown now had a chance to receive government recognition. Since panels were required to pay attention to everyone who applied, the discussions became more rigorous and concrete. Panels now had to commit themselves to a sustained debate based on a study of slides, which from this point on would orient a peer panel process that would embody many of the essential values of the agency.

In the development of the peer panels, no one had to make more fateful decisions than O'Doherty. No one before him knew what an effective government peer panel system for the arts would be. Once the NEA

made a commitment to it, program directors had to have the suppleness and imagination to respond to the unending challenges a government peer panel system presented. O'Doherty's positive legacy was an awareness that a viable visual arts program had to keep changing, a passionate commitment to artists and art, and an unshakeable belief that responding to the needs of the most inventive and adventurous artists could make America a more insightful and creative country. In addition, he was so respected in New York as someone who understood artists and had their best interests at heart that his presence helped the Endowment to maintain its credibility among the most vocal and activist artists during some of the most explosive years of the Vietnam War. It is hard to imagine another person who could have created as solid a base for artists within the Endowment at this time.[45] O'Doherty's programs touched many artists' lives and demonstrated how much the fellowship program, in particular, could mean to the field. But O'Doherty also created problems that program directors after him would have to deal with.

James Melchert (1977–1981)

It is to O'Doherty's credit that he recommended as his successor James Melchert, who could not have been more different. Melchert, forty-seven when he became program director, was also more than six feet tall, with an even stronger physical presence. He was gregarious but at the same time self-effacing, with a touch of awkwardness that contrasted with O'Doherty's smoothness. He was definitely not a New York art world insider. "I talked with Bob Irwin at a party," Melchert recalled. "He couldn't get over that I'd been chosen to succeed Brian and observed that it wasn't as if I'd come in from left field, I wasn't even in the ballpark. It was true. I knew much of the country, but I had no experience in New York other than occasional visits with friends there . . . Obviously I had a lot to learn."[46] Melchert knew what he didn't know and was open to it. When people critical of him or the visual arts program asked for his attention, he almost always gave it to them. "One thing I certainly learned was that if you're willing to listen

to people and hear them out," Melchert said, "you learn a lot of things you don't otherwise hear."[47]

On his lectures and studio visits to the West Coast, Peter Plagens, who taught at California State University, Northridge in the late sixties and then briefly at the University of California at Berkeley in 1972, learned Melchert's value to the agency. On the West Coast, Plagens said, "the NEA was always perceived as most legitimate when Jim Melchert was there. Melchert was a great big woolly bear of a Bay Area artist. He always had bushy hair and he dressed in army fatigues; he may have shown up in a jacket. He never tried to look like a bureaucrat. He always was, okay, I'm an artist and you have to accept me like that . . . Melchert, for whatever reason, seems a lot bigger than four years."[48]

Newton Harrison, a chair of Melchert's policy panel in 1978, described the differences between the two directors who essentially formed the NEA's visual arts fellowship program. "Brian is a high-focus person, always conscious of purpose, and always acting toward purpose," Harrison said. "Jim is a field-type person. Jim is always focusing on improving the quality of the field and assuming that good people in it will do good things if the context is good. Jim was from Berkeley. He was out of the free speech movement. A whole lot more was permissible in art for Jim than was for Brian."[49]

Melchert had "a far more open and populist view of things," Walter Hopps, who began his museum career on the West Coast, said, "rather than—we're the experts, we know what it should be, and we'll do anything we can to make sure it happens."[50]

Melchert began as a painter and then studied with Peter Voulkos, who received three NEA fellowships and whose brash and elemental ceramics from the fifties on have been so sculpturally convincing that they have continually undermined the hierarchical distinction between crafts and art. As a professor of art at the University of California at Berkeley, Melchert taught a course in visual thinking that reflected his resistance to artistic categories and his interest in how creativity, in whatever material or form, worked. Through the efforts of Melchert and Leonard

Hunter, his assistant director and himself an artist, the hierarchy of artistic categories that had informed the fellowship program from the start was demolished. In 1982, the money awarded for fellowships in crafts, prints, drawings, photography, video, and new genres was the same as for fellowships in painting and sculpture. "When I insisted that the fellowship amounts be the same across the board," Melchert wrote, "it was because I believe that it's the artist and not the medium that makes the magic."[51]

Under Melchert, a fellowship recipient (1973) as well as a two-time panelist, and Hunter, a former student of Melchert's at Berkeley who came to the Endowment from the University of Kentucky where he had been chairman of the art department, the peer panel system was given the form it would maintain until the fellowship program's death in 1995. The vast majority of panelists were now artists, although curators continued to be present, because of their expertise but also because they could help artists who had applied. "An artist whose slides were seen stood a chance of later being invited to exhibit somewhere," Melchert wrote.[52] Most of Melchert's panels included artists who had received fellowships, a practice that was intended to ensure that the process would be shaped by people who believed in the process and who appreciated how much it meant for an artist to be awarded government money at a moment of need. This practice also helped to build into the program a sense of continuity and community.

The panel meetings continued to take place in Washington, where Melchert lived while he was program director, but now no panelist knew the pool of applicants before the panel process began.[53] Melchert made sure there was a greater rotation of panelists. Few people served on more than one panel; the days of three- and four-time panelists ended.[54] "Each year, they would consciously choose their selection panels somewhat different from the prior year, and from the prior year," Harrison said, "which meant that over a ten-year period there was enough difference in the chemistry and preferences of the panels to get most of the good artists a grant."[55]

Brought on as director during the Jimmy Carter years when pressure

was put on institutions to respect grass-roots creativity and the diversity of artistic traditions, Melchert believed in gender and ethnic diversity. More than 40 percent of his fellowship panelists were women, compared with less than 10 percent under Geldzahler (two out of twenty-three) and around 20 percent under O'Doherty. Melchert intensified the visual arts program's commitment to seek out panel members from America's nooks and crannies who could ensure that the visual arts program was in touch with the country's artistic range and richness.

When Melchert came in, only two programs, visual arts and design, did not have policy panels. "They [O'Doherty and Lacy] didn't have planning panels because they didn't want anyone else influencing them," Lazarus said. "They had their own ideas about the way they wanted the program to go and didn't want others directing them."[56] For Melchert, the downside of this was that "visual arts had no representation at National Council meetings the way the other programs did . . . When there was a meeting, the policy panel chairs would all sit with the council members and they could actually participate in conversation and I thought, my goodness, we need somebody in there."[57] Melchert made policy panels part of the visual arts program. They met twice a year and provided advice on fundamental issues, such as guidelines and fellowship amounts. Melchert appointed and consulted regularly with his eight policy panel members—the first panel included the painter Benny Andrews, the Philadelphia Museum of Art curator Anne d'Harnoncourt, the photography editor and curator Carole Kismaric, the artist-educators Ed Levine and Nathan Lyons, and the crafts curator Eudorah Moore. "I really wanted to know what they thought," Melchert said, "because there were a lot of things that we could do and I liked feeling it was not just my decision but one that was well thought out by a number of people I respected."[58]

Selecting the panels was one of the main responsibilities of the program directors. The success of the fellowship program, and with it of the visual arts program as a whole, depended upon ensuring that the peer panel process was discerning and fair. From their travels, from previous panelists, and from the panels themselves, at which they were al-

ways present, the program directors were constantly gathering information about art and people. "It was essential to know a good deal about anyone we were considering," Melchert wrote. "'We' includes the staff member in charge of the review and often the Assistant Director. We would all prepare suggestions, a few of our own and some made by former panelists or a policy panelist, occasionally from Mary Ann Tighe's office upstrairs. Since I wasn't well versed in fields such as photography and printmaking, I relied on the recommendations of the staff person in charge."[59]

When Melchert arrived, for example, Dana Rust, who had worked at Manhattan's Zabriskie Gallery, was the program specialist for all fellowship disciplines other than photography and crafts. Melchert also inherited Renato Danese, his first photography specialist, who had been O'Doherty's assistant director and right-hand man; Danese now runs his own gallery in midtown Manhattan. "Renato knew the field, its history and its key players," Melchert said. Danese chose his panels, which reviewed applications by portfolio, not slides. "Using his argument that you couldn't read photographs well from slides," Melchert said, "we eventually persuaded the administration to let us review drawings and prints by portfolio as well."[60]

Program directors were constantly calling around and asking for advice. "Finding panelists meant checking with those we knew who were widely respected," Melchert wrote.[61] Firsthand knowledge of the panelists was useful. "I might not have felt strongly about asking Bruce Nauman had I not known him," Melchert wrote. Nauman, one of the first artists to be awarded a fellowship, in 1968, served on Melchert's artists panel in 1978. "He's patient, exceedingly attentive, decisive, and reliable when it comes to recognizing genius."[62]

Since one wrong person could disrupt, if not damage, the selection process, the chemistry of a panel was crucial. One artist balked at giving other artists money because he had been turned down when he applied; some artists were so absolute in their aesthetic or ideological convictions that they blocked open discussion. "The worst panelist would be the bully," Melchert wrote, "the most useless the one who had no mind

of his or her own. The pressure during a review could be intense and, occasionally, we would discover who couldn't handle it. I remember the panelist who broke into tears, the one who insisted on leaving after a day, and those who grew paranoid and accused others of teaming up against them."[63]

Jennifer Dowley was the visual arts program director (1994–1996) when the NEA's fellowship programs, except to writers, were eliminated by Congress; from 1996 to 1999 she was the director of the museum and visual arts program, which combined elements of the visual arts and museum programs. For her, too, the health of the peer panels was essential to the effectiveness and mission of the agency. "When I arrived I thought that what I was really paid for," Dowley said, "was to put the panels together and then manage them. My goal was to bring them to the highest standards of fairness and rigor that I could, and to really cultivate a democratic process. I needed to choose people around the country who were the smartest people in their various fields, people who had opinions, who had experience, who had knowledge of particular areas—and who were not cynical. People who were truly absorbed in their work and with their field but who were also capable and willing to engage in a discussion about it. I wanted them to come with the best that they had to offer and ready to put it out there, to see how their ideas could hold up with everybody else's."[64]

Melchert was the visual arts program director when Ronald Reagan was elected president in 1980. The existence of the NEA was immediately threatened. Reagan had no interest in visual artists, poets, and writers. He had no use for Kennedy's and Johnson's beliefs in activist government and campaigned against the government bureaucracies that began with their activism. He believed government funding got in the way of private initiatives. He set up a Presidential Task Force on the Arts and Humanities that people at the NEA feared had been put into place in order to give cause for dismantling the agency. However, in the fall of 1981, the task force concluded that "basically, the National Endowments are sound and should remain as originally conceived . . . Furthermore, we endorse the professional panel review system, which

puts judgments in the hands of those outside the Federal Government, as a means of ensuring competence and integrity in grant decisions."[65]

The most serious threat to the agency was the Reagan administration proposal to cut its budget in half. Although the cut did not materialize, the threat forced the agency to rethink just about everything. The crisis ended up streamlining the visual arts program. Previously there were fifteen funding categories; now there were four (fellowships, VAOs, Art in Public Places, and visual artists' forums). Hunter, for whom art can be a way of responding creatively to any situation, approached his administrative challenge of turning a bad situation (grave budget cuts) into a good one as a form of art-making. He made sure that all disciplines were equal. This meant not only that all fellowships now provided the same amount of money, but also that photography and printmaking applicants were now evaluated by slides. He put the fellowship program on a two-year cycle, which reduced the number of applications, as well as the number of panels the agency had to organize each year: painting, works on paper, and new-genres panels were held one year; photography, sculpture, and crafts panels the next.

Hunter gave the peer panel process more time to unfold. Under O'Doherty it could take two or three days, which sometimes required panels to work from eight in the morning until midnight. Hunter's panel process took five days. With more time to look at the work, the panel could consider all the slides that had been submitted. This eliminated one of the most problematic aspects of the process: the prescreening in the artists category because of the quantity of slides. When Michael Faubion arrived at the agency in 1976, from one to three people would come in, go through all the slides, using a light box, "and in just a glance eliminte those they felt were not competitive." The main panel, on which one of the prescreeners occasionally served, did have a book with all the applicants listed, so they could call back someone who had been rejected, but this did not help artists the panelists didn't know. Prescreening was "going on when Melchert got here," Faubion said. "Once Jim was here a year or so he wanted to end that procedure be-

cause he couldn't justify to artists that their work wasn't seen by the whole panel."[66]

From his public appearances and visits to local artists organization, Melchert also learned how justifiably upset many artists were that their slides weren't being returned. Some were thrown out, some went to the Art in Public Places program. "Jim, listening to artists around the country, was able to get slides back, which we did not do before," Faubion said.

The panel process began with instructions from the program director. "Jim Melchert was really clear about what he asked us to do, and when we got too far off the track, he pulled us right back on and said, You've really got to think about whatever it was we weren't focusing on," said Anne d'Harnoncourt, the George D. Widener Director and Chief Executive Officer of the Philadelphia Museum of Art, a member of the 1979 artists panel, and a 1977-through-1980 policy panel member. "He was looking for fairness, and real reasons why we thought something was worthy, or why we thought something for one reason or another was not worthy at that moment . . . I remember the guidelines within which we worked being set out clearly."[67]

The first two stages were defined by individual engagement with the hundreds or thousands of slides. They were projected in banks of five. "It took a lot of preparation on the part of the staff but instead of projecting them one at a time," Melchert wrote, "we would screen an entire bank of slides. This reduced eye strain and made it easier to relate slides of details to the pieces they belonged to."[68]

Only the name of the artist was provided in stage one. The name, plus information about one of the five works projected on the screen, was offered in stage two. The panelists "had to draw individual conclusions about quality, however they wanted to define it," said Richard Andrews, the visual arts program director from 1985 to 1987. "Do you buy into the work enough to push it into the next round—the quality, or the merit, or the genuineness? Does it work?"[69]

Panelists voted silently, on paper. Endowment staff members fed the votes into a computer, which tabulated them. At the end of stage one,

the panelists were given a list of artists who had survived the cut. Each panelist could bring back up to ten of the artists who had been eliminated. At the end of stage two, the "passion" vote initiated by Melchert was brought into effect. By giving an applicant a 1, panelists ensured that the artist would be carried into the next round, no matter how the other panelists voted, which made it possible for a panelist who felt a strong personal connection with an artist's work to keep it under consideration.

Discussion among the panelists began in the third of the four stages. Information about the artist could now be provided. If artists described their work, their description could be read. School, graduation date, and exhibition history were brought in. "We tried to present this information uniformly for every artist," Faubion said. "Age could not be a factor because we are a federal agency."[70]

In stage four, when the recommendations were decided, work could be discussed at length. This round was tape-recorded. Arguments had to be rigorous and clear, not only to make the case to the other panelists but also to enable the director to make that case to the National Council if a panel recommendation was questioned. The discussion could be blunt, even "down and dirty," in Andrews's words. "The panelists were so different," he said. "For them to come to consensus, to get to the point of four votes, enough to get a fellowship, meant a lot of people had to become convinced about work in front of them, and they only became convinced by looking at it repeatedly and learning from other people with very different viewpoints than their own."[71]

One of the jobs of the program directors, who sat in on the deliberations, was to ensure that attention remained on the slides. "I viewed my role as making the panel process above reproach, in terms of conflict of interest and the quality of the conversation," Andrews said. "It's a question of monitoring the character and characterization of remarks. A good example would be—well, 'I think this artist has had a hard time, I kind of know this artist, at least a little bit, and they could really use the money.' I would say, 'Money is not the issue. The issue is the work.' Or, here's an even more common example—'I can't believe this artist sub-

mitted these slides, this doesn't represent the artist. I saw her show last week, phenomenal work.' Sorry, nice to know you've seen the work. What we have to concentrate on and look at is these ten slides. That's my role."

Dowley, the last program director to award fellowships to artists, described her role in a similar way. "If they started drifting into areas of speculation or wonderment about an artist, or a kind of personal knowledge that was really not appropriate to the criteria," she said, "I would redirect the conversation back to the core issue at the table, the criteria. The panelists appreciated that."[72]

Visual Arts Program Directors after O'Doherty and Melchert

After 1982, the visual artists' program directors essentially managed the peer panel system they inherited. Melchert was followed by Benny Andrews, who grew up in a sharecropper's cabin in rural Georgia, where he picked cotton as a child. His father, George, was a self-taught artist. Benny Andrews studied at the School of the Art Institute of Chicago, then moved to New York in 1958. He taught art in prisons. In the late sixties and early seventies, he was a political activist who protested the exclusionary structures of New York art museums. He still makes populist paintings, drawings, and collages that reveal his wariness of institutional power and his empathy with all Americans suffering from the country's obsessions with money and social class.

Richard Andrews began as a sculptor, receiving a Masters of Fine Arts from the University of Washington, before working as coordinator of the Art in Public Places program for the Seattle Arts Commission from 1978 to 1984. He left the Endowment to become director of the University of Washington's Henry Art Gallery, where he works closely with artists, students, and teachers.

None of the subsequent visual arts program directors was an artist, but two of the three were known for their support of artists.[73] Susan Lubowsky (1989–1992) came to the Endowment from New York, from

the Whitney Museum of American Art, where she worked closely with young and midcareer artists. She was brought in at a volatile moment, shortly before the agency was thrown into crisis by two grants to museums, and seen as a bridge between museums—and their time-honored standards—and contemporary artists, many of whom were struggling to make art that met the challenges posed by the end of the Cold War and the rise of identity politics and postcolonial perspectives. "She was a museum curator, appointed as the head of visual arts. That was unheard of," Faubion said. "She turned out to be good. She learned really fast and then she really spoke up very effectively for individual artists and for artists' spaces."[71] In 1992 Lubowsky left the Endowment to became director of the Southeastern Center for Contemporary Art in Winston-Salem, North Carolina, where she gained a national reputation for collaborative projects between artists and local communities. Since the end of 1998, she has been director of the Des Moines Art Center in Iowa.

Dowley came to the Endowment from California, after nine years at Headlands in Sausalito, just outside San Francisco, which she describes as "a laboratory for artists to engage in their work, in conversation with others and in conversation with a place so that they could develop their work"; she had previously been director of Arts on the Line, a Boston Metropolitan Transit Authority (BMTA) public art program. "What Headlands taught me," she said, "which changed the way I work and think, is to listen to artists and to trust in process and to really embrace in an absolutely systematic and integral way that the artmaking process is a model of thinking and being in the world that has enormous value."[75]

Changing Lives

The peer panel system shaped by Melchert and Hunter was as fair and as clean as any government peer panel system committed to artistic creativity and excellence is likely to be. It was largely immune to cronyism. Because a majority of panelists (from the early eighties on, usually four

of six) was required to decide a recommendation, an artist could be
known by one or two panelists and it would not help. Benny Andrews,
who had served on a fellowship panel in 1982, shortly before becoming
visual arts program director, said: "You would see people you would go
to the wall for, and it would go down the drain, and you'd see someone
else's person go down the drain. And it had to go that way because it
was a funnel. . . . It was as pure as can be."[76]

"You can't railroad something through," said Joel Shapiro, who
served on the 1988 sculpture panel. "People get grants out of a consen-
sus of the panelists, not out of who they know. It's very judicious. . . .
I've been on jury duty, and I think I was more persuasive on jury duty,
or could swing the jury more than I could on this National Endowment
panel."[77]

"The notion of consensus worked," said Carole Kismaric, an editor
and curator who served on a photography fellowship panel in 1980, as
well as on publications and policy panels. "People would listen to
people. You really did get a chance, and if somebody made a really good
case for an artist who I felt was less talented, or whatever, I respected
that. I respected my peers, and I respected the fact that in certain in-
stances they knew more of other things than what I knew, and I think
they did the same."[78]

The peer panel process recognized and rewarded quality. "If you get
people who are recognized and well regarded in a given field, and they
then make judgments, you have to give them their due," said Raymond
J. Learsy, a businessman, collector, member of the board of trustees of
New York's Whitney Museum of American Art, and member of the
NEA's National Council on the Arts from 1982 to 1989. "They have to
deal with the term *excellence*. If they really are prominent people in the
field, they understand what excellence is. And you can't second-guess it.
You may not like it. But there's no alternative to that."[79]

"We always knew that it was a sliding scale and an enigmatic and
subjective criterion," Renato Danese said when asked to define what the
agency meant by quality, "but if you get good professionals into a panel
to agree on what constituted quality, a consensus if you will, then that

would become quality by virtue of consensus. I can't think of any grants that were made over the years in the area of artists' fellowships that were bad, much less controversial."[80]

Given the United States government's belief and trust in artists, and given that the recipients and amounts of the fellowships were for most of the agency's existence, to all intents and purposes, decided by peer panels made up of distinguished artists who had been chosen for panels by program directors who were themselves either artists or devoted to artists and who embraced their responsibility to the field, it is not surprising that a fellowship could be a landmark in an artist's life. In 1998, on the eve of the opening of his traveling retrospective at the Hirshhorn Museum and Sculpture Garden in Washington, the celebrated painter Chuck Close testified before Endowment Chairman William J. Ivey, and the National Council on the Arts that "of all the awards and prizes and honorary degrees, everything else that I've gotten in my career, the NEA grant was the most important, came earliest, means the most."[81]

"The 'good housekeeping' seal of approval that comes from the NEA" is "important to other people as well," said Close, who received his fellowship in 1973 and served on a peer panel in 1982 and policy panels in 1983 and 1984. "I've served on other juries and it was always an important indication that this is a person to be taken seriously when on their application they had previously won an NEA. In this way, the NEA leveraged a great deal of other grant money from other organizations."

"Do we actively participate in the lives of our artists, or passively, or not at all?" Richard Andrews asked. "If we care about artists, then I don't see how we can avoid having things like fellowship programs. It's the simplest. It's brain-numbingly straightforward—to have no middleman, no taxes paid in the middle. And you have to take a kind of ecological approach to the whole thing. You're seeding, you're fertilizing. You just have to chill out, in my opinion."[82]

"For ourselves," Melchert said, "we felt the assistance to individuals was the best thing we did, the most important thing we did. It was also the most miraculous when you consider that the Federal Government

should take an interest in a single person. I'm still astonished that this ever happened."[83]

Notes

1. Interview with Michael Faubion, 14 July 1998.
2. 1973 visual arts program guidelines, 9.
3. The history of the art critics fellowships is worth a study in itself. As a result of questions raised about this program inside and outside the agency when Frank Hodsoll took over as chairman in 1981 (he left in 1989), John Beardsley, a curator and critic, was commissioned to prepare an internal report on it. His *Art Critics' Fellowship Program: Analysis and Recommendations*, submitted in August 1983, was sharply critical. Hilton Kramer, an art critic and the editor of the *New Criterion*, used the report to attack a program that he believed was too narrow, too left wing and too inbred. After indefinitely suspending the program, Hodsoll told Grace Glueck of the *New York Times* (5 April 1984) that the Endowment believed criticism was important and that he was "committed to exploring potential solutions seriously." No exploration was forthcoming. The program is still suspended. For more on Kramer's response to the program, see chapter 6.
4. Interview with Ana Steele Clark, 15 July 1998.
5. See Department of Interior Appropriations for Fiscal Year 1969, 14 March 1968, 2306.
6. I found this document, labeled "Five-Year Plan, Program Priorities, Visual Arts," in the NEA library. It is dated summer 1979. The pages are not numbered. It may also be in the National Council notes.
7. Interview with Daniel J. Martinez, 30 December 1998.
8. Shapiro, op. cit.
9. Interview with Ronald Jones, 29 December 1998.
10. Huong Vu, op. cit., 13.
11. Ibid., 12.
12. Ibid., 19.
13. Livingston Biddle, "Our Government and the Arts," op. cit., p. 33.
14. Taylor and Barresi, op. cit., 64.
15. "The Arts in a Democratic Society," op. cit., 35.
16. Pultz, op. cit., 13.
17. "The Arts in a Democratic Society," op. cit., 25.
18. Ibid., 25.
19. In 1984, as a guest curator for P.S. 1, the Institute for Art and Urban Re-

sources, an alternative space in Long Island City, Queens, New York, now called P.S. 1 Contemporary Arts Center, Geldzahler organized an exhibition called *Underknown: Twelve Artists Re-seen in 1984*. In the catalog, Geldzahler wrote that all the participants were "artists of quality who, somewhere along the way, missed the widest audience or the greatest reputation."

20. See Thomas B. Hess, "Editorial: All's Well that Ends Well," *Artnews*, February 1967, 21.

21. See Calvin Tomkins, "Profiles: Moving with the Flow," *The New Yorker*, 6 November 1971, 100. Tomkins (pp. 99–100) described Geldzahler's appointment to the Endowment this way: "One day early in 1966, Geldzahler received a telephone call from the office of Roger Stevens, the chairman of the National Endowment for the Arts. . . . Stevens was looking for someone to run the Endowment's visual-arts program. Several people had recommended Geldzahler to him, and their first meeting, over lunch at a French restaurant, was enough to convince Stevens that he had found his man. Rorimer, when Geldzahler reported the offer to him, seemed to think it would be a fine idea for the Metropolitan to have someone close to the font of federal gifts to the arts, and he asked whether Geldzahler was interested. Geldzahler said that he was."

22. Steele Clark, op. cit.

23. Pultz, op. cit., p. 17.

24. Interview with Ana Steele Clark, 4 September 1998.

25. See Henry Geldzahler, *Making It New: Essays, Interviews, and Talks* (New York: Turtle Point Press, 1994).

26. Segal, op. cit.

27. Interview with Richard Hunt, 18 September 1998. Tomkins writes about Geldzahler's departure from the Endowment this way: "After the 1968 election . . . he announced that if Roger Stevens was not reappointed by the New Administration he would resign, and that's what happened." Tomkins, op. cit., 105.

28. Interview with Walter Hopps, 7 January 2000. Pultz's comment on the panels is somewhat contradictory and it suggests that although the panels worked by consensus, that might not have been Geldzahler's preference. "The panels came to the meetings with lists of artists they felt merited support," Pultz wrote. "Each panelist made the case for the artists he sponsored; the decisions were usually made by consensus, without a vote. If funds remained after granting the awards to those artists the whole panel could agree on, Geldzahler would go around the panel until the funds were depleted and give each member a 'free throw,' which meant to assign a grant to an artist of his or

her choice. It would be better, Geldzahler felt, to support artists individual panelists favored strongly than to let the outcome of a vote make the decision." Pultz, op. cit., 18.

29. Hunt, op. cit.

30. See Michael Straight, *Nancy Hanks: An Intimate Portrait*, (Durham and London: Duke University Press, 1988), 282.

31. Hunt, op. cit.

32. See Brian O'Doherty, *Inside the White Cube: The Ideology of the Gallery Space* (San Francisco: Lapis Press, 1986).

33. See Brian O'Doherty, *American Masters* (New York: Dutton, 1982).

34. Straight, 1988, op. cit., p. 286. Straight wrote: "In his oral history interview, Bill Lacy was asked: 'Would you say that you had more creative leeway in your field than other program directors?' "

He replied, "Yes, Brian and I did, because we were Nancy's pets. Michael was always after Brian and me to set up a program panel like the other programs. We would fend him off. Then, finally, we would hide behind Nancy. She would tell him: 'Let them do what they want to do. They're doing fine.' "

35. Interview with Fred Lazarus, 3 September 1998. On the basis of a passing reference to Lazarus in Frances Stonor Saunders' book, it may be that any attempt to examine every possible connection between the cultural cold war and the NEA would have to consider this enormously able and respected arts educator. In 1956 "Fred Lazarus, Jr., chief donor of the Fred Lazarus Foundation" made "a substantial contribution to the Farfield" Foundation, Stonor Saunders wrote. Many organizations made contributions to the Farfield, which was probably the most important front for CIA cultural activities. Stonor Saunders, op. cit., 138.

36. See Brian O'Doherty, "National Endowment for the Arts: The Visual Arts Program," *American Arts Review* (July/August 1976), 69.

37. Irwin, op. cit.

38. Pultz, op. cit., 25.

39. Ibid., 27.

40. Lazarus, op. cit.

41. Pultz, op. cit., 26.

42. Ibid.

43. Ibid., 27. Michael Straight, the Endowment's deputy director (1969–1978), with an animosity toward O'Doherty that needs to be taken with a grain of salt given his cheerfully disguised cynicism, his willful ignorance of contemporary art and artists, and his clear jealousy of O'Doherty's closeness with Hanks, wrote a damning description of O'Doherty's 1972 fellowship panel

that is worth noting. There is undoubtedly truth in it, and it suggests the kinds of personality conflicts among leaders of an institution in which there is such strong mutual dislike that it might end up having an effect on the way they devise programs. "On April 4, 1972," Straight wrote, "an ad hoc panel appointed by Brian met in Washington, and in the course of a few hours picked forty artists [the actual number was 45] for fellowships from a field of over one thousand. Of these one thousand artists, 250 had been nominated by sponsors; 750 were applicants who had filled out a form and mailed in a 35mm transparency of a painting or a piece of sculpture. That in itself seemed bad enough to me, since the transparencies varied greatly in quality and could not give a reliable sense of a painting, let alone a three-dimensional work. To make matters worse, the transparencies were not reviewed with any care. The panelists simply held them up against an electric light bulb and then tossed them into two cartons marked REJECT or CONSIDER FURTHER.

"The few that survived this round were projected on a screen, along with transparencies of the works of the nominees. From time to time, a panelist would remark, 'This one is by a student of mine,' or a staff man would murmur, 'I don't mean to influence your judgment, but this next one is by a black, and you've only picked one black so far.'

"The nominees rated about one minute apiece of each panelist's time by my count; the applicants, about fifteen seconds. The panelists paused for a buffet luncheon. They finished up in the late afternoon and headed for a nearby pub. I went to my office and pecked out on my typewriter a memorandum on the Artists' Fellowship Program. It began, 'My views on the Program are well known. They were reinforced by today's meeting. I believe that the Program is misconceived in principle and inoperable in practice. I believe that it harms rather than helps artists. I believe that it will harm the NEA.'

"No answer; not a word. Nancy disliked arguments, she feared confrontations, she could not countenance a challenge to a program or a principle to which she was committed." Straight, 1988, op. cit., 287.

44. Interview with James Melchert, 28 December 1999.
45. O'Doherty's ability to maintain the connection between the artists and the Endowment at precarious moments is clear from the minutes of the eighteenth meeting of the National Council on the Arts, May 22, 1970. Ana Steele [later Ana Steele Clark], then the Endowment's director, office of budget and research, reports the council's concern with artists' protests about the Vietnam War: "Mr. Brian O'Doherty described briefly the activities in New York of a group of artists, art critics, and museum people who had joined together earlier in the week to protest trends and actions in American society and the U.S.

government. Mr. O'Doherty noted that he had been in touch with the group and had assured them that their views would be made known to the Council and Endowment.

"An additional consideration brought before the Council was the intent of the members of this group to boycott U.S. government programs, including government-sponsored exhibitions abroad, and, presumably, Endowment grant programs as well. Mr. O'Doherty suggested that the Council indicate its willingness to listen to these artists, and put forth a resolution stating, in effect, that the Council would view with sorrow any action detrimental to further-ance of the artist and his work.

"General discussion followed. A resolution—'the Council notes the com-munication as presented and stands ready to accept the return of any funds'— was not passed. Council members indicated their unwillingness to be placed in a situation which might threaten the Endowment, or might at least lead to a whole series of requests to take 'moral' or 'political' positions, and, in general, agreed that while as private citizens they were free to express themselves on these matters, as a Council their concerns should be solely esthetic.

"A motion was passed:

'RESOLVED: that the National Council on the Arts acknowledges receipt of the communication from the New York Artists Strike Committee and re-minds them of the Council's primary and only mandate which is support of the arts in America.'

"Council members Jimilou Mason and Richard Hung [both visual artists] voted against the resolution." See Rodney Campbell, "Ten Years for Tomor-row," an unpublished oral history project for the National Endowment for the Arts, in the NEA archives, NEA III/18/18-19.

46. Fax letter from James Melchert to the author, 29 Dec., 1999.
47. Interview with James Melchert, 29 September 1998.
48. Plagens, op. cit.
49. Interview with Newton Harrison, Dec., 1, 1999.
50. Hopps, op. cit.
51. Fax letter from Melchert to the author, 29 December 1999.
52. Fax letter from Melchert, 4 January 2000.
53. It is not unusual for NEA bashers to claim that many of the artists who got grants knew who the panelists would be and catered their application to them. This was the assertion by the gifted art critic Dave Hickey in his careless at-tack on the NEA—which he said was founded in 1968—in a 1997 keynote address: "We all sat upon these panels," he said, "as many of you have in this room, with the best of hearts, dreaming that we were going to see something

that was going to totally repudiate our entire lives. The people sending in these grants were not stupid. They knew it was going to be Peter [presumably Peter Schjeldahl], they knew it was going to be [John] Baldessari, they knew it was going to be me. They knew who the hell was on that panel. And you know what we got? What we wanted to see, they thought. And the great wheel of style change that had driven American art for 150 years ground to a halt." In fact, hardly any artist had any way of knowing before applying who would serve on the panels. What's more, Hickey never served on an artists' fellowship panel. Neither did Schjeldahl. Baldessari served on one, on video, in 1983. Dave Hickey, *Address to the National Council on Education for the Ceramic Arts*, Bally's Hotel, Las Vegas, 2 April 1997. The address was taped.

54. It was rare for someone to serve on more than one panel. Six people served on three, and three people served on four. They were curators who became regulars before Melchert was appointed visual arts program director. The three were Van Deren Coke, Alan Fern, from the Library of Congress, who served on panels in 1971, 1973, 1974 and 1975, and John Szarkowski, from the photography department of New York's Museum of Modern Art, who served on panels in 1971, 1973, 1975, and 1976.

55. Harrison, op. cit.

56. Lazarus, op. cit.

57. Melchert, 28 December 1999.

58. Melchert, 29 December 1999.

59. Melchert, 4 January 2000.

60. Fax letter from Melchert, 11 January 2000.

61. Ibid.

62. Melchert, 4 January. Nauman's presence on that panel helped make Ellen Phelan's 1978 fellowship "particularly meaningful. I thought Nauman was some sort of Olympian," she said. Phelan, op. cit. For David Ireland, too, receiving a visual artists' fellowship in 1978 was particularly meaningful because Nauman had been a panel member. Interview with James Melchert, 20 January 2000.

63. Melchert, 4 January.

64. Dowley, op. cit.

65. Biddle, "Our Government and the Arts," op. cit., 505.

66. Faubion, op. cit.

67. Interview with Anne d'Harnoncourt, 20 December 1999.

68. Melchert, 4 January 2000.

69. Richard Andrews, op. cit.

70. Faubion, op. cit.

71. Richard Andrews, op. cit.

72. Dowley, op. cit.

73. The exception was Rosilyn Alter (1992–1994), who was brought in by acting chairman Anne-Imelda Radice, a former schoolmate, at one of the most vulnerable points in the agency's history. Radice's mandate from George Bush's White House was, at all cost, to keep the Endowment out of trouble.

74. Faubion, op. cit.

75. Dowley, op. cit.

76. Interview with Benny Andrews, 18 October 1998.

77. Shapiro, op. cit.

78. Interview with Carole Kismaric, 28 January 1999.

79. Interview with Raymond J. Learsy, 10 September 1998.

80. Interview with Renato Danese, 7 July 1998.

81. Chuck Close, "Address to William J. Ivey and the National Council on the Arts," Washington, D.C., 4 November 1998.

82. Richard Andrews, op. cit.

83. Melchert, 29 September 1998.

IV

1968

The fellowships to individuals that were essential to the Endowment's identity as an informed and audacious institution ensured that the agency, like many of the artists it funded, would know what it was like to live close to the edge. Although the visual artists' fellowship program never got the Endowment in trouble, its fellowship programs left it permanently exposed. Any politician who did not like the arts, or who did not want artists to be part of the image of the United States, or who found the concept of unrestricted federal funding unacceptable in principle could, through the fellowship programs, find some grant with which to target the NEA. Because the fellowships were intended to encourage independence and risk, there were always projects or novelists, playwrights, poets, choreographers, photographers, or other artists funded by the Endowment whom enemies of federal arts funding could hold up as examples of government betrayal and waste.

In the dramatic February 1968 House debate about reauthorizing the NEA and NEH, critics of the NEA zeroed in on grants to individuals. They believed direct and unrestricted fellowship programs meant the agency would not be bound by congressional authority or by the authority of mainstream values. They knew the independence of these programs gave the agency much of its energy and appeal. They were convinced that if fellowships were scrapped, the agency could be put

in its place. Its supporters understood just as clearly that the fellowships had to continue. They believed that if grants to individuals were eliminated, the agency could become so institutionalized that its ability to support creativity, develop the field, and identify the government, and with it the United States, with confidence and invention would be seriously diminished. Both sides knew that without fellowships to individuals, the agency would lose much of its reason for being.

The 1968 debate clarifies the attitudes toward artists at that time and the role of the NEA in both developing a place for the artist in America and in marshaling the resistance of people who wanted artists kept out. The debate unfolded against the background of the Vietnam War, violent unrest at home, a national debt of more than $350 billion, and the chutzpah of congressional supporters of the arts and humanities Endowments to ask for a two-year appropriation of $55 million, almost three times the amount requested by the Johnson administration, which had made their reauthorizations a priority. Many of the thorny conflicts that would define subsequent battles over the Endowment were contested here, in 1968. These included individuals versus institutions, contemporary art standards versus museum standards, long-term investment versus immediate accountability, and who is censoring whom. They included the conflict between those who can tolerate art only as a skillful rendering that is respectful of their icons, and those for whom art offers the freedom to go wherever the pressures of their own experiences and consciences lead them.

The issue of grants to individuals entered the House debate slowly. Here and there, critics of the Endowments cited examples of what they saw as grants so absurdly specialized that they were irrelevant to the national interest at a time when the government's main concern had to be winning a multibillion dollar war in Asia while insisting on fiscal responsibility at home.[1] Scattered remarks signaled the eventual face-off. Representative John M. Ashbrook of Ohio complained that the NEA "might reward the avant-garde artists and discourage the traditional artists as it is now doing," which, in his view, amounted to government censorship.[2] A short while later, Representative Carl Christopher Per-

kins of Kentucky, arguing for the Endowment, acknowledged "in-
stances of controversial grants to individuals or projects." He said that
"controversy in the arts and humanities is to be expected. In any case,
we ought to judge the Foundation by its total accomplishment, not by
one grant here, or one grant there, that one or the other of us might
disagree with." Perkins responded to an argument that had not yet been
made but which he knew was coming. "Some of us apparently believe
that we should not make grants directly to individuals but only through
institutions. The reason that America is great today is the contribution
of individuals. This is particularly true in the arts where creativity ulti-
mately rests on the shoulders of a single individual working alone. To
force him into the mold of a given institution leads to a subtle kind of
Federal control that we have carefully tried to avoid."[3]

Eventually Representative William Scherle of Iowa, whom Michael
Straight, Nancy Hanks's deputy director, would describe several years
later as the "Endowment's most implacable enemy,"[4] moved the issue
of direct and unrestricted fellowships to the center of the debate. "I do
not feel that it is past time to give thought to the propriety of
Government-subsidized art," he said. Scherle quoted from Alvin Tof-
fler's book, *The Culture Consumers, A Study of Art and Affluence in
America*: "No program of front door subsidies . . . can ever be
problem-free and pressure-free." He added that "when Congress ap-
propriates funds for a specific purpose, it is not making out a blank
check for whatever use some bureaucract chooses." Then he got to the
point. "One of the most questionable features of the current Arts and
Humanities Foundation program," he said, "is the system of individual
grants." Awarding $5,000 to sixty painters and sculptors in 1967 was, in
his view, a "Government giveaway." "As a method of providing incen-
tives toward improved quality workmanship," he said, "it must fail."
He concluded "that the 'individual grant' program should be ended."[5]

The amendment to eliminate grants to individuals was offered by
Representative William A. Steiger of Wisconsin, who described him-
self as a supporter of the arts and humanities legislation. His amend-
ment would "clearly limit the power of the National Endowment for

the Arts in giving grants to specific individuals for work that they may do."[6] Steiger's aim was clear. Not being able to fund individuals would, he said, "restrict the power of the Foundation." It "would more clearly limit those who are in charge of the Foundation."[7] Steiger believed the money should instead be given to "those institutions, organizations, and groups that have legitimate reasons for their existence, that can be benefited and whose expertise can be shared by more people."[8]

Although the attacks on the agencies were often made in the cause of fiscal responsibility—and their critics had every right to feel provoked by the $55-million request—and sometimes in terms of guns or butter,[9] it is clear that for some or most of the Endowment's enemies, artists were, as they had been during the McCarthy era, nothing but subversive, good-for-nothing, antisocial freaks. Representative Paul Albert Fino of New York raged that "because any production, irrespective of origin" can be subsidized by the Endowment, "taxpayer dollars can be used to subsidize anti-Vietnam movies made by European Communists or antiwhite plays written by black nationalists like Leroi Jones." Fino said he would support the current appropriations if the NEA "would cure all of the shortcomings by making the following changes. First, remove the authorization to make grants to individual artists. This is done by removing the power of the Endowment to contract with individuals and to give them grants-in-aid. I think it is much safer to allow grants and subsidies to groups only. Aid to individuals is liable to turn out to be nothing more than a subsidy for hippies, beatniks, junkies, and Vietniks."[10]

Representative Frank Thompson of New Jersey reacted strongly to Steiger's amendment. He knew what would happen if arts funding became more institutional. "Most institutions are composed of individuals who share similar interests and outlook. Therefore, the selection of an institution identified with one school of art, music, or study would put that institution in the role of censor, in the sense that it would at some point award the money to an individual artist. It will likely go to an individual artist who shares the tastes of the institution."[11]

Representative Ogden Reid of New York understood that the

amendment, if passed, would "affect the heart of the Arts Endowment." It would "seriously weaken and circumscribe the Endowment for the Arts, and it might remove the individual and creative artist from an area of basic and fundamental support." Reid read a letter in which Roger Stevens wrote that requiring artists to maintain contacts with institutions "might cut the Federal Government off from the main sources of progress in the arts, as elsewhere throughout American experience: the creative individual."[12]

The amendment passed. The Endowments were reauthorized by the House but for only one year, at 11.2 million, 7.1 for the NEA.

The vote mobilized the agency. At its next meeting, in Tarrytown, New York, in April, the National Council, which now included Marian Anderson, Duke Ellington, Helen Hayes, Harper Lee, and Sidney Poitier, as well as Ralph Ellison, Gregory Peck, and Isaac Stern, recognized the gravity of the situation. The unpublished history *The National Council on the Arts and The National Endowment for the Arts During the Administration of Lyndon B. Johnson* reports that "distress at revocation of Endowment authority to award individual grants . . . permeated the entire meeting, touching off a series of discussions and culminating in a resolution affirming Council's belief that individual grants were fundamental to Federal support of the arts in the country; that the Council could not be responsible for the quality of Endowment programs in support of creative artists if the authority to recommend such awards was to be delegated to outside institutions rather than to the Council; and that, therefore, the action of the House with respect to individual grants should not be allowed to stand."[13]

The council's defense of the individual artist was exemplary. It emphasized that "all arts depend on the single creative artist." It said that in contrast with institutions, a small grant to an individual can make an enormous difference: "Institutions need so much, the creative artist so little," therefore the "wisest use of limited funds might be for support of the individual rather than the institution."[14]

In the months after the February House debate, President Johnson announced he would not seek reelection and the Reverend Dr. Martin

Luther King, Jr., and New York Senator Robert Kennedy were mur-
dered. The Endowments had been brought into existence to help the
country find its way through a period of emergency. In the postwar his-
tory of the United States, it would be hard to find a year of greater
trauma than 1968. In May, the Senate rejected the House amendment to
eliminate grants to individuals and reauthorized the Endowments for
two years. The 1969 authorization was roughly $8 million for each
agency.

The close call led Stevens to order an analysis of grants to individu-
als. The resulting five-page memorandum, prepared by Charles C.
Mark, the director of planning and analysis at the agency, is a defining
document. Mark noted how hard it was to evaluate the effectiveness of
grants to individual artists yet how crucial they were to a national arts
funding agency. "If a general program is conceived in which help to the
individual is excluded," he wrote, "it is a declaration that cultural
progress is unimportant, that we can live with only the past to preserve
while the future is left to some other granting body. Since the Endow-
ment has a mandate from the Congress, this position would then be
viewed as the cultural policy of the United States."

Mark underlined the importance of the period "after training and be-
fore the attainment of stature" and said that this transitional space is al-
most "barren of any philanthropic attention. Recognition of the
benefits of occasional sabbaticals from nonartistic but economically
necessary jobs is given even less attention. If private philanthropy were
to elect to adequately meet the needs of individual artists there would
perhaps be reason for the Federal government to pause, but none of the
foundations have made such a declaration, nor is there a discernible
trend in this direction."

While communicating the value for artists of NEA grants, Mark em-
phasized the unending struggle of artists to establish a place for them-
selves in America. "The prestige and honor which come with
recognition from the Federal Government should not be undervalued,"
Mark wrote. "Recipients of Endowment grants often feel the recogni-
tion they have received is of far greater value than the amount of

moncy. This is particularly true in the cases of individuals attached to universities and in the smaller cities. The new respect these artists receive is most often from the general community where they have heretofore been virtually unknown."[15]

For the next twenty-seven years, the visual artists' fellowship program continued to fund artists and evolve in ways that enabled it to be responsive to the changing needs and conditions of the field. Shaped by words like *progress, experimentation,* and *risk,* the program remained committed to locating the creative pressures of the moment and supporting artists whose thinking was vitalized by them. Along with artists struggling alone in their studios with paint, plaster, or steel, it funded artists who wanted to work on or with the land and artists who wanted to work collaboratively, with other artists or with communities outside any institutional art world. It funded artists who wanted their work to be seen on television, billboards, bus stops, or buildings, and artists for whom art could be a parade or a landfill. Because it was at home with risk and experimentation, the visual artists' fellowship program understood the importance of process, and even of failure. It recognized that art was no longer just painting and sculpture and that the artistic experience was no longer confined to the gallery and museum. It was unafraid of imagination, curiosity, desire, and change. It continued to support ways of thinking about and making art that had the ability to ask fundamental questions about art, the United States, and human nature.

It would be senseless to list all the influential artists this fellowship program supported. Suffice it to say that without the artists it funded at the right moment, postwar American culture would be unrecognizable. Many of the artists it funded are thinkers and poets whose creative utterances have made it possible for others to think more clearly and deeply, and feel and imagine with greater intensity and wonder. Many of those who have been given fellowships—including Laurie Anderson, Siah Armajani, John Baldessari, Jonathan Borofsky, Chris Burden, Ping Chong, Felix Gonzalez-Torres, Dan Graham, Hans Haacke, David Hammons, Newton Harrison, Gary Hill, Robert W. Irwin, Al-

fredo Jaar, Donald Judd, Allan Kaprow, Barbara Kruger, Sol Lewitt, Robert Mangold, Daniel J. Martinez, Gordon Matta-Clark, Robert Morris, Bruce Nauman, Maria Nordman, Dennis Oppenheim, Adrian Piper, Martin Puryear, Yvonne Rainer, Susan Rothenberg, Richard Serra, Joel Shapiro, Cindy Sherman, James Turrell, Bill Viola, and Ursula von Rydingsvard—are internationally known artists admired and needed in other countries. They have helped to ensure that American art and culture would have a privileged place in the dreams and imaginations of people throughout the world.

Notes

1. For example, a month before the February debate, Representative Walter S. Baring, Jr., of Nevada made a statement expressing his concern about what he saw as frivolous NEA and NEH grants: "Surely such high priority programs of the Foundation, such as issuing grants to colleges and universities to study the history of the comic strip, to research and edit the unpublished memoirs of the Spaniard Oviedo, for a study on the political thought of William of Ockham, 14th-century theologian and philosopher, and research of sign language of the monkey, the latter being a grant to the University of Nevada, in my State, are hardly worthy of any increase to our staggering national debt.

 "If the administration deems it must spend this $10 million [referring to the increase over the 1968 budget requested by President Johnson], then at least put it in a program where it will do the country some good." See *Congressional Record*, 30 January 1968, 1491.
2. See *Congressional Record*, 27 February 1968, 4313.
3. Ibid., 4315.
4. See Michael Straight, *Twigs for an Eagle's Nest: Government and the Arts: 1965–1978* (New York/Berkeley: Devon Press, 1979), 26.
5. See *Congressional Record*, 27 February 1968, 4321–22.
6. Ibid., 4346. One of the three individuals Steiger cited in his examples of questionable grants was the musician Alexander Schneider, whom Representative Thompson later noted "is the first violinist, or was, with the Budapest String Quartet." He "is acknowledged to be one of the greatest living musicians." Ibid., 4347.
7. Ibid., 4325.
8. Ibid., 4346.

9. The most colorful declaration of the guns-or-butter argument was made by
 Representative Frank T. Bow of Ohio, who did not believe it was the respon-
 sibility of the government to build culture, and who was offended at the in-
 crease in the amount of money supporters of the agencies were requesting in
 their reauthorizations. "Certainly at this time there is not a soul on this floor
 who does not realize that we are at war," Bow said. "Those who say that this
 bill will help the men in Vietnam make an argument that I cannot understand.
 We are at war. We cannot have guns and butter. And this is guns with straw-
 berry shortcake covered with whipped cream and a cherry on top. It is some-
 thing that we just cannot afford." Ibid., 4345.
10. Ibid., 4333-44.
11. Ibid., 4346.
12. Ibid., 4347.
13. *The National Council on the Arts and the National Endowment for the Arts During
 the Administration of President Lyndon B. Johnson* volume 1, *The History*, No-
 vember 1968, an unpublished document in the NEA archives, 79.
14. See National Council pages, 1968, 39.
15. The memo is included in the 1968 National Council pages just after the reso-
 lution supporting individual artists. In a section called "Arguments Against"
 grants to individuals, Mark mentions on page 2 the "danger of fostering 'offi-
 cial' art, or art which is prejudiced in favor of one means of expression," which
 was brought up again and again over the years by people critical of the agency.
 Mark said the Endowment was no more concerned with this than private foun-
 dations were; he wrote that the diversity of panels was a protection against
 this. He described another danger as "irate letters from disappointed appli-
 cants and self-appointed critics, both amateur and professional," which he de-
 scribed as "routine events." He wrote that "often the disappointed artist will
 take his case to his congressman, who, in turn, feels a responsibility to explain
 or justify the action and pacify his constituent. As a result, the congressman
 and the Endowment invest unproductive time and expense in an exercise of
 defense. Perhaps this is another problem which can only be accepted and tol-
 erated." At the end of this section (page 3), Mark makes an observation that
 suggests both how small the arts community was assumed to be in 1968 and
 how much the Endowment saw itself as creating as well as nourishing the
 field. "Exhausting the supply of quality grantees is a possibility the Endow-
 ment has considered, but little investigation has been done to date due to the
 short history of the program and number of grants made."

V

1995

The Vote

In 1968, congressional critics of the Endowment were willing to allow the agency to exist if fellowships to individuals were eliminated. The same was true in 1995. "The issue of NEA grants to individuals has resurfaced as recent controversies have drawn new attention to the NEA's practice of awarding grants to individuals whose 'art' offends so many of us," Senator Nancy Kassebaum of Kansas said. "I believe that the time has come to draw the line on grants to individuals. . . . I believe that the literature fellowships are the only worthwhile exception."[1]

Senator James M. Jeffords of Vermont, a strong supporter of the Endowment, shared her position. "Under the leadership of Senator Kassebaum, in our committee this year, we took up the Endowments and reauthorized them," he said. "In doing so, we also changed the law such that the chance of having the American public offended by grants for projects that they consider less than acceptable is totally eliminated.

"How have we done that? First of all, we have addressed the issue of individual grants, where many of the problems have been. . . .

"There still will be grants available to individuals at the state level, and there will be a large number of challenge grants. All these things that are presently allowed under the national endowments, all the good

works which have not proven to be offensive to anyone, will still be able to go forward."[2]

The government decided that in order to save the Endowment, it had to stop investing in artists and invest its cultural authority in institutions. "In our bill," Senator Kay Bailey Hutchison of Texas said, "we make sure that the funding goes to organizations of the arts, not to individual artists that might do things that would offend the conscience of mainstream America. . . .

"I think we can easily determine what should be used for arts appreciation and what is inappropriate. Do those people have a right to go out and use private funds to have their interpretations of art? Absolutely. But do we have to have Government funding of that? No. . . .

"I want to make sure that we have the book of art and the book of words along with our great standard of deeds in this country for our future generations to appreciate. And that is the purpose of this amendment . . . to make sure that the NEA does what our standards would require that they do; and that is, provide the support for the excellence in the arts for our future generations to be able to have the access that we would like for them to have."[3]

This time, it was hard to find anyone willing to stand up for the individual artist. Senator Phil Gramm of Texas said that "the support for the small artistic institutions or the individual artists is the seed corn for our ability to exercise that type of a strong cultural influence in the world."[4] Senator Edward M. Kennedy of Massachusetts, like Jeffords a consistent supporter of the NEA, said: "We do not have to mention at this time the list of writers and painters, those individuals whose creative energy and expression have enriched the Nation, achieved the top tier of recognition and accomplishment, and look back with pride and gratitude to Endowment support in their early years of development."[5] As far as support for individuals artists went, these tepid, and in Kennedy's case eulogistic, remarks were about it.

In 1995, funding for the Endowment was cut 40 percent, from $162.3 million to $99.5 million, but the agency survived. Despite the advocacy of NEA chair Jane Alexander (1993–1997) and others, fellowships to

individuals, except writers, were eliminated. That astonishing govern-
ment trust and belief in the artist was dead.

After Congress eliminated funding to individuals, the Endowment,
too, detached the power of art from the power of the artist. One of the
aims of *American Canvas: An Arts Legacy for Our Communities*, a book
initiated by Jane Alexander and published by the Endowment in the fall
of 1997, was to "transform the arts in the civic context from their
present status as amenities that are added once the necessities are taken
care of, into one of the primary means of addressing those necessities in
the first place."[6] Based on roundtables open to the public around the
country in which museum directors, corporate executives, elected offi-
cials, and just about every kind of responsible professional was wel-
come except the artist, the book defined the value of art in terms of
community embeddedness and social good. By so doing, it admitted the
Endowment's insularity. "In the course of its justifiable concern with
professionalism, institution-building, and experimentation during the
60's and 70's," the book said, "the arts community neglected those as-
pects of participation, democratization, and popularization that might
have helped sustain the arts when the political climate turned sour."[7]
The book accused supporters of the arts of having taken too much for
granted about art, its audiences, and its place in society. "Gone are the
days—if, indeed, they ever really existed," the book said, "when art
can be left to speak for itself, its right to public patronage unchallenged,
its value to society universally acclaimed. In addition to offering their
basic programs, arts organizations will increasingly need to place their
work in a social context, making clear their stake in the community."[8]
Clearly the Endowment could no longer afford to pay more attention to
artists and to the needs of the field than to the needs of the general
population and the multitude of ways in which the artistic imagination
could enrich and strengthen the fabric of everyday life. Clearly it was
no longer productive to think of artists as prophetic outsiders.

While describing all the good art could do inside society—for
neighborhoods, communities, businesses, and people with limited cre-
ative outlets and access to power, *American Canvas* avoided any discus-

sion of the individual artist. In its eagerness to root art in community and demonstrate art's potential for social good, the individual artist was thrown out. Because it essentially refused to allow the kinds of artists the NEA had supported to be part of its roundtable conversations, the book reinforced the congressional notion that these artists were too untrustworthy to be part of a national conversation—which, in turn, reinforced the old assumption that artists are irresponsible and childish and therefore too unreliable to be welcomed into formative debates about America.

Just as important, by separating the social value of art from the courage and personalities of the artists who make it, *American Canvas* facilitated an unprecedented institutionalization of the art world that continues unabated as this book is being written. Apart from institutions devoted to contemporary art, living artists have almost no active presence in American museums. Many museums don't like artists. They want to be able to use art as their boards of trustees, economic advisers, and curators direct them to. By emphasizing the importance of art to the nation while banishing the individual artist from the national stage, Congress and *American Canvas* gave institutions full permission to use art to advance their social status, economic aura, global ambition, and brand name without any obligation to consider the realities of its makers or the condition of the artist in America. By separating art from the artist's body, Congress and the NEA made it easy for art to be institutionally perceived as weightless and portable property, like a stock, or a bond, or an image that could be instantaneously called up and manipulated or marketed on the Web.[9]

The elimination of all fellowships, except to writers, essentially disembodied the agency. The NEA could still fund projects, some imaginative and important, but it could not embed those projects in the stories and struggles of the artists who inspired or led many of them and who previously identified the agency with imagination and risk. The power was now in group or institutional hands. Along with helping to relegitimize the old American wariness of the artist, the Endowment's sudden distance from the individual artist disconnected artists from the

agency. Not only was it harder to find artists willing to serve on peer panels but with most of the Endowment's funding going to institutional projects, there were fewer places for artists in the peer panel system. Not surprisingly, the applications received by the agency got tamer. "What we end up funding is what the applicants submitted," Jennifer Dowley said, "and what people were submitting were things that had very little to do with the support of the creation of work. It was as if our whole contact with a segment of the creative world was lopped off, and not only from artists but also from visual artists' organizations."[10]

In a stunning turnaround, the same agency that had been devoted to nourishing artists and making them feel they were necessary to their country's ideals and dreams was now telling them, in effect, that it was only by becoming socially responsible in ways defined by the Endowment that they might be invited into the lobby of the nation, where they could watch community organizers, museum directors, and other arts adminstrators on their way to the penthouse. In Congress, in the Endowment, and in society, there was a place for the art artists made and for the people who commissioned and administered it but there was no place for them. We want what you make, artists were told, but we don't want you. Artists had been sent a message, and the country had been sent a message about them.

Targeting Fellowships

The visual artists' fellowship program was not the program that got the NEA in trouble. The artists whom politicians, the news media, and the general public identify with the crisis of 1989 and the contempt and wrath that poured down on the agency in the following years were Andres Serrano, because of *Piss Christ*, a large (40-by-60-inch), golden-yellowish photograph of a cheap plastic cruficix in a Plexiglas container filled with the artist's urine, and Robert Mapplethorpe, primarily for his *X Portfolio*, photographs of hard-core, multiracial sex acts in a sadomasochistic gay subculture; and, to a lesser degree, Karen Finley, who gained notoriety for a performance in which she covered her naked

body with chocolate in order to make a statement about the abuse of women. The Serrano and Mapplethrope photographs were included in exhibitions supported by NEA institutional grants. Since 1981, the NEA, in a public-private partnership with the Equitable Life Insurance Company and the Rockfeller Foundation, had given money to the Southeastern Center for Contemporary Art (SECCA) in Winston-Salem, South Carolina, for *Awards in the Visual Arts*, an annual juried contemporary art show that toured the country; from 1986 to 1991, the amount of the NEA grant was $75,000. Each show consisted of a selection of ten works by ten contemporary artists. One of the artists selected for the 1987 show was Serrano; *Piss Christ* was one of his ten works. In 1988, the NEA had given a $30,000 institutional grant to the Institute of Contemporary Art (ICA) in Philadelphia to help with its organization of *Robert Mapplethorpe: The Perfect Moment*. The tour of this retrospective was uneventful until it was about to open at the Corcoran Gallery of Art in Washington in the early summer of 1989 when religious and political conservatives used some of the photographs in it to raise hell about Endowment abuse of taxpayer money, and the Corcoran, which received roughly $300,000 a year in federal support, canceled the exhibition. Finley was recommended for an individual artists fellowship in 1990, but it was in the solo-performance category of the NEA's theater program; as were the fellowships recommended for John Fleck, Holly Hughes, and Tim Miller, who with Finley became known as the NEA Four. All four of the 1990 peer panel recommendations were turned down by the National Council.[11] The fellowships were reinstated in 1993.

Like many other American artists in the multicultural moment of the late eighties and early nineties, all six of these artists were asserting the realities of groups or communities that were still considered less than or un-American. Fleck, Finley, Hughes, and Miller make left-wing activist art that is outspokenly political and uncensored in its imagery and language. Fleck and Miller are gay; Hughes is a lesbian. For all six of these artists, the body is a personal and political site, art a way of challenging general assumptions about the body and who has a right to decide what

people choose to do with their bodies and how normality is defined. Like many other artists critical of established race, class, and gender hierarchies, the NEA Four, painfully aware of the daily emergency of the AIDS crisis, were uneasy with the image of the heroic and solitary artistic genius who made art in his studio and then had it absorbed into a market and museum system, which, if everything worked out perfectly, would eventually allow it to be contemplated for years to come on the clean white walls of corporately controlled museums. You could not detach the art of any of these artists from their bodies. Their bodies were those of gay, lesbian, feminist, or nonwhite Americans. Their art/bodies demanded attention. How could a national arts agency committed to the purpose and breadth of the arts not fund artists who were asking basic questions about the definition of art and the identity of the artist, and about who had a right to feel at home in America?

For political conservatives, for the Christian Right—the new Fundamentalist force in American politics that no one in the Endowment saw coming—and for all their supporters in the press, these artists were a confirmation and a windfall. Here was proof that at the end of the Cold War, the United States government, like the rest of their beloved country, was being infiltrated by forces intent on undermining God-fearing, flag-revering, white, heterosexual America. Here was proof that it was time for real Americans to close ranks. Here was proof that voters had to be enlisted and money raised to fight the enemy within. The more the right could keep these artists in the news, the more alarms they could set off and the more money and networks they could develop. These artists and the government agency that supported them stayed in the news so long that a connection between the artist and the alien body became part of the national consciousness. What made this connection so final was AIDS. Not only was the body of the artist identified with the difference of people who were not white and not heterosexual but it was also linked to an actual disease whose potency was demonstrated by Mapplethorpe's death from AIDS in March 1989, just before the national spotlight began to shine on his exhibition. The right's tirades against artists like Serrano, Mapplethorpe, and Finley

were shot through with images of uncleannesss. Many politicians, including President George Bush, used the word *filth* to describe the photograph by Serrano. "In the last twelve months," Patrick J. Buchanan wrote in a 1990 column, "America has begun to react as a healthy body ought—when slowly fed poisons that can kill it. But reaction is not enough." Buchanan added: "Just as water polluted with mercury will slowly destroy the brain, drinking for decades from a culture polluted with modernist dreck can make a society sick unto death."[12] Once again artists personified everything real America feared, but now the fear could be nearly hysterical because the political and religious right and the tabloid press had succeeded in identifying the artist's body with physical as well as spiritual degradation. When Congress eliminated fellowships and in effect quarantined artists from government, it sealed within the national consciousness this connection between artists and infection. One of the great strengths of *American Canvas* was its insistence that art was necessary to the health of communities, neighborhoods, and the country as a whole, but by detaching this gift of health from the individual artist, it separated the healthiness of art from the body of the artist—thereby giving its stamp of approval to the image of the artist as toxic alien that conservatives and then Congress had fixed in the public's mind.

None of the art targeted by politicians, Christian Fundamentalists, and the tabloid press had been funded by the visual artists' fellowship program. Alexander tried to convince Congress that fellowships were not the problem, but they would not listen. "It just about killed her," Ana Steele Clark said. "She would go to these hearings or go to these meetings on the Hill and they would say, 'Why don't we just get rid of grants to individuals, because that's where all the trouble comes from,' and she would say, putting aside everything else, 'That's bad information,' and she would explain about the Mapplethorpe and the Serrano and they were grants to organizations and all that. They didn't want to hear it."[13]

In the summer of 1989, Congress threatened to cut off government funding for five years to SECCA and the ICA in Philadelphia, but the

compromise bill in the early fall of that year was little more than a slap
on the wrist. If these museums were awarded grants, the bill stated,
Congress was to be notified within thirty days of the reasons and crite-
ria for the award. The ICA and SECCA continued to receive funding
from the agency.[14] When Congress decided to go after artists, there was
no such compromise.

The same outsiderness, nerve, and distrust of official thinking that
had been valued by the government now left artists exposed. They had
no power base. "Nothing represents the individual artist's programs,"
Fred Lazarus, president of the Maryland Institute, College of Art, said.
"Individual artists weren't represented by anybody."[15]

Going after artists now had no cost. "It's the easiest," Roger Mandle,
the president of the Rhode Island School of Design, who served on the
national council throughout these fateful years, said, explaining why
the fellowship program was attacked. "If they went after institutions,
it's a little more difficult as they have likely supporters on the board, and
a community of interests around them. They have other things that par-
ticular institution will also do as an entity that are salutary whereas if
you have an artist that's all he or she does. That's what they're known
for. The Corcoran is known for a host of good things and so only got
their wrists slapped. So did the Contemporary Arts Center in Cincin-
nati. But in the end they're redeemable whereas artists are easy to de-
monize, just like the welfare mothers. They're easier targets. They are
the ones who do the expressing of difficult issues. While it's a lack of
judgment of an institution, it's the sin of the artist who has made the
things in the first place."[16]

"For politicians," Suzanne Delehanty, director of the Miami Art Mu-
seum, said, "it is best to pick a target that is not going to hurt their cam-
paign war chest. For the radical right, it is best to pick not on an
institution, but an individual. For them, an artist is a tangible scapegoat.
The people who run these public opinion operations are geniuses at de-
ciding whom and what the targets should be."[17]

Going after artists could serve any number of conservative agendas.
"What they really wanted to do is stop funding for contemporary art,

particularly gender- or identity-based work," Richard Andrews, director of the Henry Art Gallery, said. "There is one way to do that, eliminate the NEA. Plan A was to eliminate the NEA, and there still is concerted effort to do that. Fallback position, B, is somehow to find a way to stop funding this pond scum of work, and that turned out be complicated because, my God, a lot of their constituences actually cared about the work of living artists, and, furthermore, by God, there is some good work being done. So I think they felt any kind of systematic removal of funding of contemporary art would be impossible, so a better strategy would be targeting the NEA's direct funding of individual artists: the fellowship program. So what's the best way to do it? We'll go on record as: no more direct funding to individual artists, only institutional grants. Case closed. Problem solved."[18]

The language used to describe contemporary artists and art by its enemies was often brutal. When artists were defended, it was usually in terms of artistic freedom, which cannot win political support from people suspicious of artists, or in instrumental terms, such as art's pivotal importance in a thriving tourist industry or in empowering communities at risk. Many people who worked with artists needed them, actually liked them, and found them indispensable. "I was always suprised at the bad reputation artists had, or the stereotype of being difficult," Dowley said. "I found artists to be engaged in the world on the most humane terms of any people I know. I find tremendous relief being around them."[19] But in the last decade of the twentieth century, many politicians, most of the media, and even some art professionals had no interest in this kind of testimony. Congress, the Endowment, and many Americans found in artists not relief but threat, and no voices were allowed onto the national stage that might alleviate their fear.

A Different World

What happened? Why were artists as unwelcome after the Cold War as they had been when it began? Why in Congress in 1995, and then within the Endowment itself, was the prophetic outsider and visionary

truth-teller who in 1965 was deemed essential to the nation's purpose and grandeur nowhere to be found?

The conditions that brought the artists' fellowships into existence in 1965 bore almost no relation to those thirty years later. The Cold War was over. The United States had won, which was understood by the country not just as a political but as a moral and spiritual triumph. If the United States had prevailed over a tyrannical, godless empire, then it, and its economic, social, and political system, must, as American Cold Warriors had claimed all along, be touched by God.[20] With the defeat and disgrace of Communism, no system existed that offered even a hint of a viable alternative to capitalism. Maybe Americans who believed in God—most certainly not artists, multiculturalists, and other cultural relativists—were most responsible for its victory. Maybe America didn't need self-analysis and self-questioning. Maybe money and consumerism had no downsides. Maybe they were unequivocally good.

The United States had won not only the arms race, but also the space race. And with the collapse of the Soviet Union, science and technology seemed more beneficial than menacing. In the sixties and seventies, a number of influential artists, including Athena Tacha, Mel Bochner, Michael Heizer, Helen and Newton Harrison, Barry LeVa, Sol Lewitt, Dorothea Rockburne, Tony Smith, and Robert Smithson, made art influenced by science. Then came chaos theory, black holes, and multiple infinities. By 1990, many more artists had turned to science. In the first part of the nineties, science was more embraced than questioned and it was hard even to remember that not that long ago advances in science had made artists and writers, as well as many other Americans, fear for the future of the human race. Much of the passion for science centered on astronomy. By the mid-nineties, many artists were making work inspired by the eye-opening photographs sent back to Earth by the Hubble Space Telescope, just as earlier artists had made work inspired by the French or Dutch landscape, or by images from Greek mythology or the Bible.

The strengths of technology were so overwhelming that its weaknesses seemed insignificant. Electronic technology was becoming so in-

escapable that almost every artist, even those whose work was patiently and insistently handmade, in some way depended on it. By the mid-nineties, the electronic technology industry had become a global corporate empire whose capital was the United States. This new technology was the future. As the American economy that had begun to boom in the mid-nineties became more and more dependent on American mastery of this industry, challenging its validity seemed as futile as resisting water or air.

Once the Cold War ended, the attitude toward free expression changed as well. By 1990 free expression was being questioned by the right and by the left, by Christian conservatives, who detested the NEA, and by multiculturalists, part of the liberal left that had formed the Endowment's main political base. The right did not want a government agency supporting anyone or anything that might challenge its religious and patriotic beliefs. The left, increasingly aware of the race, class, and gender assumptions encoded in everyday language, understood the dangers of unquestioningly accepting any belief system. But the left's tendency to find political enemies under every bed and to drive even good people out of town when anything it considered a questionable assumption or act was uncovered worked with right-wing Fundamentalism to foster a national climate of scapegoating and censorship. In both the code adopted by a liberal university like Stanford forbidding oral, written, or symbolic attacks against individuals "on the basis of their sex, race, color, handicap, religion, sexual orientation or national or ethnic origin" and in the 1990 law in which congressional conservatives demanded that the NEA take "into consideration general standards of decency and respect for the diverse beliefs and values of the American public" in awarding grants, the voice of the group, the community, and the institution took precedence over the voice of the individual.[21] For both the right, which hated big government, and the left, which expected government to protect the rights of the marginalized and the dispossessed, defense of the individual had limits.

Once the Cold War was over and the free expression that the United States had held up as a symbol of the self-confidence and fearlessness of

American democracy had fulfilled its propaganda use, it stopped being widely embraced as a national principle. Free expression could be, and indeed *had* to be, fought for on legal grounds, but when used in defense of the individual artist and artistic freedom, it could not inspire elevated oratory or arguments that could win over Congress or the nation. In 1998, the painter Chuck Close, extolling the value of individual artists' fellowships, told the National Council: "We stood as the beacon of freedom around the world because artists were free to express themselves in any way they felt was right." Could anyone in that council chamber relate to these words nine years after the Cold War had ended?[22]

By the 1990s the identity of the artist had changed as well. It bore almost no relation to the one that led Presidents Kennedy and Johnson to create the NEA. The booming art market of the eighties told the general public that an increasing number of artists could live well off their art. Popular magazines were eager for layouts of artists with designer lofts in SoHo and houses in the Hamptons. In addition, influential artists were coming out of such worldly fields as commercial and fashion photography. The affection for mass culture among many artists, as well as the craving for media attention among artists who fantasized about themselves as equivalents of rock and film stars—plus the astronomical prices for paintings by a living master like Jasper Johns—helped destroy the assumption that artists were spiritually, morally, and materially purer than other Americans. And with all the dealers, collectors, and museum directors who had been profiting from the work of artists who had lived in relative or stark neglect, younger artists found laughable, if not repugnant, the idea of devoting themselves to art while starving in a garret. In an increasingly invasive, global, media-driven culture, in which the private lives and public myths of national figures, including Kennedy and his court at Camelot, were constantly being picked apart, Kennedy's 1963 image of the artist as independent and incorruptible outsider, driven to give form to truths that a distracted, deceived, materialistic society was not ready to hear, began to seem hopelessly anachronistic, if not absurd.

In addition, as scholarly industries paid more and more attention to

the men and women, mostly women, exploited by master artists, if not sacrificed by them to their art, artists were shown to be as capable of craven and shameless behavior as rock stars, politicians, and businessmen. Peter Plagens's view of artists reflects the shift from idealism to realism. "I don't romanticize artists," *Newsweek's* art critic said. "My view of artists is that except in the way they do their art they are like everybody else. They are as unethical, as immoral, as petty, et cetera, et cetera, et cetera. They are no more unethical, no more immoral. They need checks and balances."[23]

Not only was the idea of the artist different when the fate of artists' fellowships was decided in 1995, but ownership of values had changed hands. The liberal left saw values as its property in the sixties. In 1968, in one paragraph in the *Congressional Record*, Representative William D. Ford of Michigan used the word *values* five times in his support of the Endowment. "I am sure all of the Members have received letters from our fighting men in Vietnam. These letters do not talk about cars, or television sets, or the dollar. These men write of freedom, of the misery of oppression, and of helping their fellow men. In short, they talk about the *values* of America, and they believe the sacrifices they make are necessary to protect these *values*. Shall we today reduce our support for the *values* they fight to maintain? What irony if we do. Can we in good conscience profess national *values*, and fight to protect them, and then forget these *values* because we are fighting?"[24]

In 1989, ownership of values was claimed by the Christian Right, which was considerably more apocalyptic in its rhetoric than Ford had been twenty years earlier. Echoing Buchanan, who declared at the Republican National Convention in 1992 that the country was in the midst of a culture war for the soul of the nation, the Christian Right flaunted the work of Serrano and Mapplethorpe to prove that its beloved and triumphant America was still being subverted from within. Because of gays, feminists, multiculturalists, and other apostles of antifamily and anti-Christian beliefs, the country, even in the glow of victory, was in danger of desperate decay. The blasphemy and depravity that liberals at the NEA were supporting with the hard-earned monies of decent tax-

payers were accelerating this national deterioration. Given the money and organization of the Christian Right and the way American politics works, how could politicians ignore their anger and alarm? To have values on their side was an enormous source of strength for the Endowment's supporters in the anxious, questioning, idealistic, crisis-ridden sixties. In the more skeptical and balkanized early nineties, values had been claimed by the other side, for which the Endowment was an enemy bastion in which armies of modern-day hippies and "Vietniks" were being given reinforcements by the United States Government and sent out to infect and disable the real America and do the rest of the devil's work.

The issue was not that the work of Mapplethorpe, Serrano, and the NEA Four did not deserve support. It did. The issue was rather that their work did not fit within the agency's shifting rhetorical framework during the last years of the Cold War. That always precarious balance between the language of free expression, experimentation, and risk, and the language of balance, civilization, universality, and wholesomeness was essentially gone. The ennobling, transcendent language had taken over, and it was largely in the hands of the NEA's opponents, who felt far more comfortable with it, and for whom key aims of the Endowment legislation, including supporting artistic experimentation, risk, process, and progress, were worthless. This high-minded language was inappropriate to the sometimes in-your-face, occasionally shocking art of Mapplethorpe, Serrano, and the NEA Four, as well as the art of David Wojnarowicz and Ron Athey, two other gay artists whose defiant and discomforting work was singled out for right-wing attack after it had been included in exhibitions or programs supported by NEA grants.

In a different world than the one in which the Endowment was born, with many of the key words used by its original supporters in the hands of its enemies, defenders of the agency no longer had a convincing language. Often their words were stale. During the 1995 House hearings in which the NEA's future was up for grabs, Representative Sidney R. Yates of Illinois, a champion of the agency throughout its existence, asked: "Do you believe that education in science and math is enough

without education in the other disciplines?"[25] This is almost an exact reprise of a remark he had made at the congressional hearings in 1965: "There is a recognition in this bill that the Federal Government has long testified to the development of science and technology in this Nation but that it has largely ignored corresponding inspirations to the arts and humanities."[26]

When Representative Sam Farr of California said in 1995 that "funding for the National Endowment for the Arts is an investment in our culture, our civilization, our future, which must be protected," these words, too, seemed tired.[27] So were those of Senator Dale Bumpers of Arkansas at the end of his passionate defense of the Endowments. "Someday—and it may be too late," he said, "we are going to understand that funding for NEA and NEH is not wasted money. It is money that makes us a greater Nation. It makes us more civilized. It makes us appreciate where we came from. It is a tragedy that we have to cut it."[28]

With ideas of antimaterialism, antitechnology, and civilization having little relevance to American art and politics after 1989, arguments on behalf of the Endowment and of the arts began to be made in practical terms. Senator Claiborne Pell of Rhode Island, the driving force behind the original arts and humanities legislation, rattled off the good done by the agency. "The arts, fostered by the national endowment," he said, "encourage national and international tourism, attract and retain businesses in our communities, stimulate real estate development, increase the production of exportable copyright materials and, most important, contribute to our tax base."[29] Senator Jeffords had his own list. "The agencies have proven effective in nurturing our cultural heritage, making the arts and humanities accessible to all the corners of the Nation, providing learning opportunities for young and old and generally encouraging a growth and flourishing of the arts and humanities in this country," he said. "We should not take for granted the importance of the work of these agencies, especially in the difficult times that face our Nation."[30]

What Pell and Jeffords said is correct. The NEA has played an incalculable role in the development of the economic and cultural infrastruc-

tures of many communities and cities, and it is important to try to quantify its achievements. But a product-oriented, market language is antithetical to NEA fellowships, which depended upon process words like *openness*, *courage*, and *inquiry*. The language of the market can certainly work to build support for art within communities and cities looking for reasons to use art to build up their civic and economic infrastructures and put themselves on the regional, national, or international map. But it cannot reconnect artists to art. It cannot communicate the human and social potential of artistic creativity. The bureaucratic market terms now used to measure every other kind of success cannot communicate why art matters.

Questions

Among the multitude of interrelated issues that need to be considered in order to understand the impact of Congress's elimination of support for individual artists in 1995 and the diminishing of the NEA afterward, several stand out. One is the issue of the body and the way in which conservative phobias about the artist and about the nonwhite, nonheterosexual, and particularly the gay body helped to merge the two in the general consciousness, which contributed to the congressional decision to detach artist from art and turn the artistic visionary considered necessary to the health of the nation back into an outcast. This process of demonization would not have occurred without the Christian Right, with its us-them, insider-outsider, good guy–bad guy mentality, its fundamentalist beliefs about what is purely American, and its commitment to waging a culture war in which the dreaded other, within, without—anywhere—would finally be eliminated. The political banishment of the artist's body also served the needs of the market in an increasingly global and virtual world which demanded immediate and weightless transactions of commodities that could not be manipulated so effortlessly if they had living histories and actual bodies attached them.

It is also important to recognize the radically different political reality at the end of the Cold War and how it transformed the ground on which artists, art, and the NEA stood. The United States government trusted and believed in artists for the first time in its history not because it loved artists or art but because it believed it needed them to ground itself, win a life-or-death geopolitical conflict, and prove itself a great and viable empire-nation. The NEA it created was remarkable. It enabled thousands of artists to push ideas, develop approaches and styles, gain footholds in thousands of communities and small towns, and build networks across the country. It made many artists feel part of government, and it made many people in government feel closer to them. Through its peer panel system, it inserted into government a system of values that remains crucial to America's potential for enlightened leadership.

But the NEA and its supporters, myself included, believing unquestioningly in the value of art and artists, did not grasp that it was the product of historical circumstances. Supporters of the agency, including artists, took government support for the arts for granted, as natural, as something America had to do and was finally doing, like other great civilizations, although the support of art had not been natural anywhere else either. France and Italy, as well as Great Britain, whose arts council was one of the models studied by creators of the NEA, would not have stood behind the arts if they had not helped sustain images of national glory and greatness.

Now that the Cold War was over, what were the artist's identity and mission? If artists no longer fit the image of the heroic solitary truthteller, working apart from the masses, resisting the triviality of popular culture, struggling against the repressiveness and self-deceptions of the middle class, what were they? If more and more of them were in love with science, equipped with state-of-the-art technology, and interested in joining rather than resisting the entertainment industry, were they still outsiders? And if they weren't, were they still special? If, like millions of other citizens, they were glad to profit from American materialism, scientific advancement, and mass culture, why did the country

need them? If they rejected modernist notions of heroism, survival, and transformation, what stories could the nation tell about them that served its larger interests?

What explains the paradox that at almost the precise moment, 1995, when multiculturalism, with its insistence on difference, was being replaced by a global corporate-media-entertainment-internet empire intent on developing a global monoculture that waters down differences, artists were being demonized as outsiders as much as at any time before? If they really weren't outsiders, why demonize them? Is it because they now looked and acted like everyone else that their foreignness was more dangerous? Is it because artists remained, still, both outsiders and insiders, even though the framework that had defined them as outsiders had collapsed, and the new global empire was denying that difference mattered? Is it because the new electronic machinery of consumption, like the Christian Right, could not consume the artist's body? Is this space of possibility and impossibility that is always both outside and inside, forever susceptible both to America's terror of difference and to its desire for and dependence on it, the artist's space—the artist's place? Is living and creating in the teeth of this paradox with the greatest possible consciousness and imagination now part of the artist's identity and mission?

Notes

1. See *Congressional Record*, 9 August 1995, 512059.
2. Ibid., S11982.
3. Ibid., S11989.
4. Ibid., S11999.
5. Ibid., S11988.
6. See Gary O. Larson, *American Canvas: An Arts Legacy for Our Communities* (Washington, D.C.: The National Endowment for the Arts, 1997), 167.
7. Ibid., 14.
8. Ibid., 122.
9. Malgorzata Lisiewicz, a Polish curator and art historian, made the revealing observation that the social and community language of the book, commissioned by an agency that had been created in order to help America distinguish

itself from the Soviet Union, defined the importance of the arts, after the end of the Cold War, in a way that the Soviet Union might have sanctioned. She felt there was a "totalitarian attitude toward art, communicated silently through the book, even if it claims to speak on behalf of communities." She explained that she was "coming from a particular context, a middle-European context—postcommunist, marked by communist times" and said that the "kind of rhetoric" in the book was "very problematic for me. There is so much about how art is about civic responsibility, good citizenship, civic pride, and I think these are terms that should be defined and used very carefully. If somebody would switch the word *Russian* for the word *American*, nobody would even bother to read this book in my country. It just sounds like purely nationalistic propaganda that's not trying to grasp the issues." See Michael Brenson, Alejandro Diaz, Judy Kim, Malgorzata Lisiewicz, and Jessica Murray, "'American Canvas': A Roundtable on the 1997 NEA Report," *Art Journal* (fall 1998), 71–72.

10. Dowley, op. cit.

11. Finley, Fleck, Hughes, and Miller were grouped together when fellowships to them were turned down in June 1990 by NEA chairman John Frohnmayer (1989–1992). They sued the Endowment, charging that the decision had been made on political rather than on artistic grounds. They challenged the constitutionality of legislation requiring that the agency consider "general standards of decency" when making its selections. In June 1998, the artists lost their suit when the Supreme Court upheld the congressional decency test for awarding Federal arts grants. Interpretations of the decision—how much weight it really carried, what effect it would have on the grant-making process, whether it violated the First Amendment—varied widely. Hughes and Miller each received three individual artists grants from the Endowment's theater performance program in the nineties.

For an article on the NEA Four, see William Harris, "The N.E.A. Four: Life after Symbolhood," *New York Times*, Arts and Leisure section, 5 June 1994, 1 and 30. For Frohnmayer's account of the crisis and the ways in which he wrestled with First Amendment and quality issues, see John Frohnmayer, *Leaving Town Alive: Confessions of an Arts Warrior* (Boston and New York: Houghton Mifflin, 1993), chapters 8 through 10.

12. Patrick J. Buchanan, "Let's Junk That Junk Art," *New York Post*, 1 August 1990, 19.

13. Clark, op. cit., 15 July 1998.

14. See Judith Tannenbaum, "Robert Mapplethorpe: The Philadelphia Story," *Art Journal* (winter 1991), 71–76.

15. Lazarus, op. cit.

16. Mandle, op. cit.

17. Delehanty, op. cit.

18. Richard Andrews, op. cit.

19. Dowley, op. cit.

20. Frances Stonor Saunders wrote that during the Cold War, "God was everywhere: He was in the 10,000 balloons containing bibles which were floated across the Iron Curtain by the Bible Balloon Project in 1954; His imprimatur was stamped on an act of Congress of 14 June 1954 which expanded the Pledge of Allegiance to include the words 'One Nation Under God,' a phrase which, according to Eisenhower, reaffirmed the 'transcendence of religious faith in America's heritage and future; in this way we shall constantly strengthen those spiritual weapons which forever will be our country's most powerful resource in peace and war'; He even began to appear on dollar bills after Congress ordained that the words 'In God We Trust' become the nation's official motto in 1956." Stonor Saunders, op. cit., 280.

21. In 1990, Nadine Strossen, professor at New York Law School and general counsel for the ACLU, said: "Now we have minorities and feminists and the left allied with fundamentalists who believe some communitarian values take precedence. To them, group rights are more important than individual rights." See Neil A. Lewis, "Law: Friends of Free Speech Now Consider Its Limits," *New York Times*, 29 June 1990, B7.

22. Close, op. cit.

23. Plagens, op. cit.

24. See *Congressional Record*, 27 February 1968, 4322.

25. See *Congressional Record*, 17 July 1995, H7026.

26. See *Congressional Record*, 15 September 1965, 23968.

27. See *Congressional Record*, 17 July 1995, H7035.

28. See *Congressional Record*, 9 August 1995, S11990.

29. Ibid., S19983.

30. Ibid., S11993.

THE PEER PANEL PROCESS II

The Reagan Years

In its September 1990 *Report to Congress on the National Endowment for the Arts*, The Independent Commission of twelve political and cultural professionals appointed by President George Bush to review the NEA's grant-making procedures revealed a history of unease about the peer panel system. The commission noted that in 1973 concern that panels were not diverse enough geographically led the House Committee on Education and Labor to recommend that broad geographic representation be required in order to "help avoid domination . . . of any one part of the country." In 1979, a House Appropriations Committee issued a report saying that "the panels operated as a closed circle of advisers with little regard for the aesthetic needs and views of those not represented on the panels." In 1985 a "House Committee on Education and Labor Report maintained that while 'panels provide continuity and expertise,' the grant advisory process also offered a 'potential for favoritism, inertia and lack of objectivity.' "[1]

The vast majority of the criticism of the peer panel system over the years was uninformed. It came from people who either had no idea how this system worked, or who assumed that if they or the kind of art they believed in had not received government support, the system had to be

corrupt. Many artists looked at the welcoming statement in the guidelines that "artists of exceptional talent of any aesthetic persuasion may apply" without studying the rest of the guidelines, which connected "exceptional talent" and "excellence" to a constellation of words that included *creativity, commitment, investigation,* and *timeliness.* The visual arts program was responsive to artists who questioned artistic givens and who were determined to reimagine art and beauty in ways that responded freshly and deeply to the pressures and possibilities in the world around them. The program was also responsive to artists who were trying to reinvent traditional genres, like still life. It was not designed to reward artists who accepted the authority of the academic tradition based on drawing from life casts, or who modeled their work on neoclassical figures and landscapes, or who painted religious narratives in a Renaissance style, or who carried on traditions of classical stone carving. A future government fellowship program might well find reason to develop a funding category to support artists skillfully reworking what has already been done, but the NEA, conceived at a historical moment when it was considered essential by government to show the world America's capacity for inventiveness, adventurousness, and self-examination required a different emphasis.

Just because much of the criticism of the peer panel process was uninformed, however, does not mean there was no cause for concern. The peer panel process could be confusing, ambiguous, and inbred. For example, the NEA obviously wanted first-rate panelists on its museum panels but inevitably some panelists chosen were affiliated with some of the dozens, if not hundreds, of museums that applied to the NEA for some kind of grant every year. If a museum official learned about the application after agreeing to be a panelist, should he or she have resigned from the panel even though his or her museum's application would be only one among hundreds? The situation was more worrisome with visual artists' organizations, an emerging field with fewer voices on which the Endowment believed it could depend. A number of people whose organizations were consistently funded were regularly chosen for panels. Much of the field might apply for a grant, which

meant that inevitably someone would be part of a selection process that considered his or her organization for government money. The susceptibility to conflicts of interest led the NEA to formulate a policy statement in October 1983 requiring that "Council members and consultant-experts shall leave the room during the discussion and determination of an application from an organization with which they are affiliated."[2] But this was not ideal either since the importance of maintaining a collegial atmosphere made it harder for panelists to turn down an application from the institution of another panel member, although such rejections did occur. In short, because the visual artists' fellowship program was so selective (96 percent of the applications were turned down), and because the peer panel process in organizational disciplines was conducive to what Ruth Berenson, the Endowment's associate deputy director during the Reagan years, referred to as "backscratching," the NEA was an easy target for people who believed, or who found it politically useful to claim, that the agency was no more than an insider network in which the art establishment rewarded its own and many deserving artists, approaches, and institutions had no chance of being funded.

Concern about cronyism contributed to the suspension of the NEA's art critic's fellowship program in 1984. In the November 1983 *New Criterion*, Hilton Kramer, its editor, wrote an essay in which he depicted the NEA as a left-wing stronghold in which standards of quality were largely irrelevant, the needs of the American middle class despised, and critics supported "who were publicly opposed to just about every policy of the United States government except the one that put money in their own pockets or the pockets of their friends and political associates." Kramer began by quoting a statement by one participant in the seminar that had been called by the Endowment to discuss the program: "All this talk about good writing sounds very fascistic to me." Making public an internal report critical of the program by John Beardsley, an independent scholar and curator, he claimed that the decisions within this program were largely governed by "the mutual-admiration principle" and argued that the program "functioned as a kind of private club to which a number of outside guests—always carefully selected on the

basis of geography, race, and gender—were each year invited." This club was leftist, its concerns political rather than aesthetic. He ended by declaring that sixties radicals had taken over. "The 'movement' was now on the inside, running or advising the bureaucracy, instead of being on the outside making demands."[3]

Kramer's ideological attack on what he saw as the ideological emphasis of the critics' program was intended to undermine not just the critics' fellowship program but the entire agency. The problem for people who disagreed with him—and many critics and other art professionals did, vehemently—was that his charges of cronyism and insularity were not directed at them but at the neoconservative establishment and anyone else who shared his opposition to the NEA. One month after the Endowment demonstrated its concern about cronyism and insularity by drawing up a conflict-of-interest policy, his essay hit a nerve. Whatever was said and written about it in the New York art world had little or no effect on policy because the protests of the art establishment did not grasp that the Endowment was faced with serious questions about its selection process and its own insularity—which only gave more credence to Kramer's charges that the professional art world was an establishment that could not see beyond its own immediate aesthetic, economic, and political interests. Kramer's article would not have contributed to the suspension of the critics' fellowship program if there had not been concern within the agency about peer panel "backscratching" and pressure on the agency in the radical first years of the Ronald Reagan administration to make sure it was not pushed around by the culture establishment's left wing.

A month after Kramer's article appeared, the agency was still trying to solve the conflict-of-interest problem. Ana Steele, the NEA's associate deputy chairman for programs and director of program coordination, and Hugh Southern, the agency's deputy director, were asked to summarize council members' and program directors' responses to "blind judging." Blind judging meant that applications would be evaluated without looking at the names of the applicants or at any information other than the slides, manuscripts, or musical scores. Only the

music program was comfortable with this method, which already existed in the music world in the form of "blind" auditioning of orchestral musicians. Blind judging was rejected for several reasons, including: "The best defense against cronyism is regular rotation of panels *and* track record of decisions over a number of years"; "Artists are best seen in the context of their personal and professional situations"; and "Recommendations from panels are likely to be fairer if they know more, not less." Steele and Southern's paper concluded: "In short, it's best to suspend the fiction, admit (in fact laud) that the process is subjective, and not do blind judging unless there are special circumstances."[4] But the memo was another indication of concern with the peer panel system, and another attempt to put the program directors on guard.

The memo was prepared for Francis S. M. Hodsoll, a lawyer and efficiency expert, and a former foreign service officer, who had been deputy to the White House chief of staff, James A. Baker 3rd, before becoming chairman in 1981. Like Roger Stevens, he was a big man (six feet four inches tall) with an imposing presence. He had boundless energy and an encyclopedic memory for detail. He knew everyone in politics and had rare political savvy. He relished the fray, valued program directors who spoke their minds, and was convinced he could meet any challenge. He believed the right and the left could work together to make a better and more dynamic NEA. He had complete confidence that he was smart and agile enough to control and mold any ideological tensions that he might unleash, or that might surface, during his stewardship.

One of Hodsoll's first priorities was to clean up the peer panel system. He personally examined all the grant recommendations, questioned a handful of them, and overturned a few. Not only was it his right to do this, but given the suspicions within Republican circles that the NEA was a left-wing cabal, he also could not have run the agency effectively without going over the grant-making process with a fine-tooth comb. Under his leadership, and with the help of the peer panel process devised by Leonard Hunter, the deputy director under James Melchert—who had been brought to the agency by Nancy Hanks—

and the acting visual arts program director at the beginning of the Hod-
soll administration, the peer panel system became more efficient,
thoughtful, and fair. Hodsoll's approach to this system was construc-
tive. "He was quite willing to back up panel decisions about work that
was by any measure risky," Richard Andrews, Hodsoll's visual arts pro-
gram director from 1985 to 1987, said, "as long as he believed and could
see demonstrated that the panel discussion was in fact thoughtful and
did deal with what he considered some of the difficult questions of con-
temporary art. What the hell is it? Is it any damned good? Why should
the NEA endorse it?"[5]

While preserving the strength and confidence of the Endowment and
ensuring that the Reagan administration continued to support it, how-
ever, Hodsoll also changed it forever. He hired people whose beliefs
were compatible with the Hanks and Stevens agency. He brought in
Southern, a British-born liberal and arts professional who had been in-
volved in the New York theater world. His first visual arts program
director was Benny Andrews (1982–1984), a great admirer of Melchert
and Hanks (who died in 1983), who was sympathetic to the kind of
grass roots populism Republicans identified with the dreaded Jimmy
Carter administration. He made his second visual arts program director
Richard Andrews, who was equally comfortable around artists and ar-
ticulate in supporting the efforts of the most adventuresome of them to
keep developing visual languages that could help others think cre-
atively about an ever more complex and rapidly changing world.

But Hodsoll also brought onto his staff agency people deeply suspi-
cious of contemporary art. He hired Berenson, an art historian who had
been an art critic for the *National Review*, and put her in charge of over-
seeing the panels. She shared Kramer's antipathy for the art critics' fel-
lowship program and made her dislike for it known. In an April 1981
article called "The Fate of Modernism," which may have contributed to
her being brought into the agency, she expressed her admiration for re-
alist painters like Lennart Anderson and Philip Pearlstein and her dis-
like of pretty much all American artistic developments after Abstract
Expressionism. "Few would question the fact that the vitality and

promise that made American art so exhilarating thirty years ago have utterly dissipated," she wrote. She saw artists as self-indulgent dead-beats. "Naturally, there is considerable hand-wringing in the art world about the Reagan budget cuts, which threaten to halve the $173 million that supports the National Endowment for the Arts. Young would-be artists who, except for fellowships and grants-in-aid, would have blushed unseen or starved in garrets, will have a rough time; no longer will they be able to 'find themselves' while living at taxpayers' expense. It seems safe to predict that the number of those calling themselves painters or sculptors or video artists will be sharply reduced as more and more rejoin society and get an honest job."[6] Berenson became more open to contemporary art as she settled in. Her change was already evident by December of 1982. When asked by Richard Goldstein of the *Village Voice* about her 1981 article, she replied: "A lot of the opinions I expressed then, I might not express now. I've learned a great deal. And when it comes to the visual artists, I bend over backwards." However, her standards, like those of the agency under Hodsoll, remained museum standards. She told Goldstein of her admiration for "the great emotions of man, the great ideals of man," and suggested that she expected to dislike much of the contemporary art the Endowment would support. "She expressed a determination to allow art to do whatever artists want it do," Goldstein reported. "We may not like it, but that's not our business," Berenson said."[7]

Hodsoll brought onto the national council Samuel Lipman, a musician, music critic, and the publisher of the *New Criterion*. Lipman (1982–1988) was a strong believer that the Endowment should serve high culture, small audiences, and the tried and tested and was pitiless in his advocacy of this position. From 1985 to 1992, the visual artist on the council was Helen Frankenthaler, a lyrical abstract painter who was a known supporter of high art and museum standards. Frankenthaler had made it big in her early twenties, largely as a result of the support she received from Clement Greenberg, the art critic whose remarkable influence between 1940 and 1965 had become identified with his belief in artistic "quality" and in taste. For Greenberg, the production and expe-

rience of quality depended on a highly developed self-consciousness of art as art that required an insider's knowledge of the language of art and its developments and variations throughout Western art history. In the Greenbergian aesthetic, overt content was not welcome. Greenbergian "quality" demanded a detachment of art from a direct engagement with social and political life. Brought into the agency by conservatives critical of the aesthetic insularity of the agency, Frankenthaler represented the most insular aesthetic system of all. In a 600-word 1989 *New York Times* Op Ed piece expressing her sadness about the "mediocre art enterprise" the national council and peer panels were supporting, she used the word *quality* six times and remembered better days: "I feel there was a time when I experienced loftier minds, relatively unloaded with politics, fashion and chic" who "encouraged the endurance of a great tradition and protected important developments in the arts."[8] Making herself a voice for quality, lofty thoughts and the great Western tradition, which she linked, she wrote off almost the entire field of contemporary art, of which she was the primary representative on a national council on which she had enormous influence. "No matter what she said, she was so respected, she had such a name," Michael Faubion, the assistant director of the visual arts program, said. "She was the only visual artist on the council and they deferred to her."[9] Her arrogant abusiveness worked with Lipman's honed mind and contempt to undermine respect within the agency for new art, for visual artists, and for the responsibility many artists felt to ensure that their art responded to the social and political pressures driving that tumultuous late-eighties and early-nineties moment.

"It reached a point where one side had too much influence and started dictating," Benny Andrews said, talking about the council even before Frankenthaler joined it. "It was not a fair debate, where there would be tolerance and maybe one area would be given a little more credence than others but they wouldn't wipe out the other area, where it was not total victory. And that was something they wanted, total victory. To get rid of filth. It was not like, we disgree with you but you do have points."[10]

"I spent a lot of time in front of the council," Richard Andrews said, "much more than the other program directors, because there were so many aspects of the program they wanted to question . . . The program director made the opening presentation and then the conversation looped among the council members, and you weren't an equal participant. You couldn't butt in there. The way I would characterize my own feeling about many of the times I was up there was that I was struck by not so much the point of view, the cultural conservatism, as the mean-spiritedness of some of the comments directed toward contemporary art and artists, and it was the mean-spiritedness more than anything else that I felt was destructive. Having a debate on an issue on its merit and losing that debate, that's life. But if Helen or somebody else was dismissive of all contemporary artists, dismissive of their efforts as not even being worth looking at, that's mean-spiritedness, that goes beyond—what are the problems today?—and that sort of thing."[11]

The Hodsoll administration tried to reform the Endowment through its market as well as through its museum emphasis. "Business was the operating paradigm for government," Andrews said. "Lean and mean, product-driven, consumer-based, marketing mentality applied." Hodsoll believed that only that which proved itself in the marketplace was worth saving. With museums, which cannot survive if they do not respect the bottom line, this may have made sense. But the visual artists' fellowship program argued for nonmarket values. "It kept coming up the marketplace, the marketplace, the marketplace, which is antithetical to the idea of fellowships," Hunter said.[12] For most Reagan Republicans, the idea of direct and unrestricted fellowships, intended to provide a way for artists to inquire and risk and listen to their creative voices without having to justify their journeys and investigations in quantifiable terms, was anathema. "They didn't want these people to be given money to do something they couldn't define," Benny Andrews said. "The worst thing in the world for them was that the artist didn't have to say, I'm bringing in 18 and a half paintings or 213 pounds of sculpture. When they couldn't say that, then that was to them a give-

away."[13] Hodsoll's market and museum emphasis put the agency in conflict with itself.

From the beginning, the Endowment had developed and worked within two languages. One was the language of greatness, grandeur, "lofty" thoughts, "the great emotions of man, the great ideals of man." At the same time, it embraced a language of risk, experimentation, process, and progress. Until Hodsoll's administration, these languages were compatible. The Endowment had understood that you could not sustain excellence without rewarding creativity and risk, and if you did not continue to reward creativity and risk you would eventually lose the ability to recognize greatness. In her *New York Times* article, Frankenthaler pitted one language against the other. She wrote about lofty minds, the great tradition, and quality; and she wrote about "nondeserving recipients," "a mediocre art enterprise," and losing art "in the guise of endorsing experimentation."[14] She made the language of experimentation and the language of greatness incompatible. During Hodsoll's eight years, the museum language of great emotions, great ideals, "relatively unloaded with politics," which had always been important to congressional supporters of the Endowment, was institutionalized as *the* language of the agency. By the time Hodsoll left, just before the controversy erupted over Serrano, Mapplethorpe, and the NEA Four, the language of contemporary art that might have been able to defend the support of them had been discredited and suspicions about the mediocrity and filth of the contemporary visual art enterprise had become engrained in the administrative structure of the agency. The museum language was essentially the only one the council had. It had no language with which to respect and explore the extraordinary ways in which art and artists had changed since Frankenthaler made a name for herself in the fifties. If it had been able to fight effectively for contemporary art and artists, would the subsequent history of the Endowment have been different? Would American art and culture be different?

What's more, the "quality sifting" of the peer panel process, which continued to depend for its ability to function on listening, openness, and exchange, had been so consistently questioned by Frankenthaler,

Lipman, and other critics of contemporary art, and the spectacles of indignant council members pounding the art and artists they did not like in the least lofty of tones had so dissociated the council process from the peer panel process, that the peer panel system no longer had the power to shape the agency. Even while effectively reforming the peer panel system, the Hodsoll administration cut off the governing body of the agency from the values of the peer panel system that represented the Endowment at its best.[15]

With all the questions about the peer panel system raised under Hodsoll, the visual artists' fellowship program rarely, if ever, was directly attacked. Even when particular recommendations for visual artists' fellowships were questioned by Hodsoll, Frankenthaler, or the national council, or when they made requests to put certain people on panels, the program directors were able to do what they believed was right, and the visual artists' fellowship peer panel process continued to work beautifully. Even Berenson was comfortable with the visual artists fellowship program. "I think it was clean," she said.[16]

It was not hard for these panels to be clean. The curators on the fellowship panels were not judging curators, which encouraged them to speak freely. They had everything to gain from listening to and engaging with artists in such a way that they could learn from them. Many of the artists on panels had received fellowships and understood their significance, they felt honored to serve on the panels, and they wanted to act in ways that would honor the process that had honored them. The odds were so minuscule that an artist receiving a fellowship could one day give one in return to one of the six panel members that awarding a fellowship in the hope of one day receiving one was nearly unthinkable. If the panel members competed with one another, it was by being more thoughtful, more attentive, more subtle. By looking for and supporting what was gestating and trying to bud or flower within a body of work, the panelists were working in their best self-interest. By supporting what they believed was most valuable and necessary in themselves, they were helping to ensure that a climate prevailed in which the kind of creativity and commitment they believed in would be appreciated. On the

fellowship panels, artists continued, right to the end, to act with responsibility and professionalism. The image of the visual artist that emerges from the peer panels is very different from the one that was being promoted on the council and in other parts of the agency.

Peer Panel Values

The peer panel system embodied the idealism and nobility of the NEA. Like the United States jury system, it was grounded in a faith that however much human beings might be driven by narrrow self-interest and immediate personal gratification, they also carry within them a need to learn, a belief in justice, and a commitment to the common good. The peer panel system assumed that if people were brought together by their government and asked to consider the work of hundreds, or thousands, of artists and decide who in that year's pool of applicants was most worthy of their nation's support, their inherent seriousness and fairness would emerge and they would do their jobs with integrity and pride.

The key to the peer panel value system was trust and belief in process. In the five-day, morning-till-night, peer panel adventure—which art critic and painter Peter Plagens described as "absolutely mind-bogglingly arduous, and that was the price of the meritocracy"—as in the art the fellowship program was intended to support, respect for the journey was essential.[17] If the panelists wanted to meet their responsibilities to the artists who had applied, to the field, to the other panel members, to their government, and to themselves, they had to give themselves to the process and be guided by it—not by their own agendas, or by impatience to arrive as quickly as possible at the list of recommendations. As a result of their willingness to deliver themselves to the panel process, assumptions and approaches of the panelists, as well as those of the applicants, were tested and ways of responding could be developed that were searching, elastic, rigorous, and just.

The peer panel process was, at best, a reflection of the creative process at work. The Endowment was convinced that the mechanisms, demands, and logic of the creative process provided clues to a deeper,

more integrated, and more responsible life. If an artist's creative process was fearless and incisive, important lessons could be drawn from it about courage and responsibility, perception and knowledge, self-awareness and democracy. In the creative processes of artists for whom uncertainty and unknowing are friends, nothing is unimportant, everything calling for attention is worthy of being heard. Learning and growth are important in themselves. Through the peer panel process, which was designed to find and echo artistic creativity, the understanding that could be gained from the ways in which artists thought and imagined could, in theory, inform the identity of the NEA, a federal agency, and perhaps even, in a small way, the country. In the art and artists the Endowment supported, and the peer panel members who selected them, the means were every bit as important as the ends and the advantages of inquisitiveness, openness, endurance, and distinction were revealed.

The peer panel process was a particular kind of process. It was given its final shape by an artist, Leonard Hunter, and reflected not only his values, and Melchert's, but those of many other people who worked at the agency. What was Hunter trying to recognize and reward? He believed "anything could come from anybody." He did not believe the "Endowment's purpose" was "just to sublimate or duplicate market taste, i.e. blue chip artist and so on." He wanted "to find a way of nurturing another group of artists or ideas that are culturally pertinent." If that is a goal, what "are the qualities you are trying to encourage?" he asked. "You look at, what is a creative act and how does it work in a pertinent moment in time . . . You think about risk-taking, about a willingness to go beyond convention, about the idea of personal commitment that puts time and energy into something beyond an economic goal, whose real purpose is inquiry." He makes an analogy between artistic inquiry and "scientific research, where it's more like inquiry for inquiry's sake," but adds that artistic inquiry must be understood "in the context of what's been done before and within a cultural context." So knowledge of the history of art is important; so is a sensitivity to the broad social, economic, and philosophical issues defining the moment in

which the applications were evaluated, even if those issues are not directly discussed by panelists. Hunter uses the word *quality* but with a small *q*. He suggests that whenever it is used with a large *Q*, it is used to assert the authority of an established art historical system. The quality he wants to reward is located in the "process of inquiry being followed." Recognizing it requires an appreciation of the "obsessiveness" and "love" in the inquiry. These two words suggest the passion and will that help define other key Hunter and Melchert terms like "personal commitment" and "risk-taking." Hunter admires folk painters, in part, because "the obsessiveness and love that go into their work are astounding."[18] His peer panel process was intended to retain its independence from the art market and museums. What most defined it was depth of passion, quality of searching, quality of need, quality of mind. It is easy to see how Hunter's process could encourage a deprofessionalization of creativity that could make it easier to recognize and reward creativity in the general population as well as in the art world.

The peer panel process shaped by Hunter was radically different not only from any market process but also from the political process. In the political process, which involves vastly greater numbers of people vying for power and influence, expediency is common, arm-twisting expected, debate a word that refers not to people listening to and acknowledging one another but rather to individuals and groups asserting ideas and opinions into a large arena defined by a news media that filters information according to its own economic and political interests. Eventually the "debate" ends, one side wins, and because of the polarizing spectacles of the media, the victory often ends up perpetuating, if not hardening, the walls between people. Hunter's peer panel process was not cynical. It did not reward browbeating and abusing and twisting other people's words. It required the panelists to engage one another so directly that their interaction was, to all intents and purposes, unmediated, except of course by the process itself and the values embedded in it. Its recommendations depended upon a consensus arrived at by respect for insights and questions coming from multiple perspectives. The peer panels recommended money to unknown artists and other artists

who needed it. They fostered an enduring sense of community among many of the artists and curators who participated in the process.

The Endowment's relationship to the market was fascinatingly complex. The agency strengthened the market in many ways. Because peer panel judgments were widely respected, they guided people looking for talent. "The public sector, in the wonderful way the Endowment was constituted, was able to do things that the private sector doesn't even address," the collector Raymond Learsy, Frankenthaler's main opponent on the council, said. "How does a businessman know that there is a small publishing house someplace that is doing important work bringing out authors? How does he even find that, address that, make a decision? You had a process in place, with the Endowment, where those issues were determined by whether funding was made available to them. The process was the key. You had people who knew about it, thought about it, who made a value judgment about it. Business people don't have that focus."[19]

More fundamental, in its dependence upon matching or challenge grants, which has remained its primary funding principle, the Endowment acknowledged the indispensable importance of the deal-making and entrepreneurial personality that are the bread and butter of American politics and business. In the matching grant system, money is awarded for a project, programming, or seasonal support, and the same amount, or two or three times that amount, then has to be raised by the recipient of the grant. By encouraging private-public partnerships, matching grants helped to solidify the economic base of many institutions. "The challenge principle gave a certain imprimatur, a very definite goal," said Martin Friedman, the former director of the Walker Art Center in Minneapolis and a member of the National Council from 1979 to 1984. "The community thought, if the government feels it's that good, we should help support it. That whole challenge principle was a brilliant notion. You've heard over and over again what it has leveraged, and it's all true. One cannot begin to measure in dollars what it has leveraged."[20]

The matching grant system was certainly an attempt by government

to inspire the private sector to support the arts. "If government funds
the arts to some degree, and does it with a thoughtful policy, and con-
tinues to do a match, that's a way of making sure that corporate money
out there also supports the arts in our country," Suzanne Delehanty, the
director of the Miami Art Museum, said. But matching grants were
more than just a brilliant way of helping VAOs, museums, and many
other cultural organizations survive. They were also a way of ensuring
that strategies for fiscal success continued to be informed by an engaged
awareness of the common good. Delehanty believes in a balance be-
tween the public and private sectors and is afraid this balance will be
lost. What about the new corporate leaders, she asks, now that there is
such a massive amount of money in private hands? "Are they trained to
be good citizens and civic leaders? . . . What's going to happen to
that generation? Because the private sector can now have so much
power, it's even more important for government to set an example, to
lead."[21]

The visual artists' fellowships program argued for the importance of
sustaining nonmarket values within a free-market society. Its peer panel
system did not encourage the quid-pro-quo mentality that is the essence
of political and economic deal-making. Giving with the hope, but no
requirement, of a return! Giving that did not involve any obligation ex-
cept to be worthy of the trust and belief that the country was showing in
you! Giving that implied so much faith in artistic creativity that it took
for granted that if it appealed to the best in artists and panelists, the best
in them would emerge! The visual artists' fellowship program assumed
that no matter how Americans functioned in their professional lives,
and no matter how much they adored and thrived in a free-market
economy, they also needed to pay attention to another self, inside the
one striving for power and influence in a capitalist system. The Endow-
ment assumed that this inner self was at or near the core of the human
heart. Until the end of the Reagan years, it assumed that it was this self
that gave the free-market system its ethical dimension and made it the
envy of much of the world.

The peer panel system ensured that the NEA, and with it the Ameri-

can government, would generate essential questions. What is a healthy individual? What is a healthy nation? What is the place of the market in the individual and of the individual in the market? What is the place of democracy in the individual and of the individual in a democracy? What relationship do Americans want its different value systems to have to one another?

Can the private sector make up for what has been lost with the elimination of NEA fellowships and the severely diminished influence of government patronage? It is impossible to know at this point how much the private sector can do, and how it can expand and reinvent arts patronage, but it cannot replace the NEA.

Art galleries are indispensable. They locate and then expose talent by circulating it through a dealer-collector-critic-curator system that enables the art public and perhaps the general public to encounter it. By their willingness to exhibit and promote art, they argue for its aesthetic and economic value, which encourages people to pay attention to it. They provide incentives for people to find and preserve art that matters. They give many artists a vital sense of independence and self-reliance that public funding may not be able to offer artists who came of age after 1989.[22] They can give artists the confidence to ignore or the authority to attack the American assumption that artists are deadbeats and parasites. In addition, many of the best galleries support experimentation. "Depending on the nature of people's work, what kinds of materials they work in," mixed media artist Barbara Kruger said, "galleries are still places where people take risks."[23]

When the art market is essentially the only source of funding for individual artists, however, art can become more narrow. The sculptor Beverly Semmes, who received fellowships in 1994 and who is known for her large-scale fabric installations, believes that in the last few years young artists have had no choice except to make smaller work because only small-scale work can succeed in the galleries.[24] Dorothea Rockburne, who has been represented by blue-chip New York City dealers like Xavier Fourcade and André Emmerich, said that "when you have just the gallery system, you have what the galleries want, and that's

what's going on right now. Many of the Chelsea galleries [referring to the concentration of galleries on Manhattan's West Side] are built to function to sell corporate art, and it's a market-driven economy art, and that's ok, but it should be 50-50."[25]

"The private sector is not making up for what the Endowment was doing," Chuck Close said, which was to recognize and encourage artists at the point when it could "have the maximum impact on an artist's career."[26]

"I think the marketplace is very capricious and difficult," Joel Shapiro, who, like Close, is represented by New York's prestigious PaceWildenstein Gallery, said. "I think it's important, but I also don't think it's broad-based. I think there's a narrow group of people who do ok. . . . There's very little opportunity now for development. And for a kind of natural gestation of work."[27]

Since the collapse of public funding it has been harder for tough, noninstitutional voices like those of Daniel J. Martinez to be heard. Martinez is known for collaborative public art projects in which he has worked with people outside the art world, in streets, parks, and prisons. Since the weakening of the NEA, he has had less opportunity to work in public spaces. Recently he has been producing large color photographs simulating the impact of criminal violence. Their terrifying poetry of confrontation and vulnerability suggests his refusal, even in his objects, to make art that can be easily marketed and institutionally consumed. "When you choose to do work in multiple forms, prioritizing ideas that invent forms," Martinez said, "and call that experimentation, you are less concerned with the resolution and with the cultural confinement of the tradition of modernism, and you have set yourself free to engage process and failure as part of the vocabulary of risk." The NEA was essential to him. "There was no other place in the United States where one's ideas could be validated. Artists like me have been kept outside the pale of inclusion," he said, meaning "women and people of color, artists who operate outside the traditional vernacular and who don't measure success by their appeal to the marketplace."[28]

One of the most precious aspects of an NEA fellowship was that it was often experienced as a gift in the fullest sense of something given especially to one particular person, with a special knowledge of who that person is and what that person needs, by someone or something that cares—in this case a government agency, on the advice of peers. Deborah Groover described the $20,000 crafts fellowship she received in 1992 as "a true gift."[29] The experience of a true gift is always, in part, the experience of being truly and empathetically seen. "I was totally thrilled that I could be considered for such a prize and understood in some way that I'd never been understood before," Rockburne said of her fellowship in 1974.[30]

The experience of the gift, not as giveaway but as profound recognition, shapes the language of some fellowship recipients. Kristin Jones and Andrew Ginzel, a husband-and-wife team that works collaboratively, mostly on civic public art projects, received fellowships in 1986 and 1994. For them the language of the gift is connected both to a special kind of generosity and to the possibility and the experience of public space. Of a 1986 project in a nonprofit space in lower Manhattan made possible by the first fellowship, Jones said it was "an effort to do something that was entirely accessible to the public. . . . It was really meant to be a gift." Of their relation to the art market, she said: "I've always been very conflicted about any financial gain. Putting a money value on an effort or on something that was meant to be something completely other is problematic to me. I really feel as though I have an enormous responsibility to make work as a form of generosity."[31]

Since the collapse of public funding, the meanings of words like *generosity* and *gift* have been restricted. When a "product-driven, consumer-based, marketing mentality" rules, these words are largely defined in terms of contributions, donations, and gestures so essential that this country cannot do without them, but these words lose their connection to an experience of giving and receiving in which the award or reward holds within it an offering of fusion and freedom that seals the transaction. The kind of trust that was embedded in fellowships carried within it both intensely personal recognition of the artist and the

conviction that he or she would create something good for the society as a whole. It made private and public inseparable.

Missing Connections

As remarkable as the visual artists' fellowship program was, it had to change.

In its section on Findings and Recommendations, the 1990 Independent Commission explained that "lost in the current debate on the National Endowment for the Arts is the recognition that the arts belong to all the American people and not only to those who benefit directly from the agency." The report "recommendated that the preamble of the legislation that authorizes the National Endowment for the Arts be amended to make clear that the arts belong to all the people of the United States."[32] The point was clear: In the view of this commission, and in the view of some of the agency's strongest critics, the NEA belonged more to the field than it did to the American people.[33]

The NEA began at a Cold War moment when many of the most imaginative American artists were so marginal, and when the general population seemed so hostile to artists and so easily distracted by mass culture and money, that government decided artists had to be allowed to decide what was right for them and do with their fellowship what they saw fit. In many ways, the Endowment's trust and belief in artists paid off. The fellowship program did a superb job funding gifted artists at the right time. By supporting VAOs and contemporary art museums whose job it was to find artists who commanded attention and present their work, the Endowment contributed to the energy and credibility of art institutions. By supporting American art as a field—artists, galleries, VAOs, community centers, museums—the Endowment solidified the base and reputation of American art, and gave many people, here and abroad, more confidence in it, which could not help but serve local and national interests.

Several presidents needed the NEA. Being associated with the arts and with glamorous artists of all kinds helped John F. Kennedy culti-

vate a cosmopolitan aura. Like Kennedy, Lyndon B. Johnson and Richard M. Nixon also knew they had a better chance of being remembered as great presidents if they demonstrated their commitment to artistic genius and to spiritual and intellectual endeavors. Johnson and Nixon also needed ways to mute the resistance of opponents of the Vietnam War. "Nixon received advice similar to that which Schlesinger gave Johnson," art historian John Pultz wrote. "Strong support for the arts would be an inexpensive way to curry favor with intellectuals and urbanites, two groups with whom Nixon was not popular. Nixon responded to the advice with an aggressive policy of strong support for the arts."[34] In 1971 and again in 1972, Nixon nearly doubled the NEA's appropriations.

Reagan was different. He was swept into office by a tide of Republicans sick of wishy-washy, self-doubting liberalism and eager to reestablish ideals of masculine decisiveness and heroic patriotism. The Vietnam War was over, so its critics, whom Reagan had never liked, had little or no power over him. He proclaimed Vietnam veterans heroes and the war an honorable cause.[35] He believed the problems of America were created by activist government, antimarket forces, and liberalism. Popular culture, in particular Hollywood and the entertainment industry, were fine ambassadors for American culture. What possible advantage was there in showing the country and the rest of the world that the American government was funding visual artists so that they could follow their creativity outside the market and help this economic and military giant find its moral and spiritual center?

Then came the disintegration of the Soviet empire and the equally sudden emergence of the United States as the only superpower. Had artists functioning on the edges of American society played any role in this victory? Did the specialness of artists that the Endowment continued to insist on make any sense? Did government need artists at all?

The Reagan emphasis on the market exposed the weakness of the visual artists' fellowship program. It was not set up to lead artists toward the general public. One of the characteristics of good art is that it generates circuits of connections—for example, within the artist, within

the art, within the person experiencing the art. It also has the ability to create or reimagine audiences and make audiences feel connected with many institutions and different groups of people, and to other parts of the world. But the same peer panel system that appreciated the connections that help define the specialness of the creative process did not encourage artists to extend their gift of connectedness into everyday life. The fellowship program made it easy for artists to see themselves and art apart from the rest of society. The NEA was exemplary in its attentiveness to the creative process and to the values embedded in its panel process, but it did not release that attentiveness and those values into the world.

Many artists are aware that their creative process offers information and lessons for their everyday lives. The abstract painter Pat Adams, a celebrated teacher and one of a handful of artists who experienced the benefits of both Franklin Delano Roosevelt's Works Progress Administration in the 1930s and Kennedy's and Johnson's NEA, believes the process of making art carries meanings and lessons that can be applied to all aspects of life. "I see the NEA as part of politics in the largest sense," she said, "democracy in the largest sense—how we govern ourselves. You can't make a painting and not be concerned with how you govern yourself. It just seems to me that the parallel is so direct." Adams believes that a fuller engagement with the process of making art, and also with the process of encountering art, can contribute to a better society. "It seems to me that art is a reason for every sort of civility, self-knowing, community exchange," she said. "It girds up the identity of individuals, which makes them a strong voter. I'm talking about the entire activity."[36]

In a paper she delivered at the National Academy of Design in New York City, Adams elaborated on the connection between her ways of working and being. "What drives this painting?" she asked. "What determines which way and how to push the paint around? What gives the raison d'être for those most apt relationships among visual elements, that moves all that possibility into a vision which, through its visual force, strikes me as a presence both real and inevitable?" She writes of

these sensual distinctions and what can be learned from them. "We count, sort, divide, arrange, apportion," she wrote. "We do this with grains of sand at the beach, with blocks in the nursery—and perhaps less well with distributive justice. Whatever heightens this alertness, whatever achieves a personal vividness, I see as politically potent: it argues for the freedom of the individual, for the will to form, and for the independent message concerning what it is that is coming to be."[37]

That the Endowment elicited a sense of connection to the agency is poignantly clear in the responses of artists who received fellowships. They wanted to serve on panels; they wanted to give back. "It felt like such a privilege being there," sculptor Ursula Von Rydingsvard said of her peer panel.[38] Sculptor Ronald Jones said: "I was proud to be there, ready to return something to the system that had supported me earlier on."[39] For the Conceptual artist Inigo Manglano-Ovalle, whose career has taken off since he received one of the NEA's last fellowships, in 1995, not having the chance to serve on a panel and become part of its ongoing process was painful. "Those people who have received those grants before have always been really committed to that fellowship," he said. "They know it's really important and they are committed to keeping it active, and they serve on peer panels and know the legitimacy" of receiving a grant. Then "it shuts down," he said, which "really blocks you from actually taking up that role as an artist, as an American artist, watching or helping or assessing or promoting or celebrating the next artist that gets it. I felt cheated."[40]

The problem was that serving on panels was pretty much the only way artists could give back. The agency would not have believed in the intrinsic value of creativity if it had not understood the gift of connectedness that was embedded within it. But it did not sufficiently activate the potential for reciprocity and relationship built into this gift. The fellowship program inspired a sense of connectedness in the artists who received fellowships, but for a number of reasons, many of them understandable, some practical (i.e., how can you bring artists, as a group, closer when so few get fellowships), some admirable (the Endowment did not want the experience of fellowship as gift to be undermined by

making the recipient feel an obligation), the NEA was structured to create a bond between artists and government and yet keep artists at a distance.

The fellowship program itself discouraged a thoroughly enbedded connective awareness. "One of the downsides of the fellowship program," Jennifer Dowley said, "in spite of all the beaconlike qualities it had, was that we received 5,000 applications a year and we gave 100 fellowships. This means 4,900 artists got a form letter from the agency saying, 'we regret to inform you.' It cultivated a kind of lotterylike, passive culture in the individual artist's world. They sort of threw their hat in and said, What can you do for me? When is my turn going to come? There was no relationship there, aside from one of the anticipation of the lighthouse possibly shining its light on you. Artists did think they had to know somebody on the panel and that it was an insider kind of thing. The process itself generated that attitude. I don't think the fellowship program ever explored the notion of a relationship of artists to the agency, or, more importantly, of the relationship of artists to the world. The fellowships were unrestricted. They were for individuals to carry out their work in whatever way they designed to better their work—and all the meaning behind that, the trust, the respect, the honor, the kind of galvanizing of the artist to create more. It is all splendid. But it didn't change the artists' role in society. It acknowledged that they are operating at an economic and social deficit in our society, as outsiders, that the culture overall doesn't support you. We will tap a certain number of you every year with this great honor, and because of our stature it will bring light to you, or bring attention to you, that may have positive ramifications in your life. It does say that you're valued as an artist. It does not say that your relationship with the PTA is important, or whatever web you have created for your life is important. The fellowships allowed artists to create work on their own terms, but this was not a cultural policy that encouraged connections."[41]

Hunter himself felt the fellowship program needed something else, another step perhaps. "My criticism of fellowships in general," he said, "is that it does take the artist as some kind of record of deed and not

as a record of what they are in the community. The idea of the artist being in the fabric of culture interests me more than the artist as someone doing these things totally alone and coming up with so-called great works, which I do think is important . . . Fellowships tended to reward more that kind of person than the one who has a sense of artist as citizen."[42]

The model of the heroic, independent loner struggling to provide an alternative to an unjust, self-deceived, and restrictive society produced enduring art. But it continued to pit the artist and society against each other long after artists had become technologically connected to society and an essential cog in a culture industry indispensable to the country's economic machine. Galleries and museums continue to feed off this model of the artist as heroic outsider alone in the studio producing masterful goods. This model makes it easy to exalt artists as visionaries but also to damn them as outcasts. It makes it all but impossible to move from a fetishistic preoccupation with "art" and "artist," or, for that matter, with "Quality," to an investigation of all that goes on within the creative process that suggests the possibilities of a more intense, magical, and integrated life. With all the good that the Endowment did for artists, the romantic image of the great and incorruptible artist-genius built into the agency at its inception made it harder for the gift of this creativity to be defined and dispersed.

To move in the opposite direction and totally integrate the artist in community, however, as *American Canvas* tried to do, is even more dangerous. When the artist is seen entirely as citizen, entirely within any community or institutional framework, the artist's particularity and necessity get lost. The intensity of perception and commitment required to achieve the kind of imaginative connectedness and poetic beauty that can touch or transform people cannot be appreciated. When their particular ways of struggling for meaning are overlooked, artists are taken for granted. Artists *are* like everyone else and they are as responsible to their families and communities as other American citizens, but the risk, commitment, obsessiveness, and passion their work requires, as well as their ways of processing and synthesizing information, do make them

different. Everyone who believes in their value to society must keep both their ordinariness and their extraordinariness in mind.

Manglano-Ovalle is an important voice here. He gained a reputation for a long-term community-based project with young Latinos in his West Town community in Chicago. The project taught them to use video equipment so that they could represent themselves and their realities to others and not just see themselves represented in film or on television. Because of the practical and aesthetic success of this project for "Culture in Action"—eight community-based projects commissioned in 1993 by Sculpture Chicago—Manglano-Ovalle's identity as an artist was linked to his community and to community-based work. He received many requests from other institutions to do something similar in which his previous involvement with community would be recognizable. "They were essentially asking me to replicate" that project, he said. He applied to the NEA for a fellowship. "I was applying for recognition as an individual."

In order for the particular artistic sensibility and intelligence which gave meaning to that project not to be lost, Manglano-Ovalle needed to establish and preserve a clear artistic identity. He had always made objects, but now he understood the importance of showing in galleries. "One of the successes of 'Culture in Action' was this notion that a group of us could create something together and that we could problematize authorship," he said. "That was one of the best parts of it, but subsequently also one of its worst parts in that that might actually subvert the role of the artist . . . I knew that the role of the artist as a kind of critical practioner, as an activist, even as a maker of formal things, was essential to the larger cultural project. And so returning to a product-based making was a strategic move to say, this is individual practice. This is the artist, and what the artist does is important."[43]

Future fellowship programs might consider these questions: How is it possible to respect artists both as particular kinds of thinkers and makers and as social beings who are always, at every moment, embedded in society, even in the logic and languages with which they obsess

and risk and receive and organize information? Is it possible to value their difference even while knowing that the very definition of that difference is always framed by the society from which the artist is distinguished? Is it possible to develop a language that recognizes and appreciates the specialness of their imaginations and utterances without romanticizing them?

The Endowment's national council from 1981 on, secure in its faith in the omniscience of market and museums, could only allow visual artists to be represented by artists who work in studios to produce privileged goods that can be valued and circulated by dealers and curators. The visual arts program always knew that this should never be the primary artistic model. It funded many artists who know what it means to work both in the public and in the private realms, to have work in galleries and museums, and in private homes, gardens, city squares, and other outdoor spaces. They expand the notion of the market so that it disrupts the absolute primacy of the dealer-collector-critic-curator network by revealing that the market may also include foundations, public art organizations, park departments, prisons, city councils, community centers—any person or organization that funds artists or their work. These other circuits need to be mapped and respected. Robert W. Irwin is an artist of vigorous intelligence and independence who can go into almost any situation and communicate fresh ways of thinking. So can Laurie Anderson, Newton Harrison, Gary Hill, Alfredo Jaar, Barbara Kruger, Maya Lin, Manglano-Ovalle, Martinez, Mary Miss, Bruce Nauman, Adrian Piper, and Bill Viola, all of whom work with electronic technology to make art rich in poetry and thought. So can sculptors like Siah Armajani, Alice Aycock, Luis Jimenez, and Martin Puryear, who also function in multiple markets and are able to communicate with the professional art world, community boards, and the man and woman in the street. These are clearly artists and clearly social beings. When enough of these artists, or artists like them, are allowed to become images of the American artist and voices for contemporary art, the visual artist may finally have found a viable place in America.

Notes

1. *A Report to Congress on the National Endowment for the Arts*, submitted by The Independent Commission, Washington, D.C., September 1990, 28.
2. Memorandum from Jeff Mandell, the NEA's general counsel, to the Deputy Chairman, Program Directors and Division Heads, 18 October 1983.
3. See Hilton Kramer, "Criticism Endowed: Reflections on a Debacle," *New Criterion* (November 1983), 1–5.
4. Hugh Southern and Ana Steele, Paper on "Blind Judging," sent to Francis S.M. Hodsoll, 17 December 1983.
5. Richard Andrews, op. cit.
6. See Ruth Berenson, "The Fate of Modernism," *National Review*, 17 April 1981, 437.
7. See Richard Goldstein, "The New NEA: Hodsoll's Hand," *Village Voice*, 28 December 1982, 47.
8. See Helen Frankenthaler, "Did We Spawn an Arts Monster?" *New York Times*, 17 July 1989, 17.
9. Conversation with Michael Faubion, 22 February 2000.
10. Benny Andrews, op. cit.
11. Richard Andrews, op. cit.
12. Interview with Leonard Hunter, 1 October 1998.
13. Benny Andrews, op. cit.
14. Frankenthaler, op. cit.
15. One of the hardest blows to the peer panel system occurred in 1994, and it demonstrates how compromised the National Council had become. The 1994 photography panel recommended 30 fellowships from the 1,700 applicants. Three — to Merry Alpern, Barbara DeGenevieve, and Andres Serrano — were rejected by the National Council. Their decisions inspired an Op Ed piece in the August 17, 1994, *Los Angeles Times* (p. F1) by Andy Grundberg, one of the panel members. Grundberg, a former photography critic for the *New York Times* and at the time of the panel director of Friends of Photography in San Francisco, wrote that "the National Council, which includes no one with a background in the art of photography, saw fit to overrule our recommendations. Never before had the council rejected a fellowship peer panel's judgments." He emphasized that the panel had made its decisions "solely on the basis of artistic quality" and asserted that quality had little or nothing to do with the council's rejections. "As the transcript of the council's public session reveals," he wrote, "the discussion about the photography fellowship began with citations of Congress's eagerness to see that the council not be a

'rubber stamp' of peer panel decisions." Grundberg wrote that "ultimately their [the council's] decisions come down to two factors, personal taste and politics. Neither belongs in the process." He stated that "two dozen political appointees constituting the National Council for the Arts will continue to be national arbiters of what art is good enough to be recognized and rewarded" and concluded that "the process is now fundamentally flawed."

One of the most disturbing aspects of this affair was that the decision to reject the fellowship to Serrano was made not on the basis of the slides he sent in, from his morgue series, which Grundberg described "as among the strongest we had the privilege of seeing." Rather, he was "judged on the basis of past work," another panelist, Ellen Brooks, a photographer who had received fellowships in 1976, 1980, and 1990, said. "This was done with no other artist. This was an extraordinary breach of procedure." Interview with Ellen Brooks, 11 September 1999.

For council member Roger Mandle, rejecting the grant to Serrano on the basis of his past work was "absolutely reprehensible. It was branding somebody with their past sins, so-called, as though nothing they would ever do would redeem them. That's totally outside the American ethos. Totally outside the Christian ethic. Totally outside any religious ethic you could think of. It's heinous!" Mandle, op. cit.

16. Interview with Ruth Berenson, 30 October 1998.
17. Plagens, op. cit.
18. Hunter, op. cit.
19. Learsy, op. cit.
20. Interview with Martin Friedman, 9 July 1998.
21. Delehanty, op. cit.
22. Jessica Murray is an art dealer whose experience of the NEA began with the culture wars. "In 1989 I graduated from college," she said. "I was majoring in early modern French art. I wrote my thesis on Watteau, so my interest in contemporary art hadn't even really started. My perspective on the NEA began with that. I don't remember when it was ever a good thing." "American Canvas: A Roundtable on the 1997 NEA Report," op. cit., 75.
23. Kruger, op. cit.
24. Interview with Beverly Semmes, 25 October 1998.
25. Rockburne, op. cit.
26. Close address, op. cit.
27. Shapiro, op. cit.
28. Martinez, op. cit.
29. Huong Vu, op. cit., 18.

30. Rockburne, op. cit.

31. Interview with Kristin Jones, 13 October 1998.

32. "A Report to Congress on the National Endowment for the Arts," op. cit., 59.

33. For example, in his response to the question "Can the NEA be fixed?," Frederick Turner, the Founders Professor of Arts and Humanities at the University of Texas at Dallas, stated that the "NEA should be for America—not for artists; artists should be for America, in this country—and for the world." He offered a plan for a new selection system: "We should create arts panels, if we have them, out of leading citizens in business, law, medicine, sciences, religion, philanthropy, the arts, entertainment, the academies, sports, and so on, who will be, in a sense, patrons. . . . I would expect that in the first 10 or 15 years they would be doing this, they would be funding trite, nice, pretty art. And then, after a while, they would begin to learn. It's the duty of patrons to learn. We just have to go through that period. You can't just go on having contempt for the people; you have to have the people learn how to be good patrons. We just have to put up with a bit of trite art. We'll surely get it, but just let the process flow for a bit, and then something—more interesting things—will happen." Turner was convinced the NEA and NEH were penetrated by "political correctness and by really very restrictive neo-Stalinist forces." He wrote that "no significant art, or significant artists, that I know of, in any field—especially in my field of poetry—have emerged as a result of NEA support of new art or of individual artists." He said that "in order to be any good as artists, they need the challenge to be shamans for a whole people, to express the inchoate voice of the culture, to speak what that culture knows of truth and beauty and goodness. They need to have their feet held to the fire so that they do that." The way to help them meet these responsibilities, he wrote, is to create a new system of patronage. The new patrons would help create commissions that would go to artists and say, 'This is what we need.' And then the artists rise to the challenge." See Frederick Turner, "An Embattled Establishment," in *The National Endowments: A Critical Symposium*," ed. Laurence Jarvik, Herbert I. London, and James F. Cooper (Los Angeles: Second Thought Books, 1995), 75–81.

34. Pultz, op. cit., 22. Alice Goldfarb Marquis cites a letter in which Leonard Garment wrote to Nixon that "it struck me as politically wise to build up the Endowment." She writes that "in a long memo outlining a response to Nancy Hanks's plea for more funding, Garment urged Nixon to approve her request for $40 million. Such an eightfold increase over Stevens's budget, he wrote, 'would have a high impact among opinion formers. . . . Support for the arts is, increasingly, good politics. . . . you will gain support from groups which

have hitherto not been favorable to this administration.'" Marquis, op. cit., 92–93.

For a number of artists in the late sixties and early seventies, the Endowment did indeed create some sense of connection with a government whose Vietnam policies they violently disagreed with. "I remember feeling there were a lot of things my government was not doing then, and many things I didn't like," Chuck Close said. "There was the Nixon administration's bombing of Cambodia and all that sort of thing, and I thought, at least there's the National Endowment for the Arts, something that recognizes that artists are a part of this country, too. It's not just who can go over there and catch bullets, but that artists were making a contribution, too; and that at least one agency of our government recognizes that even while you don't really approve of some of the things your country does, you could still be involved with another arm of the government, which was doing something right." Interview with Chuck Close, 4 November 1998. The interview took place just after he had addressed the council.

35. For the shifting attitude toward the Vietnam War during the Reagan administration, see Levi P. Smith III, "Objects of Remembrance: The Vietnam Veterans Memorial and the Memory of the War," an unpublished doctoral thesis written for the University of Chicago, Ann Arbor, Michigan: UMI Microfilm, 1997, vol. 2, pt. 2.

36. Adams, op. cit. Adams has taught for thirty years at Bennington College in Vermont. In 1984, she was given the College Art Association's Distinguished Teaching in Art award.

37. Pat Adams, paper delivered at "Artists Conversations: Out of Joint," a panel discussion at the National Academy of Design, New York, N.Y., 20 January 2000.

38. Ursula von Rydingsvard, op. cit.

39. Ronald Jones, op. cit.

40. Interview with Inigo Manglano-Ovalle, 16 November 1998.

41. Dowley, op. cit.

42. Hunter, op. cit.

43. Manglano-Ovalle, op. cit. For information on his project in West Town, see *Culture in Action, A Public Art Program of Sculpture Chicago*, curated by Mary Jane Jacob, essays by Mary Jane Jacob, Michael Brenson, Eva M. Olson (Seattle: Bay Press, 1995).

VII

WHERE DO WE GO
FROM HERE?

I

Is another government visual artists' fellowship program possible?

One with the mission and impact of the NEA's program is inconceivable now, and it is hard to imagine another federal fellowship program of any kind. Demonizing artists is still profitable. Artists think in ways that challenge systems of official power neither government nor business in this institutional moment wants challenged. Just as important, artists no longer have an identity with which to distinguish them from actors, filmmakers, or other kinds of entertainers on whom much of the marketing of America now depends.

The dust has not yet begun to settle after a decade of attacks on artists and the agency. Indignant tirades in the House and in the media about public funding for these enemies of Main Street America gained too many votes and campaign donations for politicians, too many television viewers, and too many tabloid readers for politicians and the media to permit the dust to settle. In addition, government and business need scapegoats to deflect attention from our impoverished public life and from the massive power of the global corporate entertainment industry—mass-media-electronic industry network whose influence on

just about every aspect of American institutional life is partly respon-
sible for this impoverishment. Artists remain easy targets. Because the
vast majority of them are not allied with institutional interests, there is
no cost in pointing fingers at them and saying, in effect, See, there's the
problem, that's why American morals are declining and mainstream
American values are not being sufficiently respected and American po-
litical and business leaders, even after the collapse of the Soviet empire
in 1989, still have to work to convince people in other countries that the
American way is the way of the world.

The artists who are thoughtfully engaged with art and culture really
can be nettlesome. They think for themselves and are therefore difficult
to manipulate. They are uncomfortable with fundamentalisms of any
kind and likely to question everything, including the art of the past, in-
stitutional power, corporate culture, and themselves. They are well-
read and articulate, and guided not by institutional rules but by what
artist Newton Harrison refers to as an internal critic. "This internal
critic says when it's good enough, or when it's not sufficient," Harrison
said, "and you will do this work over and over again until it is sufficient,
and you do not count the costs. We have moved into a cost-accounting
society, where all costs are counted. Once the poor Endowment had to
confront the cost—a cost-efficient, cost-accounting, insurance-policy-
type-world in Congress—it became lost. It lost the artist. Artists can
lose money, time, energy, anything, but the artist does not count the
cost. This is more than just an obsession. It is paying attention to the
internal critic that you have and giving it a voice, whatever the cost.
The great value to the culture is to have a wing of culture creating with-
out counting the cost."[1]

In what Thomas Krens, the director of the Solomon R. Guggenheim
Foundation, has characterized as a "consumer-driven, market-oriented
society," valuing the logic and demands of the creative process even
more than the products that result from it seems downright unnatural.[2]
Art museums, like the media and entertainment industry on which they
are increasingly dependent, are now guided far less by their internal
critics than by marketing surveys that tell them what the public is ready

to consume. What many of the most influential art museums want is passive audiences that will keep coming back, not active audiences that might talk back. The NEA put pressure on all the arts, and on their institutions, including museums, to respect artists who were interested in incisively and poetically engaging the challenges of the moment, and artists who did not want their work to fit effortlessly within institutional machineries of consumption. There is no such pressure now.

The NEA was instrumental in the development of artists who have been able to create spaces in which visitors can imagine ways of thinking and being different from those promoted by the market. For example, in 1988 it gave a sculpture fellowship to Maya Lin; it "legitimized for me that I was an artist," she said.[3] Since Lin was known then only as an architect and designer, the fellowship was clearly given on the basis of her 1982 Vietnam Veterans Memorial, which by 1985 had become the most visited monument in the nation's capital. That memorial, like almost all of Lin's public art, encourages visitors to enter a process that cannot be hurried. Like a first-rate painting, it creates a sense of the fullness of the moment, but it holds that moment open, keeps it open, does not allow it to consume or be consumed, even enables it to expand so that the experience of inner fullness seems to flow through and yet concentrate the space around it. The publicness of Lin's work is the condition of trust and intimacy that makes knowing possible. The experiences of recognition and revelation her public art offers become tissues of embeddedness.

The NEA gave three fellowships to Mary Miss (an artists' fellowship in 1974 and 1975 and a sculpture fellowship in 1984), who continues to investigate the possibilities of public space, which she defines as a space in which all people can feel part, regardless of race, class, or gender. Public space, she said, is different from the space of the Internet, which is "still an exclusive context" that has not "eliminated the need for a larger public realm."[4] Her pockets of landscape are meditative, conducive to wandering and musing. At the same time they create a sense of shared ownership in that the access they offer to archetypal memory encourages a feeling of interpersonal connection. They really are public

spaces. They appeal to people of all ages, leading people inside themselves and yet enabling them to value the proximity of others sharing with them a corner of a park or waterfront. As with Lin's public art, their respect for privacy and ability to put people in touch with their intimate selves—their internal voices—gives the idea of public space a symbolic, even mythical, weight.

Miss asks questions the market does not ask: "Is there any way you can get people's attention with something other than selling things?" Can you make art in the real world that is engaging enough to compete for the public's attention with theme parks and malls? Can you make art that connects people to their environments and enables them to believe they are both personally and communally owned? Who will stand behind these questions now?

In 1965, the NEA's support of the independence and imaginations of artists made sense. It was a crisis time. Artists promised both propaganda value and genuine moral and spiritual guidance. They were understood as heroic, inner-directed forces of resistance to the temptations of mass culture and materialism and to the dangers of technology. In the sixties, the military-industrial complex seemed impregnable, and even some conservative politicians believed the United States needed some protection from its power. In the spring of 2000, America is being driven by an image of itself as a boom nation, making money hand over fist, proud of its wealth and might, spearheading an electronic technology revolution that requires its citizens to maintain a ruthless, win-at-all-cost, business edge if they are to prevent the leadership of this decisive industry from falling into other hands. America is still at war, but it is a technology war, which is not a war of values. It is a war of nonstop digital innovation in which countries within and outside the West are competing for the ownership of global circuits of power. Any viable government artists' fellowship program would fund artists who think about values and consequences, and about the full human and political implications of electronic technology's annihilation of space and time that enables the new global technocracy to make money and infiltrate the world. Mobilized to retain the competitive and entrepreneurial

edge that will enable it to win the technology war, the United States wants no part of that.

And what story, what myth, of artists can the country latch on to now? Many artists have been eager to align themselves with mass culture and technology and prove to everyone they are not outcasts or heroes but ordinary citizens. They have cut themselves down to size. In aligning themselves with American mass culture, they have blurred the boundaries between themselves and the entertainment industry, which dwarfs them in its influence and whose aura of omnipotence depends in part on the assumption that there is no aspect of society it cannot infiltrate. How do artists define themselves so that society can recognize them? Where is their space to maneuver? Given the dependence of museums on the global corporate network, artists who resist this network will find it hard to have their work shown in them. But if they cannot create an image for themselves that suggests a strategic awareness of and resistance to massive institutional power, society will not be able to distinguish them from corporate ambition and professional entertainers and it will not understand why they matter.

The private sector is probably the only hope now for an ambitious fellowship program that can think imaginatively about artists, their place in America, and the needs of the field. In principle, a private foundation can fund whomever and whatever it wants. When it announced its existence in early 1999, the Creative Capital Foundation, the first major attempt to fill the gap that was created by the elimination of NEA fellowships, made a point of declaring it would fund controversial and provocative artists. The foundation is based on a venture capital model that requires a small percentage of the profits from the art made possible by a fellowship to be given back to the foundation. It also requires fellowship recipients to define their audiences and work with the foundation to develop them. As this book is being written, the Ford Foundation is doing research for what may be a major commitment to funding individual artists. Private foundations can be imaginative and protected enough to be able to locate and cultivate art that defines the

fault lines and artistic challenges of the moment. The possibilities of private arts funding have barely been developed.

But no private foundation can replace the NEA. No foundation can make artists feel their country needs them. Probably no private foundation, no matter how generous and inspired, can make the case that funding artists is in the national interest.

Can a private foundation think ecologically? The Endowment constantly referred to "the field." Its visual arts program directors used metaphors like fertilizing and seeding. It supported artists like Harrison and Lin who have been instrumental in developing the ecological imagination. Few foundations have developed arts fellowship programs that functioned ecologically, in part because each foundation has a niche, and each arts program has to serve a large agenda for the agency that is almost never decided by its arts officers.

Any ambitious new fellowship program must learn from the NEA. This means thinking through its assumptions about artists, its attitudes toward museum and contemporary art, and its entire selection system, the peer panel process but also the national council. The effect of the national council was far greater than has been recognized, just as boards of trustees have a much greater effect on the programs and policies of museums than museums, most scholars and critics, and the boards themselves, acknowledge. If a new fellowship program is committed to serving artists and art, it needs to be introspective about its own administrative machinery and ambitions and honest enough to keep examining its own motives and the reasons why it believes artists are worthy of their investment.

II

The NEA was a great agency, with irreplaceable strengths, but it also had weaknesses. With all that it did for artists, it ended up sustaining their marginalization. In its visual artists' fellowship program, in its Art-in-Public-Places program, and in other visual arts programs, it put artists on pedestals, which reinforced the predisposition of many people to

feel that artists, and the NEA, were arrogant and disdainful. The agency's primary model of the artist remained the one of the artist working alone in his studio to produce paintings and sculptures that would help a general population easily manipulated and misled by an "intrusive society and an officious state" to remain ethically and spiritually grounded. No matter how much great art has been made in the studio, this model cannot reduce the artist's alienation. It assumes social, and often moral, separateness as the condition of artmaking.

Just as important, it results in objects that depend upon galleries and museums to mobilize an aesthetic emotion whose specialness is defined, in part, by its separateness from everyday life. One of the attractions of art museums has been the promise of an aesthetic experience so intense that it makes viewers feel they are in the presence of something deep and timeless. Since a signature, even a brand, feature of this intensity is the autonomy and therefore the disconnectedness of the aesthetic experience, it has been almost unthinkable for museums to assert the value of asking questions about aesthetic emotion that could make available the extraordinary information embedded in it. For example, what does that response to that painting at that moment reveal to you about your history, your circumstances, and your psychological and professional condition?

Because the museum aesthetic experience has remained largely separate from everyday life, visitors do not own that experience. It belongs more to the museum. The museum model is essentially a missionary one: the institution owns or borrows the art and presents it in a way that delivers aesthetic emotion to its audiences. They, then, demonstrate their gratitude by becoming members of the museum church so that they can serve it and have continuing access to that intensity that enables them to feel the depths of their inner or spiritual lives, which assures them of the existence of a self that cannot be erased or corrupted by everyday life. The gratitude of audiences, in exchange, empowers the institution and makes it more attractive to social, political, and financial movers and shakers, who manage and use the institution for their own purposes, and whose resources and connections are needed to

give museums the authority to keep buying and borrowing art for their congregations. Museums assume a clear power relationship. They can be joyful, hospitable, revelatory, and endlessly informative, and many have been working on becoming more interactive, but they are not built for the kind of introspection and reciprocity that would allow visitors to assimilate and own their aesthetic experiences. Without that ownership, the marvelous and addictive jolt of self and spirit museums offer remains confined to the realm of the aesthetic. The sources of the aesthetic experience remain the art object and the museum far more than the stories, experiences, conflicts, and talents of viewers. Museums perpetuate the separateness of art and its makers.

While the majority of artists still work in studios and the best of them create objects of enduring poetry and power, enough other artists have resisted the studio model to make "post-studio practice" a common term in visual artists' organizations and university art departments. Many artists who want their objects or ideas to generate a sustained engagement and freewheeling connective consciousness work outside museums. Some do not work in studios at all. Some of the best have developed practices that depend both on solitude in the studio and on collaboration outside it. The dialectic between solitary concentration and public engagement helps them to make both inquisitive, or more participatory, museum art, and community, landscape, or architectural art in which the aesthetic experience unfolds within the spaces of the everyday world.

Although the Endowment rewarded all kinds of artists and approaches, its visual artists' fellowship program continued to function within the framework of a studio and museum model. Looking at slides and making recommendations on the basis of discussions that, for a host of legitimate reasons, could not allow for contextual considerations, meant that all artists were, in effect, as Leonard Hunter said, evaluated "as some kind of record of deed and not as a record of what they are in the community." No peer panel process faced with thousands of applications can consider the applicants "in the fabric of culture." To judge on the basis of slides, and to keep the discussion focused on the work,

meant that even with the program's profound responsiveness to
creativity—and the astonishing ability of many artists to pick up from
slides the subtlest patterns and yearnings in another artist's work—the
applicants were essentially evaluated as studio producers of gallery and
museum objects. The culture in which artists were considered was an
art culture.

The NEA had no procedure after the fellowship year in which the
panel that made the recommendations, or another, could have engaged
interested fellowship recipients in discussions about the connections be-
tween an artist's creativity and the larger culture. No opportunity to ask
recipients questions like: What is your community, or communities?
What relationship do you have or want to have with those communi-
ties? How can the way you think and work have the maximum impact
on other people's lives? The Endowment understood splendidly the
value to the larger culture of artistic creativity, but it did not understand
the importance of working with the fellowship recipients to develop a
consciousness of the information, energy, and magic embedded in it.[5]

The history of the Endowment reveals how tricky and delicate the
relationship between contemporary art standards and museum stan-
dards can be. The NEA was committed to experimentation, risk, pro-
cess, and creativity, the support of which helps younger artists and new
art to flourish. It was also committed to excellence and quality, which
recognized the authority of established criteria. For a long time, there
was no conflict. Within the fellowship program, the balance between
supporting the not-yet-formed and the already-defined, the emerging
and the mature, the unknown and the known, could swing either way,
depending on the panel or the year, and this flexibility was a sign of the
system's health and dynamism.

But the attention to the energy and ideas pushing toward form in
an artist's work took place within a peer panel system that evaluated
artists on the basis of an artistic discussion of slides. This meant that the
appreciation of process unfolded within a product-oriented museum
framework. Once the Hodsoll administration shifted the balance of the
agency to the museum side, experimentation and risk continued to be

rewarded but the market and museum languages that managed the agency made it harder for it to appreciate how interdependent museum and contemporary art standards are. Once the museum language became the primary one, and was pitted against and detached from the core language of contemporary art, contemporary art was vulnerable. An agency whose language of authority is a museum language will not easily be able to make an effective argument for artists reaching for what society does not yet want to see or hear. The danger of words like *quality* and *excellence* is that they impose a will to declare good or bad that can make it impossible to enter a work and see what is there, which means they can actually make it impossible to recognize quality. Part of the greatness of the NEA was that it knew that respect for the inherent value of creativity could not be separated from the support of quality. Any effective fellowship program must understand the danger, as well as the importance, of words like *quality* and *excellence* and develop a language in which they cannot be disconnected from the pressures and questions that give new art its urgency and purpose.

When the Endowment began, there were signs that the agency would be capable of rethinking the studio model. For the first visual artist on the National Council, Roger Stevens chose David Smith. It was a glorious choice. Smith was a great sculptor: a producer of brilliantly intuitive welded-steel constructions that gave modern American sculpture an intelligence and sense of possibility it had not had. For Smith, making was a way of thinking, playing, and dreaming. He had a deep appreciation of the creative process and an abiding belief that good art required a synthesis of intuition and intellect, doubt and conviction, vulnerability and statement. For much of his life, he fretted about the place of the artist in America and thought about how sculpture could be reinvented so that it, and those who made it, could become shapers of the larger culture. Smith owed a great deal of his success to gallery support and he depended on museums to root his work in the history of art, test it against other art, and give audiences a chance to see it. But his dissatisfaction with the ways in which museums displaced and disconnected art and the art experience, along with the amount of sculp-

ture he was producing, contributed to his reimagining of the sculptor's studio. In the early sixties, Smith kept planting his abstract steel sculptures in his fields in upstate New York, where their lines and shapes echoed the trees and the tracks in the snow, and their reflective surfaces made the burnished surfaces dance with space and light. A sense of place, in particular, of the grand and raw Adirondack landscape that was Smith's home from 1940 until his death in 1965, was essential to the form and content of his sculpture, and to how it functioned. After seeing his photographs of his sculptures in those fields, it is hard to disconnect them from that environment, even when they are seen in galleries and museums.

Stevens understood the importance of this connection to place. In the 1965 conference in Santa Barbara, he described Smith as "one of our greatest sculptors." Then he said: "In his studio in Bolton Landing, New York, he created more sculpture than he ever dreamed of selling and he placed it around in an environment that is so perfect and so unified that it cries for preservation just as it is. It's interesting to hear how many American museums are now saying that perhaps we've reached the point in America where, for the first time, there is a monumental achievement of one of our own artists that should be maintained intact in its setting as he put it together. This is unprecedented in this country.

"This would be a very worthwhile project, and one of our panel members, as a matter of fact, is concerned with it."[6]

If the artistically curious and fiercely articulate Smith had lived to realize sculpture commissions in other locations and to be a force on the national council, or if the NEA and museums had preserved what Smith called his "sculpture farm" as a national landmark, the history of the NEA—and perhaps even of museums—might have been different. Within a few years after his death, Smith's sculpture fields were dismantled by Clement Greenberg, the most influential executor of the Smith estate, who had little use for the notion of place. Greenberg believed great modern art should not be limited or frozen by place, and he made sure Smith's sculptures were inserted into the gallery and museum

system from which they could be acquired and circulated in galleries, museums, and homes.

No subsequent selection of a visual artist for the national council was as inspired as Smith. None suggests a model that would have considered each of the artists part of an evolving council conversation. Under such a model, the council would have digested Smith's ways of thinking about art, considered the implications of his resistance to the boundaries of the studio, and allowed its curiosity about the efforts by many younger sculptors to go beyond Smith in giving sculpture a firm and formative place in the world to direct the chairman to the next council selections. Of all the chairmen, Stevens came the closest to understanding the educational potential of the council. His choices reflected an instinctive grasp of how the artistic imagination worked and a belief that an effective council depended on its awareness of the major issues living artists were grappling with. He replaced Smith with the painter Richard Diebenkorn (1966–1969), who had arrived at his own eloquent resolution of the problem of abstraction and figuration that had obsessed so many other artists, including Smith, through the first sixty years of the century; Diebenkorn began his "Ocean Park" series, the paintings for which he is best known, in 1967, while he was on the council. Stevens also chose Richard Hunt, like Smith a welded-steel sculptor engaged with the abstraction-figuration issue who, when he joined the council in 1968, was beginning to make public work.

Nancy Hanks was more strategic. She selected the precociously talented and well-connected realist painter James Wyeth (1972–1978)—he had been commissioned to paint a posthumous portrait of John F. Kennedy in 1967, when he was twenty-one—at a time when the Endowment was taking heat for not funding enough realists. Wyeth was well liked and he carried the aura of the Wyeth name, which was useful for the agency, but he was not as informed about pressing aesthetic issues as Smith, Diebenkorn, or Hunt, which made it hard for him to be the spokesman for the visual arts field after Hunt left the council in 1974. Neither was Jacob Lawrence (1978–1984), the first visual artist chosen for the council by Livingston Biddle, the third NEA Chairman.

Or the Pop Art painter James Rosenquist (1979–1984), who was put
on the council by Joan Mondale, "Joan of Art," the wife of vice presi-
dent Walter Mondale—an indication of the intrusion of Jimmy Carter
politics into the Endowment, which contributed to the vehement con-
servative reaction to the agency during the Reagan administration.
Lawrence's appointment maintained within the council an African-
American artistic presence and the memory of the WPA, on whose Ea-
sel Project he had spent eighteen decisive months in the late thirties;
Rosenquist's appointment told the council that popular culture had be-
come an ingrained presence in American art. But Rosenquist rarely
spoke at council meetings, was fixated on one issue, resale rights, and,
like the more responsible Lawrence, who felt humbled by the intellec-
tual authority of other council members, was an ineffective spokesman
for the field. By the end of the Carter administration, Stevens's belief
that the council had a responsibility to be engaged with pressing artistic
issues, and that the visual artists on the council had an essential role to
play in this engagement, had largely vanished from the executive offices
of the agency. So had Smith's awareness of the dangers, as well as the
strengths, of market and museum thinking.

The artists selected to the national council reflect another aspect of
the Endowment that must be carefully considered by future fellowship
programs: it did not have an arts policy. It believed policy should be
decided by the field, in particular, by artists and the people who worked
with them. Jennifer Dowley spoke about "the sense of staff as facilita-
tors, as strategic listeners and of reviewers. The field was the genesis of
the advice; the practice of making art in a studio was where policy ema-
nated from. That's what we could trust and believe in. We shouldn't
look to ourselves for that kind of truth because we were workers in an
office, we were bureaucrats in Washington, we were influenced and
swayed by a lot of things around us."[7] As commendable as this be-
lief was in its respect for artists, as productive as it was in enabling the
Endowment to be continually responsive to changes in the field, and as
astute as it was in its awareness that a government agency could easily
make inappropriate or destructive decisions about artists and art, the

absence of an arts policy made it difficult for the Endowment to ensure that all the parts of the agency, including the fellowship programs and the national council, remained connected. There was no disconnection under Stevens, who made his council a brain trust composed of distinguished artists and arts professionals who had no trouble taking a stand behind artists when fellowships were threatened in 1968. Stevens's council, which included powerful institutional figures, was so attuned to artists that it may have been able to help lead the national conversation about Mapplethorpe, Serrano, and Finley, and the issues their works raised about the body, religion, sexuality, and race.

Already under Hanks, the council was less permeated by artistic and cultural thinkers. Under Hodsoll, the council became more like a board of trustees on which the chairman depended to help him manage the agency and keep it out of trouble. His council was less connected to the ways in which artists lived and less sympathetic with the pressures artists were facing at that time, and how these pressures were different from those facing artists in the sixties and seventies. Under Hodsoll, the council began to be cut off from the field. The absence of a thoughtful but flexible arts policy that could have established central issues, like the challenges facing each generation of contemporary artists and the place of the artist in America, as the cement for the agency, allowed for damaging disconnections. One was the disconnection of museum values—now linked to keeping-the-agency-out-of-trouble managerial values—from contemporary art values. From this point forward, the council's understanding of the visual arts was ruled by a studio art model that many of the agency's influential fellowship recipients had been trying, with good reason, to resist.

III

Here are a few suggestions for leaders of future artists' fellowship programs for whom the place of the artist in America is a formative issue.

If a program boxes artists in, for example, by making them conform to a conventionally acceptable image of the artist, it will become just

another engine of official culture. If artists want to work in community, fine. If they don't, fine. If gifted artists make the case for standing apart, as artists and as individuals, from any social or institutional program, listen to them. Any fellowship program that respects artists will not set out like missionaries to train them to be good citizens, which will do as much to reinforce the popular assumption that artists are irresponsible children as supporting facile aesthetic tantrums. There will always be a handful of necessary artists who are recluses, and they need to be supported in their isolation. Many artists want their work to be accessible, but some gifted artists do not. Poetic difficulty in a consumer-driven, market-oriented moment should be recognized as a gift.

But a new program should also allow for the kinds of relationships the NEA did not develop. It should be equipped to give artists feedback—particularly feedback an artist asks for—throughout and, ideally, after the fellowship period. It should provide ways in which artists can give back to the foundation or agency, or to the community to which the artist belongs. The means by which artists could reach out and give back could include public lectures and panels, interviews in foundation publications, or even the design or a Web site or publication. Imagining ways in which artists can work with the foundation and with other artists to communicate better with museum and nonmuseum publics are part of the new funder's challenges. Engaging the art it funds— which means examining, encouraging, and also, if need be, questioning it—on the artist's terms as well as on the funder's terms, is now part of the funder's job.

The visual arts field should be seen as an ecosytem in which many different kinds of art must be able to flourish. This includes paintings that extend the traditions of realism and abstraction, photographs or any other kinds of works that point fingers at institutional complacency, and performance pieces that refuse to allow artists or institutions to be bullied by political, religious, and cultural fundamentalists. It includes art that is smart enough to be an eloquent advocate for social justice and art smart enough to expose the kind of sentimentality that can accompany works by artists who insist that art should work toward a better

world. It includes the art of those few artists at any moment who can be wretched human beings and yet create images that startle audiences into new ways of seeing. It includes internet art by artists who can develop the possibilities of working within the global digital network to reinvent "the public" and enable art to meet the challenges of the electronic transformation of space and time, and it includes art by artists who are not convinced the new technology can do justice to the density of embedded cultures and histories, or who are dismayed by the ruthlessness with which this technology has rendered obsolete the hard won wisdom of many older men and women. It includes artists who can reveal the psychological and philosophical complexity of the concept of consumption, as well as artists who can demonstrate the aesthetic pleasure and political potential of making art that resists the will to consume.

I hope funders recognize that one of the convincing models for the contemporary artist can be found in those who are committed to the ecological imagination. Newton Harrison and his wife and artistic partner, Helen Harrison, work in a studio and also collaboratively outside it. They are educators, lecturers, writers, thinkers, and storytellers. They make objects that are an essential part but just one part of their broad cultural project. Like Lin, their art is a meditation on the earth, but they are more concerned with calling attention to our inescapable yet deeply troubled and constantly changing relationship with it. Their installations, sometimes incorporating living elements, like algae, shrimp, or meadows, ask audiences to remember that they are part of, and therefore responsible for, the processes of nature. Their work encourages an awareness that nothing is self-sufficient, nothing complete in itself, and that what happens here affects what happens there and there is a price to be paid for oversights and shortcuts and a preoccupation with ends.

They ask questions about the global marketplace, which, like the Internet, is now assumed by many of its followers to be a parallel nature. The Harrisons have written of the "belief that the global 'free market' will do for all and everybody what nature was assumed to do. This world of discourse states that market forces have a will of their own

which must be obeyed or else! The once common belief in Nature as animate is now, without real understanding of the implications, applied to the global marketplace, within which money itself and its acquisition by any means not directly prohibited, is seen to have taken on intrinsic value. The market has a life of its own that we should not tamper with nor attempt to control . . . It is alive with activity and shares its bounty with the wise. Its priests are the stockbrokers, money fund managers and the controllers of interest rates. Its heroes are the rich."[8] By communicating a respect for place and for a quality of storytelling that they believe is essential to the sense of trust and shared experience that helps make a reverence for place possible, their art insists on a connective awareness that works against the global marketplace's "amoral structure."[9]

Where you find artists with an inspired ecological consciousness, or with an ability to create images or situations of such fierce presentness that they expose the limitations of familiar conventions and allow people to engage their blindnesses and uncertainties, you will find an appreciation of the language of creativity. At the heart of this language is a constellation of words that includes *connectedness, conviction, courage, improvisation, inquiry, intuition, introspection, passion, pressure,* and *process.* This language values emerging as much as closing, meandering (to use a Harrison word) as much as arriving, releasing as much as owning. It bears within it so much potential for intimacy, empathy, and engagement that any individual, or any arts agency, that uses it owes it to this language to fight again and again for the most serious, poetic use of it in a world in which the media, politicians, and Madison Avenue will exploit any word or idea, even—or perhaps particularly—those respectful of process and means, for its immediate ends.

One way to respect the soulfulness of this language is to remain attuned to the kinds of questions raised by the Endowment's commitment to creativity. What is inside the work, or person, that is trying to emerge, to take form, to complete itself? What is the need an artist, or anyone, is struggling with? What is the content of this need— aesthetically, psychologically, politically, spiritually—and what does

its shape and substance say about the individual and the moment? How can the aesthetic experience be known sufficiently to allow the intensity of perception and emotional courage that often accompany it at its most profound to clarify and deepen our relationship with one another? How can that quality of awareness and mind that can be developed through the making and experiencing of art inform everyday life? How can the astonishing and dynamic interconnectedness of the creative process give artists and their audiences a surer sense of place, both within themselves and in their multiple worlds? These are aesthetic questions, political questions, ecological questions, questions with which artists and the people who believe in them need to feel at home.

Notes

1. Interview with Newton Harrison, op. cit.
2. Thomas Krens used this expression in a lecture on the Guggenheim at the Art Show, organized by the Art Dealers Association of America, at the Seventh Regiment Armory in Manhattan, 20 February 1999.
3. Interview with Maya Lin, 13 October 1998.
4. Interview tih Mary Miss, 28 February 2000.
5. The Creative Capital Foundation, founded in 1999 to fund individual artists, is extremely sensitive to this issue. It asked the first year's fellowship recipients if they were interested in participating with the leaders of the foundation in some kind of retreat. Almost all the recipients were eager to go.
6. "The Arts in a Democratic Society," op. cit., 33.
7. Dowley, op. cit.
8. See "Peninsula Europe as a Twenty-First Century Garden: Bringing Forth a New Space of Mind," an unpublished manuscript, 1999, pt. 1, 25–26.
9. Ibid., 29.